INTERNATIONAL CALLIGRAPHY TODAY

INTERNATIONAL CALLIGRAPHY TODAY

Foreword by Hermann Zapf
Introduction by Philip Grushkin and Jeanyee Wong

WATSON-GUPTILL PUBLICATIONS/NEW YORK

Copyright © 1982 by International Typeface Corporation

First published 1982 in New York by Watson-Guptill Publications,
a division of Billboard Publications, Inc.,
1515 Broadway, New York, N.Y. 10036

Library of Congress Cataloging in Publication Data
Main entry under title:
International calligraphy today.
 Based on a show organized by International Typeface
Corporation.
 Includes index.
 1. Calligraphy. 2. Calligraphy—Exhibitions.
I. International Typeface Corporation.
Z43.17ʹ 1982 745.6ʹ1977 82-8513
ISBN 0-8230-2556-X AACR2

Manufactured in U.S.A.

First Printing, 1982

1 2 3 4 5 6 7 8 9/89 88 87 86 85 84 83 82

Every effort has been made to secure complete
and accurate credits for each piece of calligraphic art
appearing in this book. In a few cases it was not possible
to contact the calligrapher.

Photographs on the following pages were taken
by Diorio Studios: 52 bottom, 76, 119,
169 top, 175

Page 28: Carl Orff TRIONFO DI AFRODITE
© by Schott and Co. Ltd., London, 1951
Used by permission of European American
Music Distributors Corporation,
sole U.S. agent for Schott and Co. Ltd.

Page 29 bottom: Title page from THE 26 LETTERS
by Oscar Ogg (T. Y. Crowell) Copyright
1948, 1961 by Harper & Row, Publishers,
Inc. Reprinted by permission of
the publisher.

Page 101: Photographer Stephen Hampton

Page 143: Libretto of "Das Rheingold"
reprinted by kind permission of Decca
Record Co. Ltd.

Page 155: From Elektra, opera by Richard Strauss,
libretto by Hugo von Hoffmansthal,
English translation by Alfred Kalisch.
© 1980 by Adolf Furstner; Renewed 1935, 1936.
Copyright assigned 1943 to Boosey & Hawkes, Ltd.
Copyright and renewal assigned to Boosey & Hawkes, Inc.
Reprinted by permission.

Page 170: From THE SILMARILLION by J. R. R. Tolkien.
Copyright © 1977 by George Allen & Unwin
(Publishers) Ltd. Reprinted by permission of Houghton Mifflin
Company.

Edited by Susan Davis
Designed by Jay Anning
Photography by Greig Cranna
Graphic production by Lesley Poliner
Set in 11 point ITC Galliard Roman

To Herb Lubalin
1918-1981

CONTENTS

BEHIND THE SCENES:

THE EXHIBITION AND THE BOOK

KALLIGRAPHIA
—Greek, from **kalli** (beautiful) and **graphia** (writing). The exhibition "International Calligraphy Today" proved to be a collection of very beautiful writing indeed.

In March 1980, a call for entries for the exhibition was published in *Upper and Lower Case (U&lc)*, the international journal of typographics published by the International Typeface Corporation (ITC). The quarterly publication is read by more than 500,000 people throughout the world, a good number of whom practice calligraphy as an avocation or hobby.

In a report on the exhibition that appeared in the December 1980 issue of *U&lc*, Hermann Zapf, chairman of "International Calligraphy Today," offered the following thoughts on the "kinship of calligraphers":

"There is something unique about calligraphers. We are the last remaining 'individuals' in the realms of art. Calligraphy is the most intimate, personal, spontaneous form of expression. Like a fingerprint, or a voice print, it is unique for each person. Calligraphers can't be compared. We can't be grouped into 'schools,' 'styles,' or 'traditions.' It is our respect for our differences that unites us and keeps us free of competitiveness that eats up so much energy in other areas of graphic design. The feelings of friendship reach across national borders and whole continents.

"We're involved in an art form that is timeless and boundless. Calligraphy has an ancient history, but it is still the source of contemporary letterforms that express the spirit and tastes of our times. There are no language or cultural roadblocks, either. Our new forms have come from the vigorous calligraphy of old Japanese masters as well as from contemporary Western scribes.

"But beyond its utilitarian service, calligraphy is a form of intense personal expression. Ray DaBoll says that spontaneity is the lifeblood of it. But the lifelong satisfaction is in the discipline, the constant practice, the repetition of exercises, the perfection of a skill and the challenge of measuring one's work against the great historic forms. Anyone who is fascinated by and practices calligraphy will never be bored with life.

"Our feeling for calligraphy, and our future in it, has nothing to do with the nature of the jobs we do, nor with how history treats our art form. Whether it is a museum treasure, a piece of printed ephemera, an informal note or a single, beautifully written character, it is all the same to us. We celebrate and appreciate each other for what we do with such humble tools as pens . . . brushes . . . and a few drops of heart-blood in our ink."

When ITC conceived of sponsoring an exhibition of contemporary calligraphy, it was predicted that this ancient art should be enjoying a renaissance in the age of the computer. And that was exactly the situation. The cold, impersonal climate of our high-technology world has perversely warmed up the fingers of an amazing number of calligraphers. We frankly underestimated, and were overwhelmed by, the response.

At the outset it was felt that the exhibition would be a success if only 100 or 200 well-designed entries were submitted to the exhibition. Several weeks later, at a reception held in New York in his honor, Hermann Zapf voiced surprise and concern about the huge influx of entries received by the ITC Center—the count was at that time about 400 pieces. By the time the last piece was logged in more than 2,400

entries had been received from Austria, Canada, Czechoslovakia, Denmark, Finland, France, German Democratic Republic, Hungary, India, Israel, Italy, Japan, The Netherlands, Peru, Poland, Scotland, Spain, Sweden, Switzerland, Taiwan, Tunisia, U.S.S.R., United States, West Germany, and Yugoslavia!

The call for entries asked for commercial or experimental calligraphy. Calligraphy was defined as the art of the brush or pen stroke. At first, retouched art was not eligible. However, during the actual judging the jury agreed that even retouching or correcting mistakes well requires a great deal of skill and decided to eliminate this restriction.

On August 9, 1980, the judging for the exhibition was held at the ITC Center. The jury's original plan was to require unanimous approval in order for a piece to be accepted. However unanimity was not always possible; as varied as the calligraphic styles represented by the calligraphers, so were the opinions of the judges: Hermann Zapf (chairman), Ed Benguiat, Phil Grushkin, Herb Lubalin, and Jeanyee Wong.

Some 200 submissions were selected to be included in the exhibition. It is never easy to be a juror. No matter how much experience you have in graphic design, no matter how assuredly you make decisions on a day-to-day basis, when you are confronted with hundreds of choices, normal, rational criteria fizzle away, and certain inner reactions and personal tastes take over. Fortunately, the reactions of the members of the judging panel were those of a highly sensitized group of internationally reknowned designers and were, we felt, quite trustworthy.

No prizes were given to the calligraphers in the show. The variety of work, tastes, and functions also precluded any comparisons or one-two-three listings. Jurors reported that they were hard put to limit their selections and were thankful that the final listing of exhibitors would be given in simple alphabetical order.

This book is not a catalog of the exhibition, rather a book based upon it. Because a few examples had to be returned to their owners immediately after the exhibition (before this book was contemplated), not every piece chosen for the exhibition is included here. However, the collection has been expanded by the jurors to include the work of a number of calligraphers not represented in "International Calligraphy Today." We have also endeavored to include examples by some of the masters/teachers of calligraphy in this century.

"International Calligraphy Today" opened in October 1980 at the ITC Center in New York City. Amateur and professional calligraphers alike came to see the exhibition, not just once but several times.

Calligraphy societies from throughout the northeast arranged visits to the ITC Center. This unpredicted popularity led to a return engagement of the exhibition in the summer of 1981. Traveling slide shows of the exhibition are available from the ITC Center and are reserved months in advance. Calligraphers seem to have an insatiable thirst for brush and pen strokes!

We hope you enjoy the artwork presented here as much as we did when it first began to flow in across our desks. This book is dedicated to calligraphy enthusiasts around the world, and it is for the advancement of this noble art form that we have prepared this record of "International Calligraphy Today."

Laurie Burns
Coordinator, "International Calligraphy Today,"
and Assistant Director, ITC Center

INTERNATIONAL TYPEFACE CORPORATION

FOREWORD

*T*he exhibition "International Calligraphy Today" was shown in 1980 and 1981 at the ITC Center in New York, which is located near the United Nations Headquarters. Its unusual success may be evidence of the rediscovery of this artistic activity within our abstract business-oriented world—a world becoming more and more complicated, moving toward a life governed by electronics. This publication, based on the material in the New York exhibition, shows a selection of the best living calligraphers and lettering artists in the world. A very few are missing, only because we did not receive their works. Out of the more than 2,400 examples submitted, our jury selected 201 entries (from 21 countries) and 147 are reproduced in this volume. This book will thus become a good study and presentation of all the various styles, hands, and tools used today, as well as the diverse temperaments, following traditional forms or expressive of their native vigor and sensitive spirit.

The freedom of artistic expression that is so strongly shown in a calligraphic piece of work and the staccato rhythm of the letters that build up their words into sentences are always fascinating, when balanced and controlled by discipline. Freedom and discipline are the black and white counterparts in calligraphy, and it is in the hands of the calligrapher, matured by years of experience and training, to unite this freedom and discipline into harmony.

In addition to the ITC Center exhibition, described at the beginning of this book, some typical examples of great masters of calligraphy in the past are reproduced in the Introduction to honor their unending inspiration and stimulation to our present generation of calligraphers and (let us hope) to our new friends of calligraphy in future years.

Calligraphy can express—like scarcely any other art except music—the intimate feelings of its creator. Calligraphy is much more than handsome letterforms in any style; it is a work of permanent refinement of forms, a never-ending training of manual skill. Perfecting this skill and keeping trained in all the many variations of calligraphic exercises open up wonderful possibilities in expressing the different aspects of human emotions. Every example reflects concentration, patience, and again and again, the critical confrontation with the historic forms of a great tradition, centuries old. If you make a sheet of calligraphy you are really involved with your whole body, not alone with the brain or finger that guides the pen or brush. But these are not the only requirements for creative calligraphy—you need your heart.

These factors have long been applied to Oriental calligraphy, which is still strongly based on concentration, meditation, and—in the end— full harmony—with the artist in its center.

The areas of calligraphy and lettering are not precisely definable. Calligraphy is the vital and always more spontaneous expression. The spontaneity is important, revealing the very present mood of the calligrapher. It is the mirror of his or her feelings and emotions, together with the imagination and discipline through the word patterns one forms on the sheet of paper. Sometimes the start is in handwriting; the Chancery hand will help you develop your own personal style and thus carry you in the direction of calligraphy.

Lettering is a more carefully planned design, rendered with a pen or brush to meet a single purpose by precise execution, which of course foregoes the adventure of accidental traits for which a liberated calligraphy may hope.

The wide popularity of calligraphy and fine handwriting, especially in the United States, is the result of the influence and direction of the calligraphic societies in many cities throughout the country. This new movement for calligraphy may swing back to Europe, and I hope this book and its calligraphic examples will promote and inspire a broader interest again in this art on both sides of the Atlantic. Unfortunately, many art schools in Europe have mistakenly closed their lettering classes, incidentally injuring a centuries-old tradition of calligraphy as one of the fundamentals of any creative education in the graphic field. In books this art will survive and thus in time help Europe regain that art which her older masters' writing-manuals brought to the New World.

International Calligraphy Today shows examples of calligraphy from professionals and also from friends of calligraphy whose responsive admiration has quickly turned them into delighted amateurs, realizing that in this craft you don't need any expensive equipment. Indeed, a few personal sentences written in letterforms sensitively shaped and placed will open to the scribe many doors of friendship and mutual pleasures and esteem. Scribal practice adds judgment and grace to letters and to their making. As the scribe gains confidence, he or she realizes how much there is still to learn, and thus his or her confidence is tempered and balanced by modesty.

The artists represented in this publication will speak to you in varying voices, stimulating interest in this art form that may well ignite the initial spark and put into your hand a broad-edged pen, as a therapy against the blues, and thus promote self-reliance. Eventually, it is hoped, this quiet and gentle art may, in its modest way, help our ailing society to recover.

Hermann Zapf
Darmstadt (West Germany)

INTRODUCTION: VIEWS OF TWO CALLIGRAPHERS

Philip Grushkin and Jeanyee Wong,
two of America's distinguished calligraphers,
agreed to discuss the current state of calligraphy
and how the collection of calligraphic works
in this book was originally selected for an exhibition,
"International Calligraphy Today," sponsored by the
International Typeface Corporation (ITC) in 1980.
They served with Hermann Zapf (chairman), Ed Benguiat,
and Herb Lubalin on ITC's selection jury.
The following essay is based on their conversation
taped in January 1982 and edited by Susan Davis.

"Beautiful writing" is a simple definition of calligraphy. The phrase—from the original Greek *kalli* and *graphia* (which Stanley Morison has promoted)—is impossible to really define. Friedrich Neugebauer called it "the mystic art of written forms," because there is a spirit in calligraphy arising from an inner/outer source that defies definition.

What is beautiful? It is subjective and varies with each person. Even though Morison was being very historically correct and very academic in his definition, he did not include experimentation—the very free calligraphy, emotional calligraphy, expressionistic calligraphy, and such that may or may not be beautiful, but that is definitely calligraphic in origin. That is one of the reasons why the word "calligraphic" is used much more than "calligraphy" to describe many things. It's related to calligraphy, but it is sometimes a matter of not following the rules at all. Only the Chinese and the Japanese practice what we can call a true calligraphy, that is, spontaneous writing, although some Western calligraphers are now taking up that practice.

In evaluating the recent renewal of interest in this ancient art form, Philip Grushkin and Jeanyee Wong don't think that it constitutes a *real* revival because calligraphers have been working constantly. Calligraphers have been teaching, working at their art, and creating posters, book jackets, and citations all along. However, there was a general unawareness of calligraphy, and its audience was small. Yet in the last ten years a so-called revival of calligraphy came about when many calligraphic groups sprouted all over the country to share common interests, and then many people became aware of calligraphy and wanted to study it. Many adult education courses were started, and calligraphic kits were advertised widely, creating a desire to explore this fascinating subject.

Both Jeanyee and Phil credited specific individuals with helping the so-called revival, particularly Donald Jackson, who came to the United States from England about eight years ago and taught an intensive three-week course in New York City. He appeared on TV, gave lectures to groups, and then conducted summer courses at different universities. Everything he did helped create a wide interest. In addition, Herb Lubalin through *U&lc,* the International Journal of Typographics, as well as Lloyd Reynolds through the western branch of the Society for Italic Handwriting, were other people in the United States who helped foster a renewal of interest in calligraphy.

Another factor that stimulated an interest in calligraphy was a desire to work with the hands, to make paper and to bind books by hand. And, as letterpress was beginning to disappear from commercial printing, people also became interested in it, and they acquired equipment that would otherwise have been scrapped. Hand work of all kinds was being chosen over technology as a way of life.

But this, Phil and Jeanyee believe, is in a sense a second revival. The first was the one they were closest to, the one that George Salter started in the late thirties when they were his students at Cooper Union. And Paul Standard made a valuable contribution to that revival with his *Calligraphy's Flowering, Decay, and Restauration* and an article on handwriting in *Woman's Day* magazine. Since then Hermann Zapf has been doing calligraphy and incorporating it into typefaces. George Salter was doing book jackets. Herb Lubalin carried calligraphy into typography. Both Jeanyee and Phil were doing it continuously, as were others like Arnold Bank, Oscar Ogg, and W.A. Dwiggins.

The big difference between what has happened in this revival and the

one that got them involved with calligraphy is training and discipline. Now, they feel, it's the person who is not skilled as an artist who has become interested in calligraphy, whereas in their time only professional people were really involved. It was then part of the art school curriculum at Cooper Union and Pratt Institute. Oscar Ogg was teaching calligraphy at Columbia University, Arnold Bank and George Salter were also teaching in New York City, and Lloyd Reynolds was teaching in Portland, Oregon. Jeanyee and Phil believe that they and their fellow students were learning it as an art form, while today it's often thought of as a craft, as something to be studied for fun, or as a way to improve handwriting.

In Europe, the study of calligraphy was not a separate involvement in the thirties and forties. It was an integral part of a total art school curriculum that developed the artist whose discipline included calligraphy. Among the masters Edward Johnston, Rudolf Koch, Imre Reiner, Ernst Schneidler, and Rudolf Von Larisch taught the usage of tools and the total development of the art. And of course it has never gone out of style in Asia where there is a different kind of connection because the writer uses it in everyday living. Writing is part of a school education and later an essential ingredient in life, while writing in the West is unrelated to calligraphic writing.

In the Orient you could be a poet and write beautiful words, but you could also *write* beautiful words, which was really the mark of a calligrapher, who was thought of as a literate artist. Calligraphy was considered the highest form of art, over painting. The ultimate art was brush-written words, which were considered poetry for the soul and the intellect. The most important people in that society were calligraphers, like Emperor Hui-Tsung, who was well known for his calligraphy. The painter and the calligrapher used the same tool in the Orient, but not so here in the West. It used to be only Oriental calligraphy that people thought of; now they are including Western calligraphy and that from other cultures, such as the Hebrew and the Islamic traditions, where calligraphy was considered sacred—done for the glory of God.

The Effects of Technology

Calligraphy is a wonderful involvement today because, says Philip Grushkin, "it allows playfulness with a pen. It permits creativity and inventiveness, and if it does nothing more than improve handwriting, then it has achieved a great deal."

However, one of the current fads is calligraphy kits that profess to make the user an instant calligrapher. Phil commented: "If it makes someone more interested in designing and writing letterforms and doing them well, then that's a plus. But it also makes everyone a calligrapher like reading a medical book makes everyone a doctor or using a phototypesetting machine makes every office worker a typographer. If anyone believes the ads 'become a calligrapher within two weeks' by using a do-it-yourself kit, that is a sad and potentially deceptive situation. An amateur is not a calligrapher, no matter how fancy their handwriting. It is misleading to make someone think that buying a kit and reading a book and pushing a pen around—whether they're doing it right or wrong—can make them a calligrapher. There are basic rules and disciplines that people need to learn and sometimes their eyes are not trained to see whether they're doing the right thing." Phil continued, "But if the kit provides a good handbook, which some of them

do, then that is valid. And if the amateur derives pleasure from calligraphy, what difference does it make? Winston Churchill and former President Dwight Eisenhower enjoyed painting, but theirs was not great art."

Some of the fountain pen companies that are promoting kits are also providing fountain pens that were generally not available thirty or forty years ago. "We had to have our own fountain pens made to order," Phil noted. "Now you can go to any art store and buy a broad-edged felt pen, a chisel marker, a big poster pen, or calligraphic fountain pen sets. When we were at school, we had available only a manuscript pen or a steel nib or a reed or a quill that we cut ourselves. If we wanted a fountain pen, fortunately there was a man who used to work for Waterman who moonlit and he made pens for all of us. I still have my three or four pens with calligraphic points, and they're still excellent."

Since then, the various pen companies have developed a wide variety of calligraphic fountain pens. Osmiroid was one of the first, and then the other fountain pen companies—Esterbrook, Parker, Pelikan, Platignum, Sheaffer—followed. Today Sheaffer puts out many pens, including cartridge pens that are even easier to use. For those reasons, Jeanyee summarized, "It's kind of wonderful today for people who want to have many tools." Also, Phil added, "Most of the calligraphy kits do provide you with a decent sheet of paper, which is half the battle, and a reasonably decent ink. We many times had to make our own ink."

Few inks were available forty years ago, and they were either waterproof or water soluble. Waterproof inks are heavy handed and less useful for calligraphy. To do calligraphic letters well, you need a water soluble ink, and "there weren't too many around," Grushkin remarked. "But we also made our water soluble ink by grinding stick ink or used some fountain pen inks that were reasonably fluid. So many fountain pens are available now with inks that flow better." "And they now come in marvelous colors, which we didn't have," added Jeanyee.

Another helpful technical advance is the so-called drafting pen that comes in sets of various point thicknesses. In order to make the ink work in this type of pen, inks were developed that flow better and don't dry up. This has also influenced the ink that is available for calligraphic use.

The manuscript pen that calligraphers are most familiar with is truly a tool designed for the right-handed person, but there is no reason why someone who is left-handed cannot develop skills with this tool either by using a left-handed nib or by training himself to hold the right-handed nib in a particular way. Phil wanted to encourage the left-handed person interested in calligraphy: "You can develop skills left-handed , or you can be trained to use your right hand in the same way that a violinist is trained to play his instrument; whether he's right-handed or left-handed, he plays it the same way. The same with a pianist. Jeanyee pointed out that "There are some extraordinary left-handed calligraphers, such as Julio Vega and Robert Boyajian in this collection, whose work shows beautiful writing. (See pages 143, 155, and 72, respectively.) Phil went on: "If you're left-handed and you want to get involved in calligraphy, don't be discouraged. The important thing is to produce a calligraphic letter silhouette that works well."

Jeanyee picked up on Phil's thought: "I've known students who are left-handed and they can do well. Whether the work is good or bad, you cannot tell if it was done by a left- or right-handed person. Every left-handed person has to work their technique individually. There are no basic rules for them because some of them write up and down and some push up or write sideways. So the basic rules, including how to hold the

paper, need not apply. Some left-handers use a regular nib rather than an oblique nib. Formerly calligraphers cut their own pens to suit their own hands, and they can still do that today."

Jeanyee reflected: "We had very few materials or books available in our time so we had to go to the sources. Edward Johnston's *Writing & Illuminating & Lettering* was what was called the 'calligrapher's bible.' And it still is one of the best sources to this day. It has all you need to know to start to learn." She summarized that besides good writing materials—pen, ink, and paper—the most important part is the person—"the hand and eye and the mind."

With an infinite variety of materials today life seems easier for the calligrapher. "But sometimes," Phil continued, "when the sky's the limit, the results are not. If you're limited in materials and tools, sometimes the result can be better. If you paint, let's say, with a limited palette, generally the result can be better than if you have the sky." "But," Jeanyee added, "then that does depend on who is using it."

All these technological advances make calligraphy more available to the general public by giving them an easier chance to get involved. Also, there are books galore on the subject, both good and bad, on many different levels. While tools, inks, papers, and pens are easy for beginners to obtain, Jeanyee worried, "How can they know the *good* books and *proper* tools without guidance? For instance, some calligraphy papers are meant only for the brush and a novice would not know that."

"It's interesting how a thing will grow out of something else," Phil remarked. "One of the reasons that you're able to have so much material using calligraphy as well as books about calligraphy today is offset printing. Before, printing calligraphy required making letterpress line-cut and halftone plates, which were expensive, and all kinds of problems went with it, such as the need for printing on specific papers. It's a lot easier to print the calligraphic image in offset because it can be printed more easily on all kinds of papers."

"In earlier times woodcuts were used for the writing books," Jeanyee went on, "and of course, it didn't show the precise images formed by the pen or the quill. For instance, the Arrighi manual really didn't reveal the true pen strokes or the exact image of his work. It was impossible to have true reproductions. But today we can photograph it precisely and print it." Phil added, "One of the books that we had available was *Lettering of Today* by C. G. Holme, which was printed letterpress. It would have been a lot more useful had it been produced in offset perhaps, but it still was a remarkable book of examples of calligraphy."

Technology has added many dimensions and spurts to the interest in calligraphy. Jeanyee concluded: "I think there is stimulation every-where—in the bookstores, in the art supply stores. Once people are aware of it, they become interested in the original letters or forms, leading to an interest in typography. It's all related. I think anyone who studies calligraphy—a true student—starts to look and then to see the ABCs of everything."

On the future role of tools in calligraphy, Jeanyee felt, "As long as people become involved with the manuscript pen or any broad-edged tool, they can write calligraphically." Phil stressed, "The tools are so simple that it's hard to think ahead to the future to see where a tool would do better than what we have today. You're dealing with very simple means. It's almost like the book, which is pretty much the shape that it was when it began. We haven't developed any better kind of physical entity. The book is still a collection of pages that are bound

together. And even though there are things like microfiche, microfilm, and computers, the book is still basically the same simple form and the easiest form to use. You can easily carry a book in your pocket in the subway. You can't carry a microfiche reader."

"I have heard that Friedrich Neugebauer," Jeanyee stated, "when he was a prisoner of war and had nothing to write with, used toothpaste. So a true calligrapher will use anything to work with."

Phil smiled. "In one of the classes I taught at Cooper Union, I set up a problem where the students had to design an alphabet calligraphically. I was not concerned with what the tool was. One of the most interesting results came through a student's use of Elmer's glue that he simply squirted from the container like icing onto wax paper. As the image dried, it began to congeal and pull itself together, and it was no longer the shape that he had poured onto the wax paper. It had totally changed. It spread, it pulled together, and so on. His idea was to lift these letters off the wax paper after they dried, and he would have an alphabet. I photographed it and have a record of the images as they manipulated themselves. These fascinating silhouettes came from just squirting glue. Of course, the ideal tool would be a long fingernail cut as a quill."

Jovica Veljović and Jean Evans, whose work is shown on pages 70, 176, and 60 respectively, both worked with wooden sticks. "In the hands of a skilled person any tool will work," Jeanyee asserted. "I know that Hermann Zapf will use a ballpoint for Spencerian handwriting. It can be done if you have the skill behind it."

"There was a series of books that we were involved in a long time ago called Archway Press Scribe Series," recalled Phil. "I remember having a discussion at the time relating to the title pages where it said 'Handwritten by Philip Grushkin' or 'Handwritten by Jeanyee Wong.' I asked, 'What if it was footwritten, would it still be valid?' And I think this is the approach that some of us take—that the tool and the result are the important things. If you can do it—if you can hold a pen between your big toe and the other toes and write nicely and create an interesting result—I think this would be certainly acceptable as calligraphy."

Jeanyee Wong, *The Flower Lover and the Fairies,* portion of handwritten title page (Archway Press, New York).

The flower Lover
and the fairies

ANONYMOUS (CIRCA FOURTEENTH CENTURY)

FROM THE TRANSLATION OF CHI-CHEN WANG

HANDWRITTEN AND ILLUSTRATED BY JEANYEE WONG

Distinctions between Calligraphy and Lettering

A distinction should be made between calligraphy, which is writing letters with a tool, and lettering, which is drawing letters with a tool. "Sometimes they can overlap," Jeanyee related, "and a skilled person can do a calligraphic piece by drawing it, and it will look like calligraphy. You won't really know the difference because of the person's understanding of how to create it by building up a calligraphic result. Drawing letters means drawing the shape of a letter and maybe filling in the outlines with black or color. It's a slow process and does not have rhythmic movement as does calligraphy. What distinguishes calligraphy is the flowing movements."

Grushkin noted, "At Cooper Union our class was always called 'Lettering and Calligraphy.' Both skills were related and intermingled. In fact if one does calligraphy, one should also be skilled in doing lettering, though that's not always the case. It takes an enormous discipline to meticulously build up letterforms. You have to have a good drawing that you're working within, and that takes an understanding of the letter silhouette. But there's also a gray area, and in a lot of cases you can't pull the two apart. Oscar Ogg made a very clear distinction in his book, *Twenty-Six Letters,* of the drawn letter and the calligraphic letter. He demonstrates very nicely the visual differences between the two. The calligraphic letter has a different kind of spirit because the pen is motivating it; the built-up letter is making compromises and changes."

Jeanyee carried on: "I feel that if you're truly interested in one, you will be interested in the other. I have heard some type designers say that they don't need calligraphy. But calligraphers I know find it very helpful in typography because you learn letterforms with proper thick and thin strokes and proper spacing as you learn to write." Phil continued, "When you set type or specify typography, it's like writing letters by hand; all the rules—the word spacing, the letter spacing, the line

spacing—come out of calligraphic origins. Also in certain areas of advertising and designing, the skill of calligraphy is very useful in making comps or rough layouts to detail the type that you're using. It's a lot easier to indicate a line of type with calligraphic skill than to noodle it painstakingly to show what typeface is being used." Jeanyee added, "Calligraphy is very helpful. They relate; they can benefit each other."

Many typographers today use instant lettering, which is quite different from either writing or drawing letters. One of the effects of instant lettering had been to weaken the use of both calligraphy and lettering. "When we prepared a jacket sketch," Phil stated, "we painted the letters to resemble what the finished result would be like. We used a brush and paint. Today it seems easier to take an instant lettering sheet and burnish the image onto a sheet of paper to resemble precisely what the letterform should be, but you are limited to the size, color, and design of what's available in instant lettering."

"Often now people don't need to invent and draw things," Jeanyee observed. "They can buy prepared art. This easy way destroys creativity. We actually designed letters for specific jobs and created our own alphabets as a matter of everyday work. But today few bother because it's all available. Creativity today is in the selection of the particular letterform that's available in the marketplace, it does not come from the individual."

In calligraphy, both Jeanyee and Phil emphasized, there is an absolute relationship between the shape of the alphabet and the tool that is used to create it. The alphabet silhouette, the letterform that results, starts with a calligraphic image. "When Gutenberg invented movable type, he was simply duplicating the calligraphic silhouette," Phil related. "There's always been a strong relationship between the tool and the result. Unfortunately, in recent times that relationship is being eliminated. So many of the letter designs that seem to be fashionable today bear no relationship to the tool."

Phil continued, "One of the things that makes calligraphy interesting for me is that I can almost sense the tool and the movement that created it. It could be a brush. It could be a pen. It could be a toothpick or a finger dipped in ink. There's a relationship between the tool and what is formed. Many of the images that we're beginning to see today don't have that relationship. They're simply built up to create an image that is already shaped in the mind of the designer."

Jeanyee noted, "One of the reasons why calligraphy is so popular today is because once beginners latch onto the idea of a tool making various thicknesses of strokes, they're fascinated by it. The regular ballpoint pen cannot give that to them." Phil picked up on her thought: "So long as you hold the tool correctly, you can shape the letterform correctly because the relationship of thick and thin will be automatic."

The Role of Discipline

*B*esides materials, the basics needed for calligraphy are the hand, the eye, and the mind working together. "Without all these working in harmony as a total unit," Jeanyee explained, "the result will not be good. The more the parts are together, the better the results will be. That's the mystique—the person and the tools becoming one to create art."

It's very difficult to define. "For instance, have somebody explain how

they write their name," Phil began. "What makes them do what they do quickly and without stopping? What is the movement involved? Something is happening with the brain, the hand, and the memory of the image that is being acted on by the hand. Training and repetition play an enormous role in developing that."

"What we would like to include in the training," continued Jeanyee, "is patience and discipline. Discipline is important whether people like it or not. Without the discipline, you can sometimes get a result, but you can't always count on it. Making a few letters well is merely a beginning. Just like practicing notes on an instrument, the music is yet to come. You must learn to combine letters to form words, then arrange words together to make lines of sentences, and then write line after line until you complete a page. Often a calligrapher will have to do many pages to make a book. Such a result requires discipline indeed. And creativity is also essential. But what is creativity? Or the ability to see? Awareness? What a complex idea that the human being plus the tool, as well as the discipline and the creativity, can make an artist!"

Phil reflected, "There are two approaches to producing a result. There may be more, but just let me analyze two. One could do calligraphy and know exactly what the result is to be even before the moment of putting pen to paper. One knows exactly the kind of letter shape he wants to put down and how it's to be formed and when it's finished, he's done. Then there's another approach where you begin to write. You don't really know what the result is to be and interesting silhouettes start appearing, and you say, 'Isn't that a great letter image. Let me take advantage of it.' And you go to the next step and develop it further. This is the kind of calligraphy that I enjoy doing most, where I'll try something and then I'll try it again and again. I'll see something and take advantage of it and do it again, and lo and behold, the hand is memorizing what's going on. Then you do it, and it's just right. But if you had begun and said, 'That's what I wanted,' it couldn't have happened. The result developed from working and reworking."

Jeanyee replied: "Sometimes, Phil, just from enough experience you know that these things will occur. You know if you do it frequently enough, these things will show up anyway. You know the results will be right." Phil added, "But there's also the point where sometimes something is arrived at and you had no notion whatever that it would happen and suddenly you take advantage of it. You know the little monogram PG that I do for myself?" Phil asked. "Well, after I'd attempted to write that combination of letters many times, over and over again, the pen exploded with ink, and I left it exactly that way. I couldn't have predicted the result, but it's as perfect as I would want. It just splattered in exactly the right places, and I took advantage of it."

"Yes," Jeanyee smiled, "that is what happens in writing. Even if you predict a result, the tool will create certain 'accidents.' That's what I'm talking about—the whole. It's not just the explosion of ink. It's everything, and I don't think it can be defined. It's the accidents that come with the leap of creativity."

Phil returned to an earlier point. "I mentioned two approaches. I didn't mean that it's either one or the other. But there is one end of the scale and there's the other end of the scale, and then there is everything in between. It's all valid and all of it is acceptable. The skill or the uniqueness of a particular calligrapher is to know when to take advantage of the things that happen. When it's right and when it's wrong." Jeanyee added, "That spatter to a beginner would be a mistake,

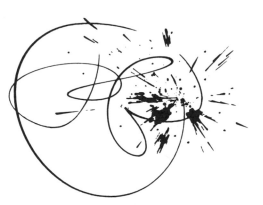

Philip Grushkin, "PG" monogram.

but to a person of skill that could be incorporated, so there is that kind of development."

"Letting a letterform almost dry brush itself across a sheet of paper," observed Phil, "can be very beautiful in one person's hand and abominable in another." Jeanyee responded with an analogy. "A singer in an interview said that he had been singing for thirty years. In the beginning he memorized all the notes and he sang every word. Now he says, 'I just sing by feeling.' That is what we're talking about—the feeling."

Jeanyee returned to the subject of discipline. "I absolutely feel that calligraphy should be taught as a discipline. What we have talked about here is what I try to introduce to students. Never will I tell anyone that one can be an instant calligrapher. Never, never! To teach that way is a disservice to students and shows a lack of knowledge in the teacher."

Phil reinforced her viewpoint: "One of the things that explains much of the calligraphic imagery that we do is the consistency of letterform throughout a page. Sure the letterform might change a little bit, but the gray color, the overall pattern, the texture are quite consistent. You can't do that without discipline. It may take you ten minutes to do a page, but it may have taken you weeks to get to the point where you could do the page that way with that skill."

He continued: "I remember when I was teaching calligraphy at Cooper Union. We'd spend hours doing m's and n's. 'Minimum' was a favorite word. All over the sheet—'minimum, minimum, minimum.' To get a pattern, to get a feeling, to get the flow, the rhythm, the regularity of down stroke, the shape of the letters. In a sense these are the piano scales. And it's very tough to get kids to play piano scales." Jeanyee emphasized, "Discipline is most undesirable to some people. They dislike it. A lot of young people don't want it, but it's important to tell them that it has to be part of the learning."

"In Oriental calligraphy," Phil remarked, "the warming up, the mixing of the ink, the contemplation, the preparations to get everything right are essential, and then just doing it in a flash of a second and it's right. That takes an enormous discipline." Jeanyee agreed. "Music is a good comparison. Most people understand that to become a soloist in Carnegie Hall takes more than ten minutes of studying. Well, it's the same with calligraphy or any other art form."

"There's another thing," Phil observed. "It's tiring to write, to hold the pen in a particular position for so long. The whole business of discipline is to train you so that you can stay with it over a long period of time. Start here and finish, turn another page, and keep it consistent. It takes training. It's discipline, and there's a monotony to the discipline that is important to the training." While both admitted, somewhat sheepishly, that they don't practice everyday, Jeanyee spoke about her needs as a professional: "I do warm up before I start calligraphy so that I get the flow and the rhythm, which are so important. I do tell my students that I do not practice what I preach, but only because I am skilled enough not to have to practice everyday, but I keep at it a lot." Phil concurred: "I still need to practice and I still have to warm up before digging into a calligraphic project. Everybody has to warm up. The less we do it, the less freely we can do it. And you've got to concentrate. That's important. God help the telephone call that interrupts in the middle of writing. It's a total disruption. The ink dries and your hand isn't quite the same when you pick it up again." "The continual flow of writing," Jeanyee repeated, "is so important. Much of my work is done late at night, without interruption."

*T*urning their attention from general concerns about calligraphy today, Phil and Jeanyee focused on the 1980 exhibition, "International Calligraphy Today," sponsored by the International Typeface Corporation, which inspired this book.

Because calligraphers all over the world submitted pieces to the show, it became a representative cross-section of everything that's happening in calligraphy today. It stirred a tremendous interest in newcomers to calligraphy—students and laypeople—who had heard of calligraphy, but who had not known or seen examples of it before. The show and this book therefore have set a standard, a goal, a quality to aim for, which will help motivate further study and experimentation.

The quality of the calligraphy here is related to the particular qualities of the jurors, who proved to be an interesting mix. There was an internationally known professional, Hermann Zapf, who is involved in calligraphy and typography; Jeanyee Wong and Philip Grushkin, who are involved with designing, graphics, and calligraphic work; Ed Benguiat, whose field is designing typefaces for phototypography and advertising lettering; and the late Herb Lubalin, who was a unique graphic designer also known for his letter designs.

Not everyone agreed with what was presented or selected. There was a great deal of interesting discussion about why someone felt something should be in, with others sometimes disagreeing. With the result that not every piece in the show received 100 percent approval from all the jurors. Many of them *did,* but there was definitely a give and take, as well as an overall respect for each juror's choices. It was because of the jurors' different backgrounds and ways of working with letters that there is great variety in the pieces selected. However, considering the diversity of opinions, it was an amazingly agreeable group.

The biggest discussions came in the area where the jurors were not familiar enough with the calligraphy, that is, in the foreign submissions—the Japanese, Chinese, Arabic, Indian, Tibetan, Cyrillic, and the European where there was a language difference. That was where some of the jurors felt unsure. But then one juror would sometimes say, "But I think it's great because I sense it" or "I know it," while the other four might not have the same feeling toward it or receive the same inspiration. Jeanyee observed, "Our backgrounds made a lot of difference in being able to see or sense a different subject. It's a mystery how we express ourselves in a certain form and what we respond to or not." Phil noted, "I remember that the most intense discussions were with Ed whose background was more in advertising lettering. He had a different concern for what was selected than some of us. Unfortunately, I can't be specific, but I remember having all kinds of interesting back and forth discussions over particular pieces with Ed."

A lot of the discussion was over dramatic versus quiet pieces. Sometimes the jurors didn't always look at a piece in the same context. Different approaches toward different kinds of calligraphy—for instance, a very simple page from a book or a poster—affected what a juror might select.

Sometimes the technique became part of the discussion. Was this done with a pointed pen or a broad pen? Because the original call for entries requested calligraphy that was not retouched—which could be called "pure" calligraphy—some of the debate dealt with defending a piece although it may or may not have been "pure."

The free and the experimental are really considered more pure calligraphy, so it was in trying to include applied material that the jurors were concerned whether a piece was retouched or built up with drawn letters. Many people did not send in retouched material at all because of the call. However, Jeanyce explained, "In the end we finally decided to accept all kinds, because so much was beautifully done. Even the retouching itself—the skill that this takes—also showed an expertise in calligraphy, because that person must ultimately know what calligraphy really is."

Phil carried on her thought: "It might be better to use the word 'repair' instead of 'retouching' because even in a single document a calligrapher will sometimes make a mistake, and it takes enormous skill to repair it so that you're not aware that a mistake ever existed. Good materials will permit correcting, retouching, repairing. Then there's another kind of retouching where you're working for the camera. You simply paint out things that you don't want to show. It's obvious that there's a retouching process going on, but the camera will not show it." So there are different kinds of retouching, and the jurors accepted all of them.

"All we could judge was the result," Phil continued. "It didn't matter how it was arrived at." Jeanyee added, "We chose from the purely visual thing." "Many people submitted photostats," noted Phil, "a technical advance that was not so easily available thirty years ago and now has much better quality. And today it's possible to do calligraphy and Xerox it." Jeanyee observed that "In fact, one of the calligraphers, Elizabeth Anderson, who did 'Purple Onion' (shown on page 141), works in the medium of color Xerox." Phil went on, "Photographic copying devices have been helpful as an area of experiment for calligraphers. If you want to use that kind of technology, it's available."

Other unusual tools used to create calligraphic works shown in this book were the big Oriental brushes. Often some of the broad edges could have been made of felt. There is also a piece that was cut in wood. This was obviously imitating calligraphic letterforms, but it was a woodcut rendition. Jeanyee observed, "Reynolds Stone used to cut calligraphy in stone and wood, so whatever tool, if you have the skill behind it, can be used to turn out calligraphy."

"All the pieces we selected reflect discipline," comment Jeanyee. "The discipline that we've been talking about shows in the overall tone of color, the strokes of the letters, and the continuity, the fluidity, the overall 'final result.' "

Phil picked out two pieces to discuss. "What's interesting in these examples—by George Watson, who is English (shown on page 184), and Michael Podesta, who is an American from Virginia (shown on page 168)—is that they're both dealing with the Italic, and both are very, very skilled in the discipline. One has definitely the English Johnstonian flavor and the other is sort of a condensed Arrighi, but in both the pattern of down stroke, the rhythm, the texture are very skillfully controlled." Jeanyee pointed out: "Look at the freedom within the strokes. 'Disciplined freedom' is what Ray DaBoll called it." Phil agreed. "And also there's a flavor that comes out of each one that's totally different from the other. One sparkles in one way. This English calligraphy is more nervous, but nervous throughout with great skill, and the other is very rounded and flowing."

Jeanyee's response gives an idea of what kind of give and take went on during the judging. "One is rounded or oval, one is pointed, but not

nervous. To me nervous is not a good description, but it does have pointed shapes with much movement." Phil persisted, "I did mean nervous visual movement." Jeanyee asserted, "Visual movement is different. It need not be nervous! One is a quieter piece, and the other is actually a little flamboyant, embellished, highly embellished."

The only way to judge when a piece of calligraphy is "good" is subjectively, which is why the jurors could not always agree. Yet if someone is involved with calligraphy, they have a basis on which to decide what is good. "If you're disciplined in calligraphy," Jeanyee explained, "it's more valid to be able to evaluate it. And the rapport with the uniqueness of a piece is also how you make a choice."

Phil continued her thought: "The skill that put it on the paper, the placement of strokes, the organization of space—all these things are related not only to calligraphy, but to calligraphic design. And design in particular." Jeanyee concurred, "Whether you design a so-called fine art piece of calligraphy to put on a wall or an advertisement in the commercial world, the same approach is given to designing it."

"This leads us very nicely into legibility," Phil noted. "You can have an exciting piece of calligraphy that is totally illegible, and you can have a very legible piece of calligraphy that's pretty dull." Jeanyee went on, "So legibility in itself cannot be all important, but should depend on the context of a piece. If it means to be legible, then it should be. Some people don't really know what illegibility means just because they can read it." "But somebody skilled in dealing with letterforms," asserted Phil, "might create a legible result without it really being legible. Take sombody's handwriting. It's totally illegible, but your familiarity with certain of the letter strokes tells you exactly what else is happening. Or you might recognize something that is familiar and therefore you guess about the rest of it. The Werner Schneider untitled work (shown on page 148) is an example of where at first glance it seems illegible, but you spot one or two letters and then you can figure out what the rest of it is. That is what I'm getting at."

"But," Jeanyee contended, "because that was an exercise for just the sheer joy of writing, the intent was not necessarily just a legible piece. The difference then is the intention. As long as someone knows what one is doing, be it illegible, that should be acceptable." Phil continued, "But the thing that I think one has to consider is that calligraphy and legibility deal with words. You're saying something. If it's not legible and the word is not eventually recognizable, all you're doing is calligraphic decoration. There has to be some message, some communication coming out of it, otherwise it's not writing." Jeanyee concurred, "It's not calligraphy. However, people will still design with calligraphic strokes." Phil went on, "Calligraphy in that meaning is really the motion that creates something which has a calligraphic flavor." And agreed Jeanyee, "So it could be abstract, though not legible, and still be a calligraphic piece."

"Even Oriental, Japanese and Chinese, calligraphy, as illegible as it may seem even to the Oriental, still starts with a particular letter image," Phil stated. "But," Jeanyee explained, "they don't go in for abstractions. That's the difference between the experimental kind of calligraphic design where it's a piece of art and Oriental calligraphy, which usually starts with the word." "Because I don't read Chinese or Japanese," Phil related, "my looking at it and responding to it is on a totally different level, which is an illegible level. If it were legible to me and I understood that it said, 'Go hop out the window,' I would feel differently. I see it as a

calligraphic involvement, but I don't read it. I enjoy it. I get a tremendous joy in seeing calligraphy, particularly Oriental calligraphy." Jeanyee commented, "Yes, Phil loves it a lot more than most people." He added, "Because I can sense the way the thing is written even if I can't read it." She responded, "It's a bit like opera where you don't know the language, but you can still love it."

Phil explained an example of illegibility he used with students. "Take the Lord & Taylor logo. I take a scrap of it. No matter how much of that scrap you crop, everybody recognizes it. They don't read it anymore; there's a recognition in the illegibility. And this happens a great deal of the time in, say, somebody's handwriting. You're familiar with it. You don't have to read it letter by letter anymore. You know immediately what it says. But illegibility with an insecure calligrapher can be a disaster. I've seen a lot of examples of playful, splashy calligraphy that look as though they're saying something, but they're wrong to me."

Jeanyee summarized, "Legibility is important, but it doesn't have to be for all work. Calligraphy is not necessarily synonymous with legibility, just as calligraphy can be a fine art, but not solely. It can be fine no matter where you use it, whether it's commercial or not. A Christmas card is not fine art, but it can be fine." Phil noted that "There are some exhibitions of Japanese calligraphy that I've seen where it's presented solely as fine art and where the calligraphy is very expressionistic. But again it starts with a word that is supposed to have some meaning."

"It would be nice if calligraphy were a fine art," Jeanyee continued, "and it is okay if it is created for reproduction. I think application of calligraphy is an important part of the twentieth century. By the way, I also want to talk about doing modern versus 'medieval-style' pieces, of which the latter appear so dated, although they require a lot of skill. I think studying the past, the sources, is wonderful for learning what it was all about, but then one should go further and use studies relevantly." Phil agreed: "Use it as a contemporary calligraphy instead of living with the 'olde' letterforms." Jeanyee added, "And not turning out pieces that at a glance look as though they came from medieval times. I don't think there was a single piece in the show that looked like a medieval manuscript." Phil confirmed her observation: "I don't think there is anything in the show that doesn't have a contemporary involvement."

Unlike the Western tradition, Jeanyee commented on the continuity of Chinese calligraphy: "Some of the Chinese writing has never changed. Most styles of Chinese calligraphy have been used continuously, as everyday writing, so that it never fell into disuse and cannot be considered to be dated, as Western calligraphy can. An Oriental calligrapher uses styles that are recognizable to all. But there are some people in the West today who would design a certificate, at first glance, to look like a page from a manuscript book. Imagine presenting a twentieth-century scientist with a citation praising his great new ideas about the cosmos and the citation looks like a page from a medieval manuscript. It's like wearing armor to fight chemical warfare!"

Influences, Internationalism, and the Future

*B*oth Jeanyee and Philip felt the calligraphers whose work is illustrated here showed definite influences by specific teachers or practitioners who themselves would have been included had they been alive. In their own background George Salter had an enormous influence. It was through Salter that they both got involved in

calligraphy while they were his students at Cooper Union. They could see the influence of Arnold Bank, Ray DaBoll, W.A. Dwiggins, Alfred Fairbank, Edward Johnston, Rudolf Koch, Oldrich Menhart, Oscar Ogg, Imre Reiner, Lloyd Reynolds, George Salter, Ernst Schneidler, Paul Standard, Jan Tschichold, Georg Trump, Rudolf von Larisch, and others. The next generation of teachers were, in turn, influenced by these masters.

allorquando sentivo dirmi che il

Jan Tschichold, *Saskia alphabet*, 1931.

Oldřich Menhart, nositel Řádu republiky a laureát státní ceny, je prvý český písmař, jehož typografická písma pronikla na mezinárodní trh. Manuscript určený pro ruční sazbu, vychází

Oldrich Menhart, *Manuscript alphabet*, 1942.

George Salter, *Book Jacket Designers Guild* logo.

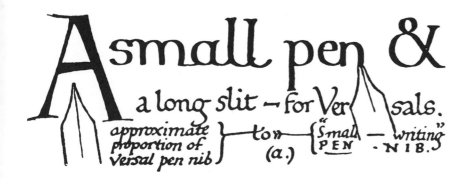

Edward Johnston, from *Writing & Illumination & Lettering*, page 117 (A Pentalic Book; Taplinger Publishing Company Inc., 1977).

Rector Magnifice

W. A. Dwiggins, *Rector Magnifice*, chapter heading (Alfred A. Knopf Inc., New York).

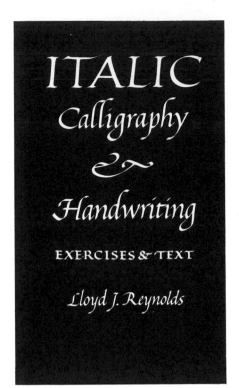

Lloyd Reynolds, *Italic Calligraphy & Handwriting*, cover (A Pentalic Book; Taplinger Publishing Company Inc., 1969).

Rudolf Koch, blackletter, from *Rudolf Koch*, by Oskar Beyer, page 199 (Bärenreiter Verlag, Kassel & Basel, 1953).

Trionfo DI Afrodite

Georg Trump, *Trionfo di Afrodite*, by Carl Orff, title page (B. Schott's Söhne, Mainz).

Imre Reiner, from *Initialen von Imre Reiner* (Benno Schwabe & Co., Basel, 1942).

DANKGEFÜHLE · INHIGSTER · ART · WEIHE · ICH · DEN
MEISTERN · DIE · DIESEM · WERKE · IHRE · KÜNSTLERISCHE
HAND · GELIEHEN : DOCH · ERST · DIE · ALLGEMEINHEIT
DIE · DARAUS · NUTZEN · ZIEHEN · WIRD : KANN · IHNEN
DAS · VOLLE · MAASS · DER · ANERKENNUNG · BIETEN ⹀

Rudolf von Larisch, page from Beispiele Kunstlerischer Schrift (Anton-Schroll & Co., Wein, 1900).

abcdefghijklmnopqrstuvwxyz
d, e, f, p, t, x, are made of two strokes:
dd ee ff pp lt xx

Alfred Fairbank, reproduction of Dryad Writing Card No. 1 (Dryad Press, Leicester).

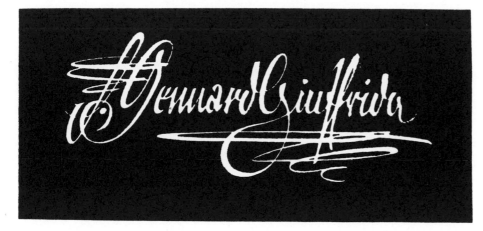

Ernst Schneidler, experimental.

The 26 Letters

Oscar Ogg, *26 Letters,* title page (The Thomas Y. Crowell Company, New York, 1948).

Arnold Bank, experimental alphabet.

When asked how their influence was shown, Jeanyee replied, "You can't really see it directly because eventually you don't imitate your teachers. A person like Herb Lubalin, for example, learns from a George Salter or a person like me learns from a George Salter, and our work is totally different. But even coming from the same background, you develop your own way. In doing calligraphy, the writing is your own finally. There is not one influence, but the influence is there. It's an unknown quality, and we all feel a debt to it."

Both agreed that the influences are there, but they need not show. Each artist develops on his or her own and can only acknowledge a gratitude to the great teachers. Influence can mean another way to think or see, a philosophy shared, encouragement, enthusiasm, understanding, and love of a subject.

"To be specific," Phil began, "one can see the kind of letterform training perhaps that was the basis for some of the skills that we see here. A certain piece could only have come from teaching in certain areas like, let's say, the English calligraphy or the German. The German you can split in two distinct areas: the Koch quality and the Schneidler quality."

Jeanyee disagreed. "And yet, Phil, at the same time, a student can do either. You know, this is the amazing thing, but when you start learning, you can learn from everywhere. Hermann Zapf had influences but was self-taught. You know there are influences from looking at work, at being exposed to things. In fact Zapf says that he looked at a lot of Edward Johnston and Rudolf Koch. If you're a Hermann Zapf—that is, if you're unusual—you can do it on your own without a teacher in a classroom situation."

Both agreed that the influences are all over the place, with a lot of "cross-pollenization." "As a teacher," Jeanyee admitted, "and I've spoken about this to other teachers, we sometimes worry about the influences that we make in the world. We influence students who may become calligraphers, who in turn will shed their influence on the future. The responsibilities of being a teacher are sort of burdensome."

Commenting on what makes this collection of calligraphy specifically international, Phil said, "We have calligraphic examples from all over the world, but even if we weren't to label it specifically as being Russian or Yugoslavian or Chinese or Japanese, the flavor of the writing or the flavor of the image is international. You can almost say this is definitely an Oriental piece or something might be Slavic in flavor because of the letterforms, the texture. Those are obvious examples, because the language is very apparent, but in those areas like Slavic where you're dealing with the same Roman letter, you can sense that this is written by a different hand that is not American." Jeanyee disagreed: "Phil feels that you still get that Slavic look. I'm not so sure about that. I don't see it that way." Phil countered, "A name that comes to mind is Oldrich Menhardt. The quality of his writing I find nowhere else and only through an area of that sort where it's almost a spring pen doing broad pen work." Jeanyee contended: "But it's a uniqueness to him rather than an ethnic quality or place to me." Phil persisted: "No, no, but I sense that some of the Slavic pieces of calligraphy have that kind of flavor."

Both agreed that what is unique about this collection of calligraphy is that these people got together in one place at one time. "It makes the show very important for that reason," said Phil. "To continue with this international flavor, there's another aspect. There are certain areas in the world where only certain kinds of calligraphy would have any validity. You can get away with, let's say, much freer writing in the German

school of calligraphy than you could here. Where we're dealing with calligraphy that might be used commercially, you would find certain styles of calligraphy more acceptable in certain areas of the world than you would in others. In other words, the free kind of calligraphy that we see coming from an Ernst Schneidler approach has been very difficult to sell in America. Do you know what I mean, Jeanyee?"

"In a way, yes, and in a way, no, Phil, because when a client, for example, will buy a certain style, it's because his mind has accepted it. To have free calligraphy used in the marketplace depends on art directors, agencies, clients, publishers, so until the art directors are trained in that direction, there may be an objection to it. An exposure to all styles might lead to greater use of them. But on the question of freedom: as much as we talk about the English style, which is often very conservative, very legible, that's what we think of as English. Yet when Donald Jackson created very modern pieces, that encouraged changes in the different approaches so that they weren't ethnic anymore, but became kind of blended, international. I think anyone who is open to any influences would be experimenting to create new effects, and the only separations would be Eastern and Western because the Cyrillic alphabet or the Oriental words are so different."

Phil concluded, "As a matter of fact, I think what makes this show valuable and ultimately this book is that it begins to show what is available, and this blending of skills will happen even more when somebody in Europe or Asia or America sees what is happening all over, and they begin to adapt. That will influence their own thinking, perhaps, style, technique, and so on." Jeanyee emphasized, "Except for the East and the West where you have totally different forms. That makes it harder, I think. But the appreciation—that has always been around. And this book will remind people that calligraphy is still here." She added, "I think the common thing here is the discipline, the love of letterforms, the ability to do them. And the love of calligraphy is evident as well."

Commenting on the direction in which calligraphy is moving, Phil stressed the direction in which it *should* go. "I would like to see it again have a greater involvement in art school curriculums, which I don't think is happening. I think most of the activity in calligraphy is happening outside disciplined educational areas. There are special classes only for calligraphy that are not tied up with anything else in graphic design. I would recommend that it become a required course for all who study graphic design, as another discipline."

"Lloyd Reynolds felt it should be taught to everyone; every school child should start learning how to write the basic forms and have beautiful handwriting," Jeanyee related. "If for nothing else than to improve handwriting," Phil added. To Jeanyee the most compelling reason to teach calligraphy was to teach "the love of words. Then it's not just handwriting, but you start to write and we're talking not about calligraphic writing, but writing words, compositions. To be able to write words and sentences so that growth of the human being—becoming a literate person—comes with the learning of the pen. It's tied together and students who love calligraphy should read better too. Studies have shown that young students learning calligraphy become more interested in words and thus in reading."

Phil reiterated, "The improvement of handwriting, which is what you are talking about, is one of the things that will be happening more than in past years. There are still marvelous teachers like Paul Standard.

And let's not forget Lloyd Reynolds, who died a while back." Jeanyee agreed, "I know there are a lot of people still involved in trying to promote the proper teaching of handwriting with a calligraphic approach." For instance, Barbara Getty, who was one of Reynolds' students, has been involved in getting Italic handwriting part of the approved state curriculum in Oregon. Jeanyee added: "It was Reynolds who started the idea of training teachers to teach calligraphy to children."

Phil raised another aspect of studying calligraphy: "I think not only the improvement of handwriting would be a result well worth all the effort, but those who do get involved and attempt to improve their handwriting will have a greater appreciation of calligraphy and letterforms in other areas." Jeanyee observed: "And of your own worth, of your own creativity. When you can do it from yourself, you like yourself and that is wonderful. A child learning calligraphy—the thrill with results—is incredible, and this leads to other things, such as words, books, good writing, and even an artistic approach because it involves layout, designing, using calligraphy."

The calligraphically educated person "eventually might demand better designed letters coming out of other communication sources, such as photo composition, computer composition, and CRT systems, that would require the designer to be well versed in letterforms," said Phil. "So it may be that one of the benefits too would be a greater appreciation and a desire for better letter images." Jeanyee noted, "That happened in industrial design. Once the artist was involved, design became part of function, and things were beautiful as well as functional—and might be even better in the future."

Jeanyee reflected on how calligraphy was integrated in everyday life in the past. "Our grandparents had beautiful Spencerian handwriting because of the pens, and they had great pride in their writing. They were doing calligraphic things without using the word 'calligraphy.' Their ordinary hand was beautiful."

That prompted Phil to tell the following story: "I rejected a life insurance policy a number of years ago that I was having changed because we added to its value. On the original policy the data were beautifully written in a Spencerian hand. Beautifully done. When I received the new revised policy, I was shocked. It had been typewritten and I rejected it. I said 'Hey, you get the same guy and put it back the way I had it or I'm picking another company.'" Jeanyee asked, "They did it?" "They sure did. It was rewritten in the Spencerian hand," Phil replied. "That's what we would like to see," Jeanyee said enthusiastically, "more people wanting and using calligraphy. We hope that in the future more art directors will love calligraphy and use more of it. There are too few in the commercial world who know calligraphy, and I think when people are trained to know, that's great. Like Herb Lubalin. Herb loved and used calligraphy in many areas."

"Today somebody with letterform and calligraphy skills can get involved designing typefaces, alphabets, and such," Phil stated. "There is still certainly a need and a market for that kind of skill." Jeanyee concluded, "Studying calligraphy is like the musician who studies because of the love of music. It's a way of life. Making a living may or may not be in the music. And calligraphy *could* lead to something wonderful!"

CALLIGRAPHIC
ART

Lorenzo Homar
Rio Piedras, Puerto Rico
U.S.A.

Unicornio en la Isla

Isla de la palmera y la guajana
con cinto de bullentes arrecifes
y corola de soles.
Isla de amor y mar enamorado.
Bajo el viento:
los caballos azules con sus sueltas melenas,
y, con desnuda piel de ascuas doradas,
el torso de las dunas.

Unicornio en la Isla
Personal print; mahogany woodcut using V-
and U-shaped gouges as well as burin work
48 × 20 in. (121.92 × 50.8 cm)

Isla de los coquís y los careyes
con afrodisio cinturón de espuma
y diadema de estrellas.
Isla de amor marino y mar embelesado.
Bajo los plenilunios:
húmedas brisas, mágicas ensenadas, secretos mato-
rrales...
Y el unicornio en la manigua alzado,
listo para la fuga, alerta y tenso.

Tomás Blanco

John S. Allen
New York, New York
U.S.A.

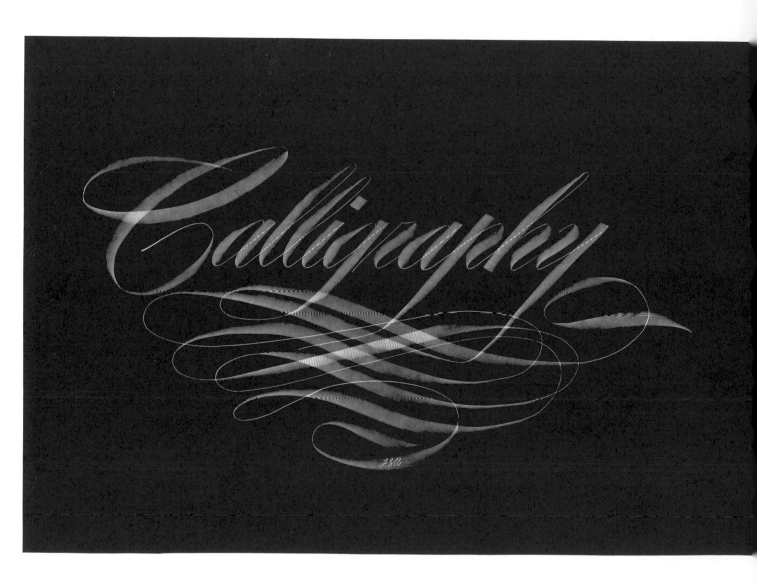

Calligraphy
Experimental; written with a multiple liner (60
lines to the inch) on white scratchboard covered
with black ink

11.5 × 7.88 in. (29.21 × 20 cm)

Guillermo Rodriguez-Benitez
Guaynabo, Puerto Rico
U.S.A.

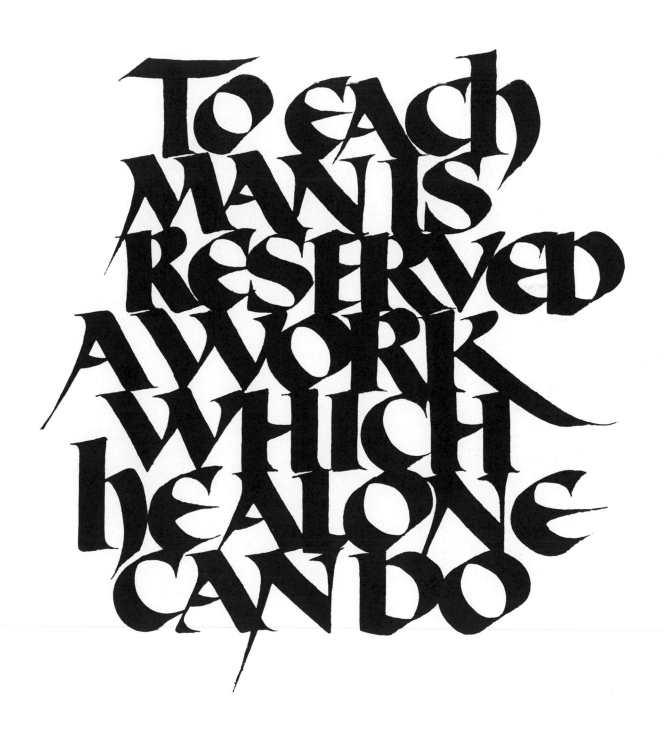

To Each Man Is Reserved a Work . . .
Experimental; written with carbon ink on
handmade paper with broad metal pen
6.75 × 6.75 in. (17.15 × 17.15 cm)

Villu Toots
Tallinn, Estonia
U.S.S.R.

АБВГДЕ
Ж

*Без красивого шрифта
не может быть
красивой книги.*

ЗИКЛМ

*Без красивой книги
нет подлинной
культуры.*

НО

ПРСУТХ

ФЦЧ

Cyrillic Alphabet with Quotation
Experimental; written on paper with a broad-
edged pen; Cyrillic capital letters written in black
and quotation written in blue

8 × 12 in. (20.32 × 30.48 cm)

Hermann Zapf
Darmstadt
West Germany

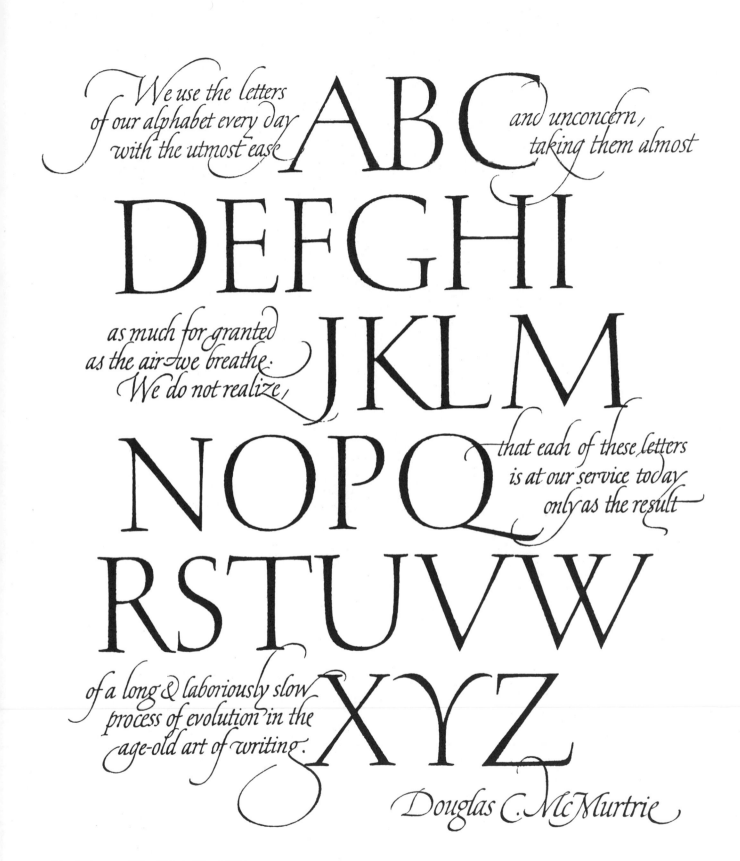

We use the letters of our alphabet every day with the utmost ease and unconcern, taking them almost as much for granted as the air we breathe. We do not realize, that each of these letters is at our service today only as the result of a long & laboriously slow process of evolution in the age-old art of writing.

Douglas C. McMurtrie

ABCDEFGHIJKLMNOPQRSTUVWXYZ

We Use the Letters of Our Alphabet Every Day
. . . Alphabet with Quotation by
Douglas C. McMurtrie
Alphabet broadside with quotation (from the
collection of Jackson Burke, New York); letters
built up with broad-edged pen on Mould-made
paper
12.99 × 18.5 in. (33 × 47 cm)

39

David Peace
Hemingford, Abbots, Huntington
England

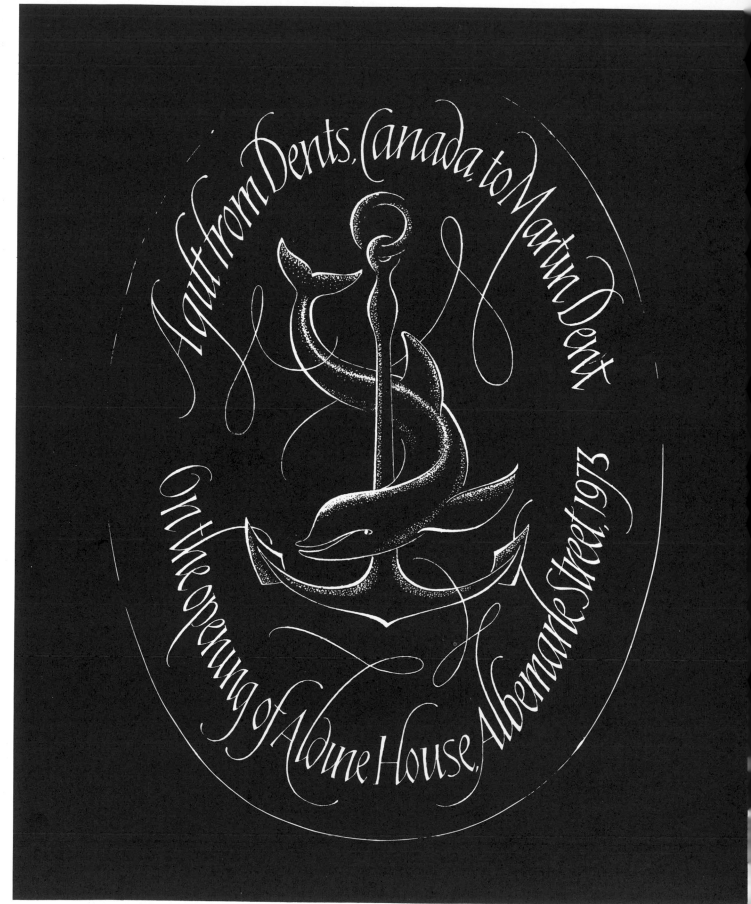

Hanging panel for the office of a publisher,
Martin Dent
Hanging panel; engraving on glass with a
flexible drive drill

40 26.15 x 36 in. (66.42 x 91.44 cm)

Jenny Rose Folsom
Washington, D.C.
U.S.A.

At half past three everything slumbered still in a primal blue, blurred & dewy, & as I went down the sandy road the mist, grounded by its own weight, bathed first my legs, then my well-built little body, reaching at last to my mouth & ears, and finally to that most sensitive part of all — my nostrils. from "Sido" by Colette · calligraphy Jenny Rose Mitchell 1982

At Half Past Three
Experimental; written in Chinese ink on paper
with a 3 ½ Rex steel nib
11.75 x 6.5 in. (29.85 x 16.51 cm)

Lubomir Kratky
Bratislava
Czechoslovakia

Aldusove litery,
pevné ako
morská nádhera
Benátok;
V ich vodách
ako nahnutá
plachetnica
plaví sa kurzíva,
čeriac abecedu;
závan
oceánskych
objaviteľov
pochoval navždy
ťahy krasopisectva

PABLO NERUDA

Caracteres de Aldus
firmes como
la estatura
marina
de Venecia
en cuyas aguas madres,
como vela
inclinada,
navega la cursiva
curvando el alfabeto:
el aire
de los descubridores
oceánicos agachó
para siempre el perfil
de la escritura

Untitled
Poster; screen printed on Ingres paper, writing
done with a flat pen
42 19.69 × 25.59 in. (50 × 65 cm)

Chris Brand
Breda
Netherlands

In Floras Schosse hingestreckt

Lacht Phoebus nun aufs neue

Von diesem mannigfachen Blühn

Umringt, atmet Zephyrus

In nektarreinem Dufte

Lasst uns um die Wette laufen

Nach dem Preis der Liebe!

Calligraphy
From "Carmina Burana"; written with India ink
on paper with a broad feather
8.63 × 18.17 in. (21.91 × 46.15 cm)

Alfred Linz
Nürnberg
West Germany

Musik ist die Vermittlerin des geistigen Lebens zum sinnlichen Leben.

Bettina v. Arnim

Bettina v. Arnim
Poster; written on handmade paper with a pen
44 12.99 × 17.72 in. (33 × 45 cm)

Walter Brzoza
Schenectady, New York
U.S.A.

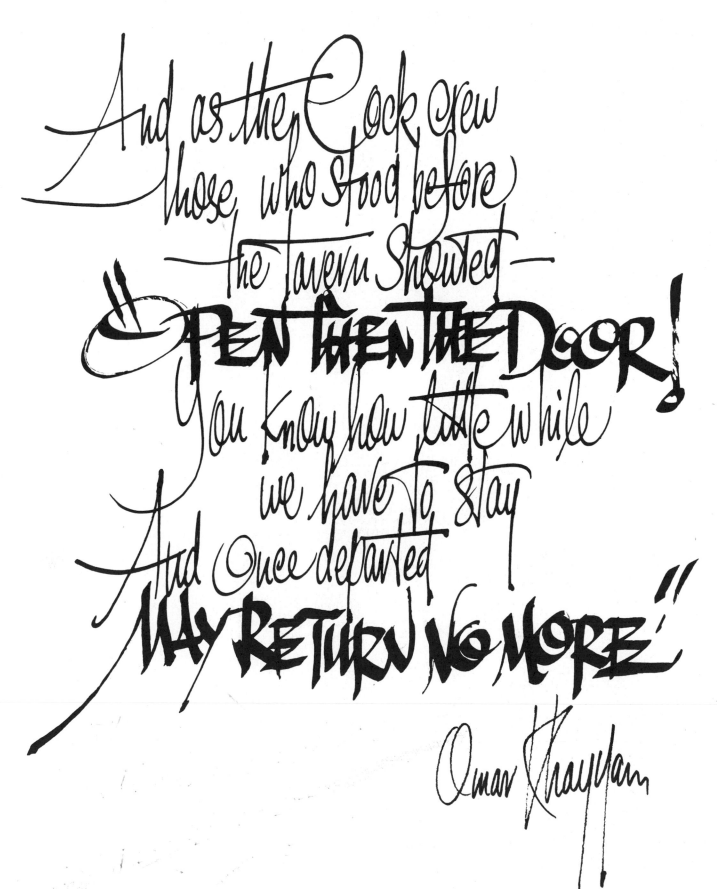

Quotation of "Omar Khayyam"
Experimental; written on Japanese paper with
Higgins ink using broad- and narrow-nibbed
Mitchell pens
10.75 × 14 in. (27.31 × 35.56 cm)

45

Gail Everett
Exmouth, Devon
· England

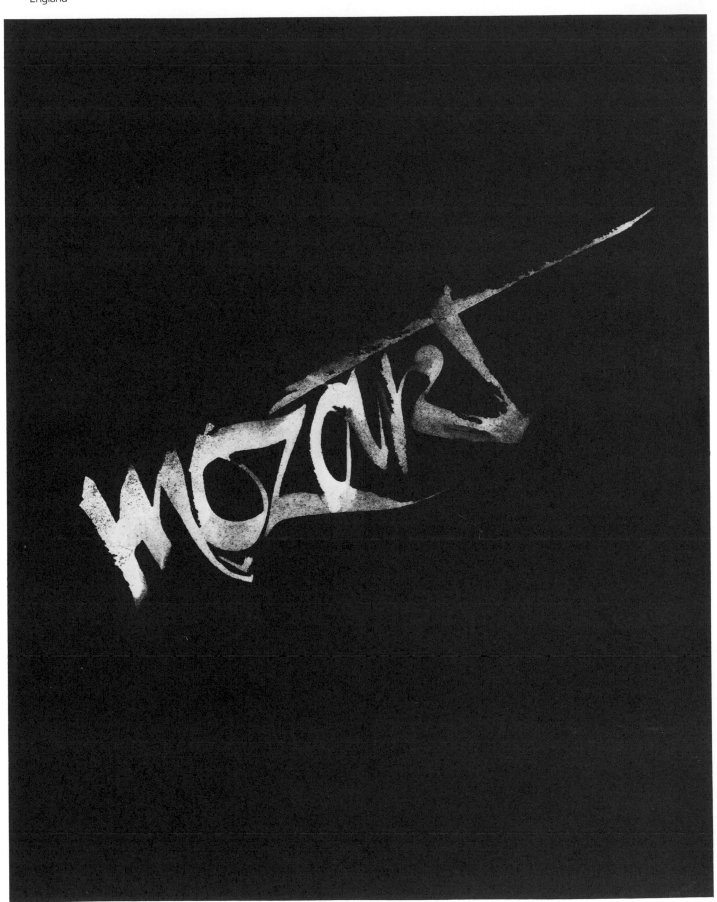

Mozart
Poster; white ink on black paper with an
automatic pen

46 8 × 10 in. (20.32 × 25.4 cm)

Christel Aumann
Munich
West Germany

47

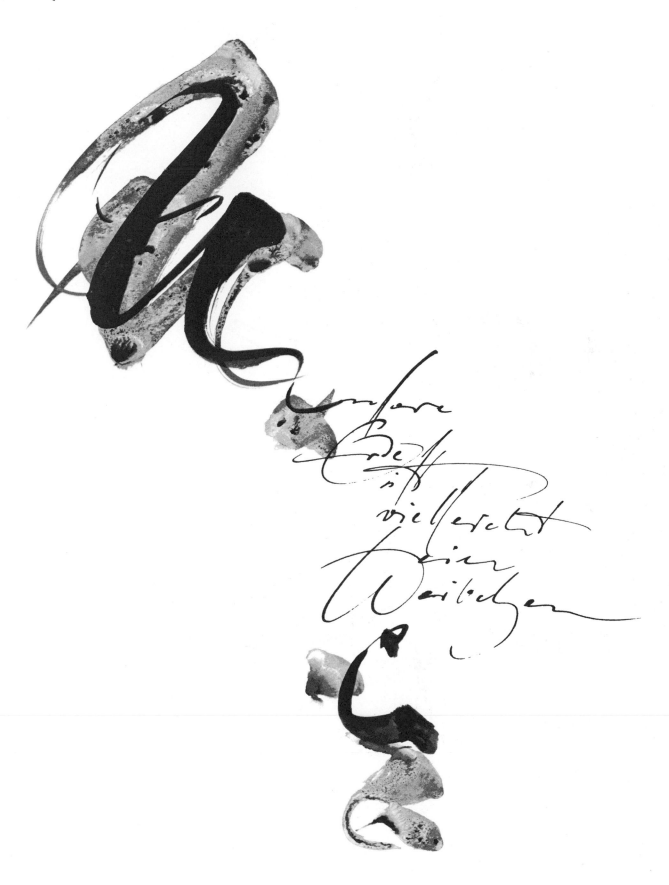

Untitled
Wall hanging; written with brush and goose-
quill and printed by silkscreen
19.69 × 27.56 in. (50 × 70 cm)

47

Toshio Fukuyama
Muko-City, Kyoto-Fu
Japan

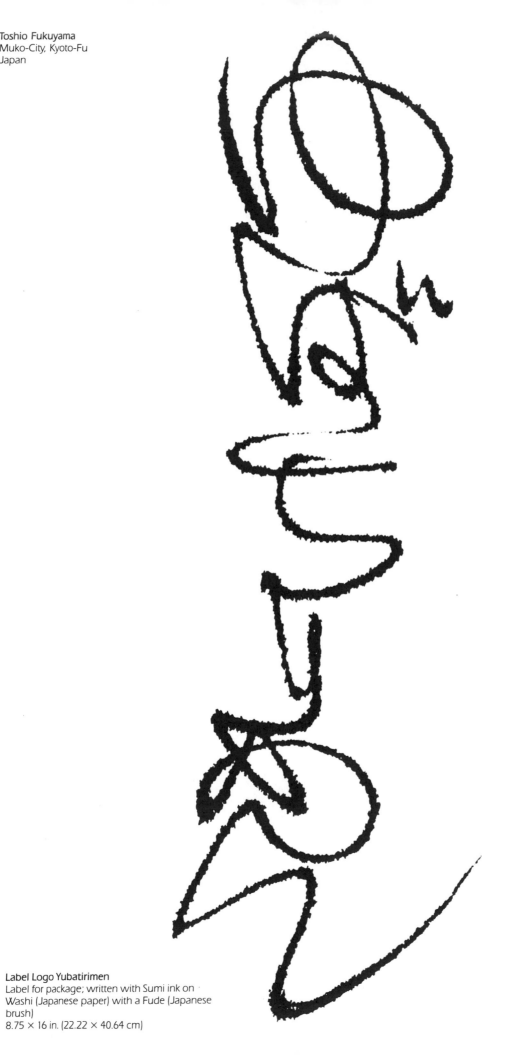

Label Logo Yubatirimen
Label for package; written with Sumi ink on
Washi (Japanese paper) with a Fude (Japanese
brush)

Ikko Tanaka
Tokyo
Japan

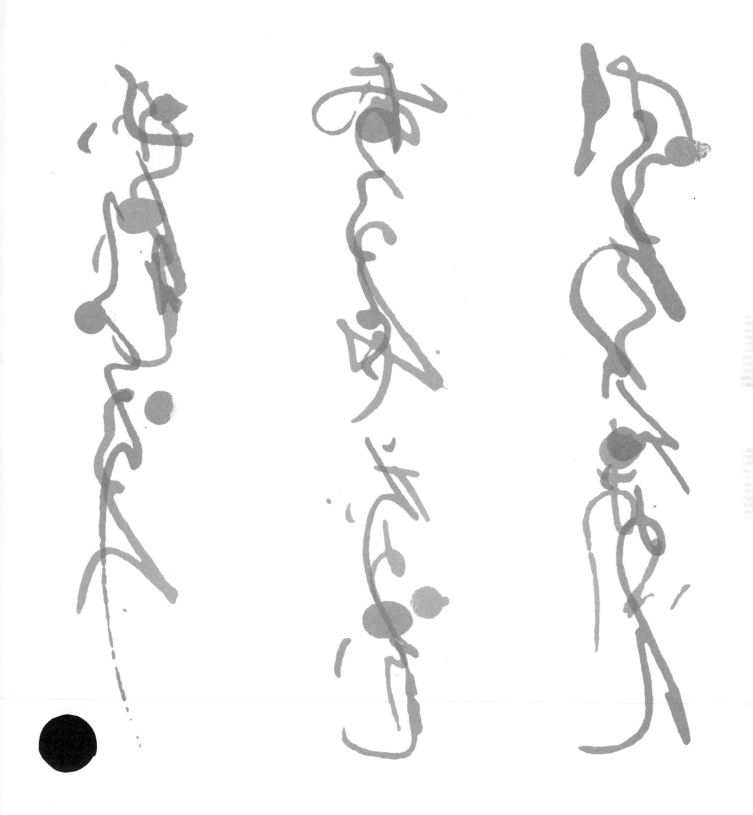

Shinkana
Experimental; silk screen, original written on
paper with brush
20.88 × 20.88 in. (53.02 × 53.02 cm)

Olivia L. Lin
Taiwan, Taipei
Republic of China

蘊義生風以鼓動流俗激素行以聰
或權立廉尚以振貴勢使天下之至
奮迅感慨波蕩而從之幽深牢
破室族而不顧並于子伏其死而毋
歡其義壯矣哉

佩衡林琳

Fan P'ang Chuan
Wall hanging; written with Chinese ink on
Motto paper with a brush pen
27.13 x 53 in. (68.9 x 134.62 cm)

Hans-Joachim Burgert
Berlin
West Germany

wasaugensehn,
istnichts,wann
wirdieaugensch
lissen,dennwer
denwirvilmehr,
jallessehnund
wissen.

Ludus Scribendi, Volume 1
From handpress book; original written with a
pen and printed on handmade rag paper and
relief printed from linoleum cuts
12.2 × 8.86 in. (31 × 22.5 cm)

Friedrich Neugebauer
Bad Goisern
Austria

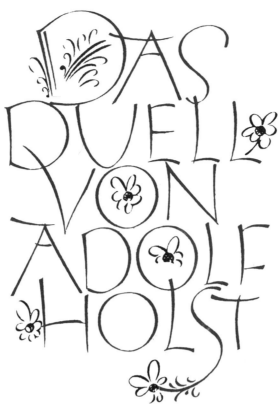

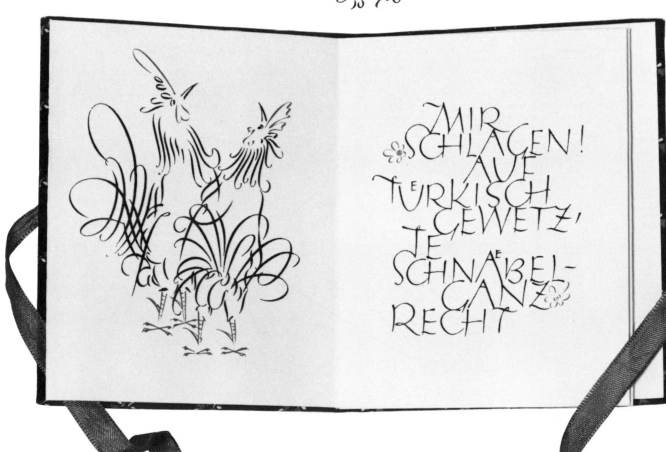

Das Duell
Book written while prisoner
of war in Egypt in 1944
and printed in 1977; written with
homemade ink and color on cheap
English typewriting paper with a reed

4.72 × 5.9 in. (12 × 15 cm)

Wieslaw Kosinski
Warsaw
Poland

Litery
Experimental; written with two colors on
wood-free paper (Letterer's Craft) using a brush
10.5 x 17.25 in. (26.67 x 43.82 cm)

Patricia Weisberg
New York, New York
U.S.A.

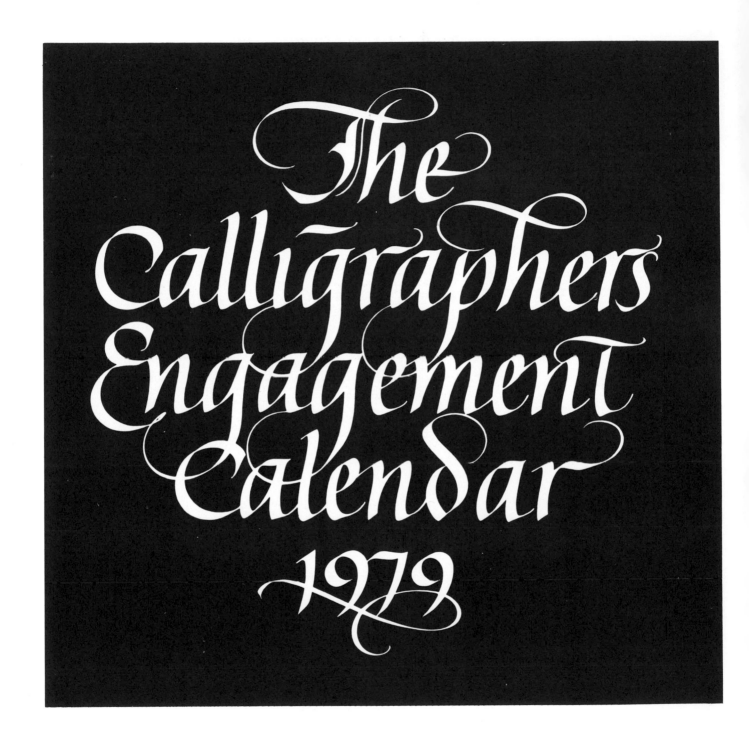

The Calligraphers Engagement Calendar
Cover for "The Calligraphers Engagement
Calendar 1979" published by Pentalic-Taplinger,
New York; written with Higgins Eternal ink on
bond paper with Bouwsma pen; printed white
with red background

8.5 × 8.5 in. (21.59 × 21.59 cm)

Leonid Pronenko
Krasnodar
U.S.S.R.

Address of Honour
Lettered for the Jubilee celebrations; written on
paper with a broad pen
10.24 x 13.78 in. (26 x 35 cm)

Ivan Boldizar
Novi Sad
Yugoslavia

GLAVHI ODBOR
STERIJIHOG POZORJA
na svojoj sednici održanoj
u Novom Sadu 16. aprila 1980.
dodeljuje

Blaženki Katalinić

dramskoj umetnici iz Beograda

STERIJINU HAGRADU

za naročite zasluge
na unapređivanju pozorišne
umetnosti i kulture

Novi Sad, 17. aprila 1980.

Predsednik
Sterijinog pozorja

Price/Calligraphy Certificate/Theatre Festival,
Sterjino Pozorje/Jugoslavija
Diploma; brown and red on handmade paper
with a steel pen
12.59 × 16.53 in. (32 × 42 cm)

Alice
New York, New York
U.S.A.

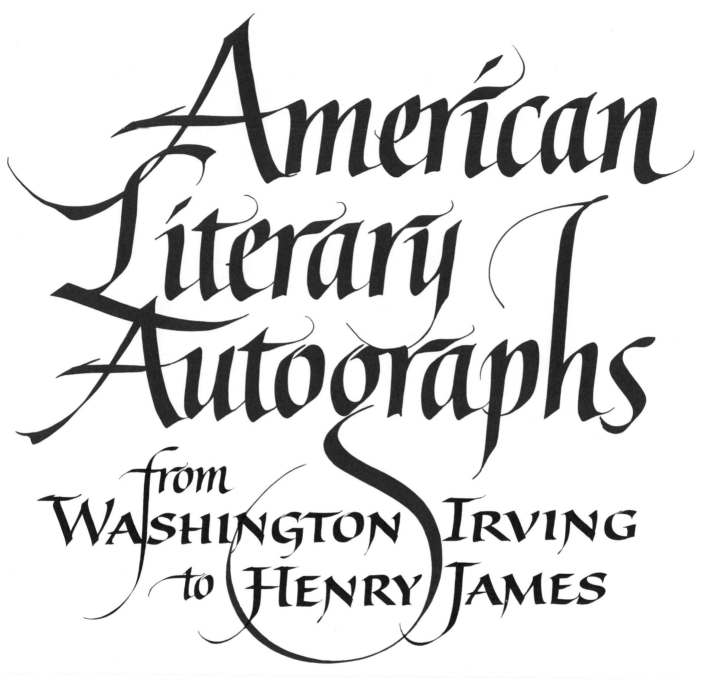

American Literary Autographs
from WASHINGTON IRVING to HENRY JAMES
September 6 · November 27

American Literary Autographs
Exhibition poster for the Pierpont Morgan
Library in New York City; written in Winsor &
Newton Designers Gouache on 2-ply mat
Strathmore paper with Coit poster pen and
Speedball C nibs
21.25 × 24.5 in. (53.98 × 62.23 cm)

Herb Lubalin
New York, New York
U.S.A.

MOTHER

(with CHILD within the O)

Mother & Child
Proposed logo for new magazine; type and
hand lettering

Alfred Linz
Nurnberg
West Germany

jeder
von uns
trägt alle
Jahrhunderte
in sich

john morley

John Morley
Poster; written on handmade paper with a pen
12.99 × 17.72 in. (33 × 45 cm)

Jean Evans
Cambridge, Massachusetts
U.S.A.

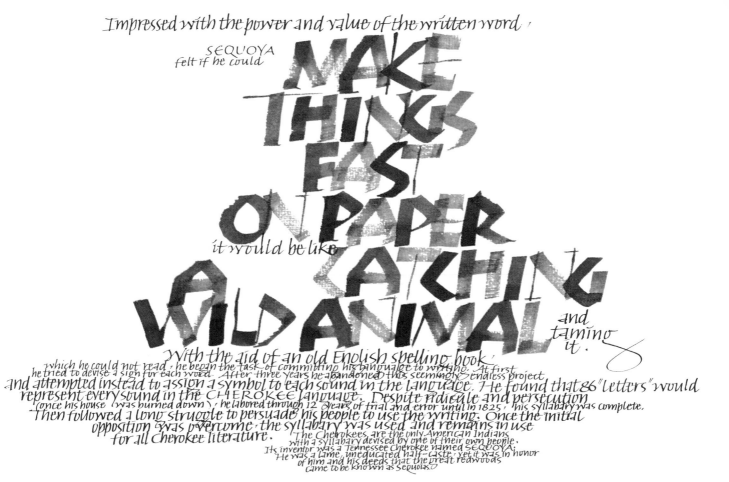

Impressed with the power and value of the written word,
SEQUOYA felt if he could MAKE THINGS FAST ON PAPER it would be like CATCHING A WILD ANIMAL and taming it.

With the aid of an old English spelling book, which he could not read, he began the task of committing his language to writing. At first he tried to devise a sign for each word. After three years he abandoned this seemingly endless project and attempted instead to assign a symbol to each sound in the language. He found that 86 "letters" would represent every sound in the CHEROKEE language. Despite ridicule and persecution (once his house was burned down), he labored through 12 years of trial and error until in 1825, his syllabary was complete. Then followed a long struggle to persuade his people to use the writing. Once the initial opposition was overcome, the syllabary was used and remains in use for all Cherokee literature. The Cherokees are the only American Indians with a syllabary devised by one of their own people. Its inventor was a Tennessee Cherokee named SEQUOYA; He was a lame, uneducated half-caste, yet it was in honor of him and his deeds that the great redwoods came to be known as Sequoias.

Make Things Fast . . .
Experimental, in appreciation of the Sequoya's contribution; written in brown- and rust-colored inks on Ingres Fabriano paper with an ice cream stick and Mitchell Rex pen

19.75 × 27.62 in. (50.16 × 70.15 cm)

Paul Standard
New York, New York
U.S.A.

Harry J. Reed
The Grand Rapids Press, Michigan

Thomas W. Reeves
The Daily Reporter-Herald, Loveland, Colorado

Robert W. Reford
Toronto, Ontario, Canada

Robert M. Reider
The Daily Sentinel-Tribune, Bowling Green, Ohio

Kenneth C. Reiley
Copley Newspapers, La Jolla, California

In memory of William S. Reilly
Daily News-Record, Harrisonburg, Virginia

George D. Remington
The Independent Record, Helena, Montana

J. Fred Rentz
New Castle News, Pennsylvania

Personal contribution to the Building Fund of
the American Press Institute, Reston, Virginia,
1974
Folio volume; written with broad-edged pens
on Charing handmade paper
11.25 × 18.06 in. (28.58 × 45.88 cm)

Edit Zigány
Budapest
Hungary

Quintus Horatius Flaccus

HOC ERAT IN VOTIS:
MODUS AGRI
NON ITA MAGNUS,
HORTUS UBI
ET TECTO
VICINUS IUGIS
AQUÆ FONS
ET PAULUM SILVÆ
SUPER HIS FORET

Erről álmodtam mindig:
kicsi, egyszerű birtok,
hol házam mellett kert
s csörgedező patakocska
s mindezeken kivül
kicsi erdő volna

Horatius, SAT.II.6. Translated by A. Bede
Exhibition piece; blue and grey tempera on
white Ingres paper with a broad nib
12.75 × 20 in. (32.39 × 50.8 cm)

Werner Schneider
Wiesbaden
West Germany

FRAGT NICHT/
WAS EUER LAND
FÜR EUCH TUN WIRD
FRAGT/
WAS IHR FÜR EUER
LAND TUN KÖNNT
FRAGT/
WAS WIR GEMEINSAM
FÜR DIE FREIHEIT
DER MENSCHEN
TUN KÖNNEN

JOHN F. KENNEDY

Fragt Nicht was Euer Land
Poster; written in India ink on handmade paper
with a metal pen
16.53 × 22.83 in. (42 × 58 cm)

Hermann Kilian
Frankfurt
West Germany

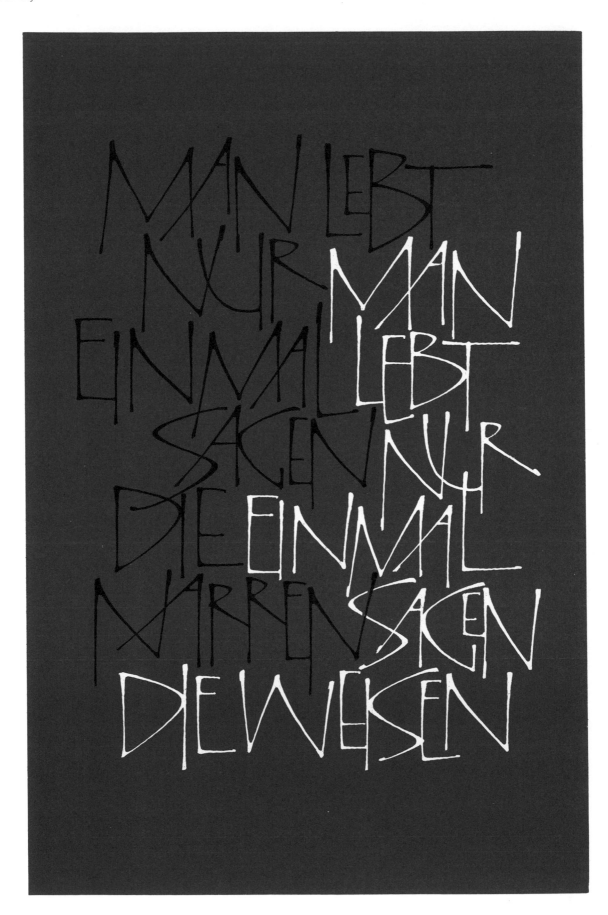

Man Lebt Nur Einmal
Private print; handwritten with metal-feather;
serigraph printed

10.13 × 15.13 in. (25.72 × 38.42 cm)

Karlgeorg Hoefer
Offenbach am Main
West Germany

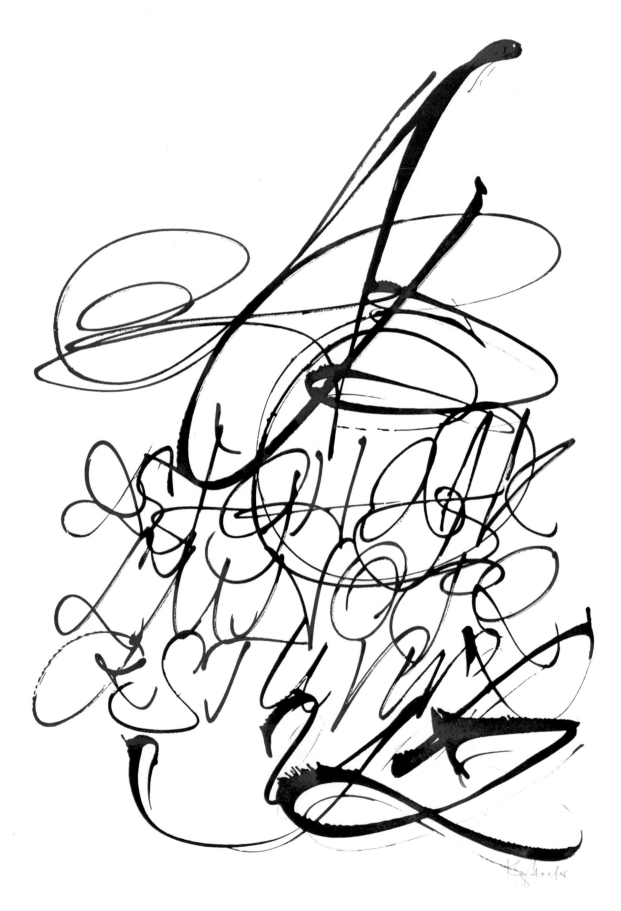

Schriftballet
Wall hanging; written with a brush
22.75 × 29.75 in. (57.79 × 75.57 cm)

Jim Gemmill
Salt Lake City, Utah
U.S.A.

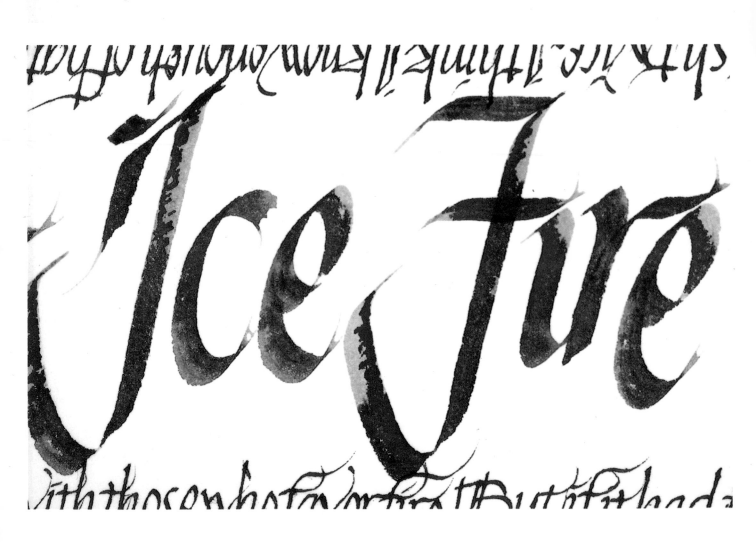

Fire and Ice (with detail)
Wall hanging; written in Chinese stick ink on
Fabriano paper with a bamboo pen
66 25 × 3 in. (63.5 × 7.62 cm)

Robert Saunders
Squantum, Massachusetts
U.S.A.

Alphabet
Experimental; wax resist with watercolor wash
on paper using wax crayon and brush
30 × 22.25 in. (76.2 × 62.23 cm)

Adolf Bernd
Bad Münder
West Germany

"Pax" from "Buchstaben Bilder/
Europaischer Zyklus"
Wall hanging; written in watercolor and pencil
on handmade paper

25.59 × 19.69 in. (65 × 50 cm)

Tim Girvin
Seattle, Washington
U.S.A.

Only the Birds Are Able to
Throw off Their Shadow
Experimental; written in hand-ground
pigments, various inks, and watercolor on
Hoshō with brushes and steel pens
22 × 17 in. (55.88 × 43.18 cm)

Jovica Veljović
Suvi Do
Yugoslavia

"Sentimentalities" by Dušan Radović
Postcard; written in ink on paper with
wooden stick

70 7.44 × 9.94 in. (18.9 × 25.25 cm)

Paul Freeman
New York, New York
U.S.A.

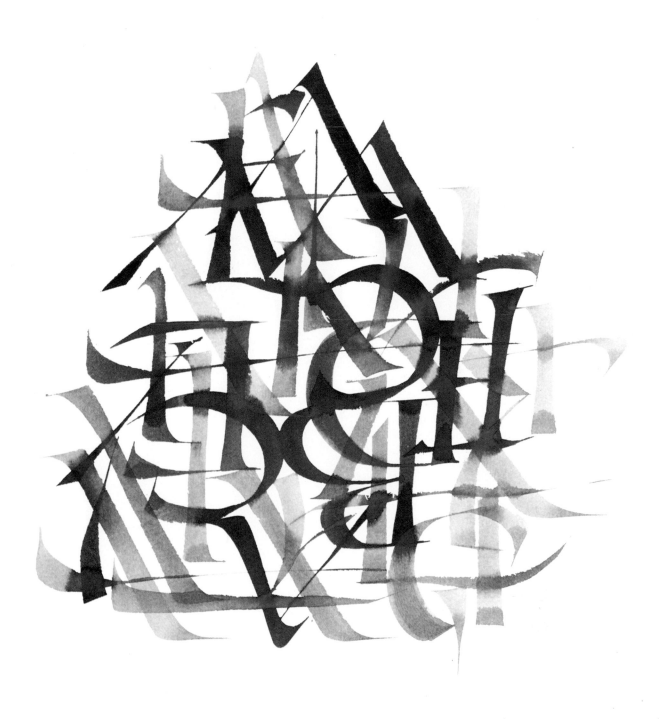

A thru Z
Wall hanging; written with pen on paper
17.94 × 25 in. (44.57 × 63.5 cm)

Robert Boyajian
New York, New York
U.S.A.

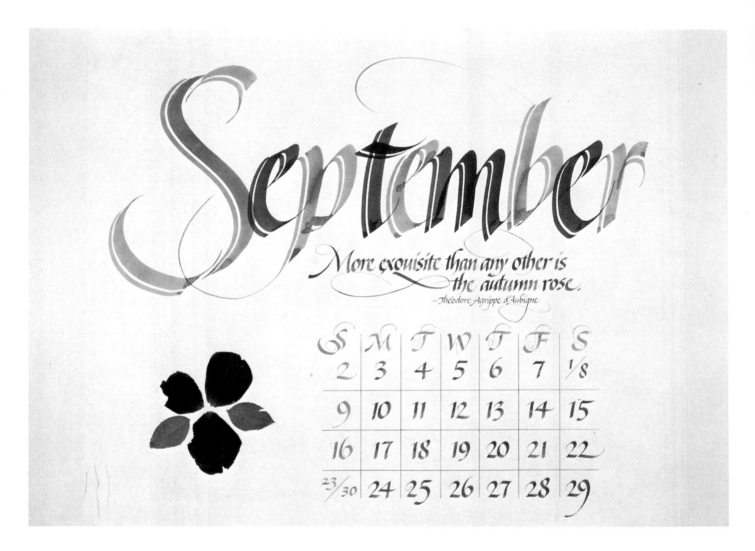

September 1979
Wall hanging; Pelikan 4001 inks (mixed) on
bond paper with Lozada Brass pen, Hughes nib
17 × 14 in. (43.18 × 35.56 cm)

Sidney Day
Welwyn, Hertfordshire
England

The drawing of an angel is based upon one in the Victoria & Albert Museum of painted oak, carved and decorated in France in the early part of the fifteenth century. Last years calendar referred to Renaissance advances in the arts, literature and scholarship in Italy at this time, when humanist scribes like Poggio admired and modelled their writing on the earlier, tenth & eleventh century Carolingian hand. The cursive variant developing from this hand was characterised by lateral compression, diagonal joins from making fewer pen lifts at speed and a slight forward slope. This early form of what we now call 'italic' was taught at a school of writing in Florence in the early fifteenth century by Niccolo Niccoli whose hand was adopted as the official form for papal briefs-hence its name Chancery. Printed examples of chancery cursive

were to be seen in the writing books of other famous scribes of the time, Arrighi, Tagliente & Palatino, whose work was copied in wood-block form. Other scribes using this fine hand in Italy were Pomponeo Leto and Bartolomeo Sanvito. The influence of chancery cursive reached England in the early sixteenth century and was used by scholars, secretaries and teachers around Henry VIII. The Lady (later to become Queen) Elizabeth wrote a fine hand - her tutor from 1548 was the Greek scholar Roger Ascham - one of two masters of the style in this country. The other was Bartholomew Dodington (1536-1595) a professor of Greek at Cambridge whose skilled work has inspired many contemporary scribes.

January		February		March	
1	Tuesday	1	Friday	1	Saturday
2	Wednesday	2	Saturday	2	Sunday
3	Thursday	3	Sunday	3	Monday
4	Friday	4	Monday	4	Tuesday
5	Saturday	5	Tuesday	5	Wednesday
6	Sunday	6	Wednesday	6	Thursday
7	Monday	7	Thursday	7	Friday
8	Tuesday	8	Friday	8	Saturday
9	Wednesday	9	Saturday	9	Sunday
10	Thursday	10	Sunday	10	Monday
11	Friday	11	Monday	11	Tuesday
12	Saturday	12	Tuesday	12	Wednesday
13	Sunday	13	Wednesday	13	Thursday
14	Monday	14	Thursday	14	Friday
15	Tuesday	15	Friday	15	Saturday
16	Wednesday	16	Saturday	16	Sunday
17	Thursday	17	Sunday	17	Monday
18	Friday	18	Monday	18	Tuesday
19	Saturday	19	Tuesday	19	Wednesday
20	Sunday	20	Wednesday	20	Thursday
21	Monday	21	Thursday	21	Friday
22	Tuesday	22	Friday	22	Saturday
23	Wednesday	23	Saturday	23	Sunday
24	Thursday	24	Sunday	24	Monday
25	Friday	25	Monday	25	Tuesday
26	Saturday	26	Tuesday	26	Wednesday
27	Sunday	27	Wednesday	27	Thursday
28	Monday	28	Thursday	28	Friday
29	Tuesday	29	Friday	29	Saturday
30	Wednesday			30	Sunday
31	Thursday			31	Monday

April		May		June	
1	Tuesday	1	Thursday	1	Sunday
2	Wednesday	2	Friday	2	Monday
3	Thursday	3	Saturday	3	Tuesday
4	Friday	4	Sunday	4	Wednesday
5	Saturday	5	Monday	5	Thursday
6	Sunday	6	Tuesday	6	Friday
7	Monday	7	Wednesday	7	Saturday
8	Tuesday	8	Thursday	8	Sunday
9	Wednesday	9	Friday	9	Monday
10	Thursday	10	Saturday	10	Tuesday
11	Friday	11	Sunday	11	Wednesday
12	Saturday	12	Monday	12	Thursday
13	Sunday	13	Tuesday	13	Friday
14	Monday	14	Wednesday	14	Saturday
15	Tuesday	15	Thursday	15	Sunday
16	Wednesday	16	Friday	16	Monday
17	Thursday	17	Saturday	17	Tuesday
18	Friday	18	Sunday	18	Wednesday
19	Saturday	19	Monday	19	Thursday
20	Sunday	20	Tuesday	20	Friday
21	Monday	21	Wednesday	21	Saturday
22	Tuesday	22	Thursday	22	Sunday
23	Wednesday	23	Friday	23	Monday
24	Thursday	24	Saturday	24	Tuesday
25	Friday	25	Sunday	25	Wednesday
26	Saturday	26	Monday	26	Thursday
27	Sunday	27	Tuesday	27	Friday
28	Monday	28	Wednesday	28	Saturday
29	Tuesday	29	Thursday	29	Sunday
30	Wednesday	30	Friday	30	Monday
		31	Saturday		

July		August		September	
1	Tuesday	1	Friday	1	Monday
2	Wednesday	2	Saturday	2	Tuesday
3	Thursday	3	Sunday	3	Wednesday
4	Friday	4	Monday	4	Thursday
5	Saturday	5	Tuesday	5	Friday
6	Sunday	6	Wednesday	6	Saturday
7	Monday	7	Thursday	7	Sunday
8	Tuesday	8	Friday	8	Monday
9	Wednesday	9	Saturday	9	Tuesday
10	Thursday	10	Sunday	10	Wednesday
11	Friday	11	Monday	11	Thursday
12	Saturday	12	Tuesday	12	Friday
13	Sunday	13	Wednesday	13	Saturday
14	Monday	14	Thursday	14	Sunday
15	Tuesday	15	Friday	15	Monday
16	Wednesday	16	Saturday	16	Tuesday
17	Thursday	17	Sunday	17	Wednesday
18	Friday	18	Monday	18	Thursday
19	Saturday	19	Tuesday	19	Friday
20	Sunday	20	Wednesday	20	Saturday
21	Monday	21	Thursday	21	Sunday
22	Tuesday	22	Friday	22	Monday
23	Wednesday	23	Saturday	23	Tuesday
24	Thursday	24	Sunday	24	Wednesday
25	Friday	25	Monday	25	Thursday
26	Saturday	26	Tuesday	26	Friday
27	Sunday	27	Wednesday	27	Saturday
28	Monday	28	Thursday	28	Sunday
29	Tuesday	29	Friday	29	Monday
30	Wednesday	30	Saturday	30	Tuesday
31	Thursday	31	Sunday		

October		November		December	
1	Wednesday	1	Saturday	1	Monday
2	Thursday	2	Sunday	2	Tuesday
3	Friday	3	Monday	3	Wednesday
4	Saturday	4	Tuesday	4	Thursday
5	Sunday	5	Wednesday	5	Friday
6	Monday	6	Thursday	6	Saturday
7	Tuesday	7	Friday	7	Sunday
8	Wednesday	8	Saturday	8	Monday
9	Thursday	9	Sunday	9	Tuesday
10	Friday	10	Monday	10	Wednesday
11	Saturday	11	Tuesday	11	Thursday
12	Sunday	12	Wednesday	12	Friday
13	Monday	13	Thursday	13	Saturday
14	Tuesday	14	Friday	14	Sunday
15	Wednesday	15	Saturday	15	Monday
16	Thursday	16	Sunday	16	Tuesday
17	Friday	17	Monday	17	Wednesday
18	Saturday	18	Tuesday	18	Thursday
19	Sunday	19	Wednesday	19	Friday
20	Monday	20	Thursday	20	Saturday
21	Tuesday	21	Friday	21	Sunday
22	Wednesday	22	Saturday	22	Monday
23	Thursday	23	Sunday	23	Tuesday
24	Friday	24	Monday	24	Wednesday
25	Saturday	25	Tuesday	25	Gina & Sidney Day
26	Sunday	26	Wednesday	26	Peter, Michael & Clare
27	Monday	27	Thursday	27	1B Desborough Drive
28	Tuesday	28	Friday	28	Tewin Wood, Welwyn
29	Wednesday	29	Saturday	29	Hertfordshire, AL6 0HQ
30	Thursday	30	Sunday	30	Telephone Bulls Green 698
31	Friday			31	STD· 043 879 698

1980 Calendar and X-mas Card Greeting
Greeting card; lithographed, original written
with a metal pen nib on goatskin parchment
paper
11.69 × 16.54 in. (29.7 × 42 cm)

Jim Gemmill
Salt Lake City, Utah
U.S.A.

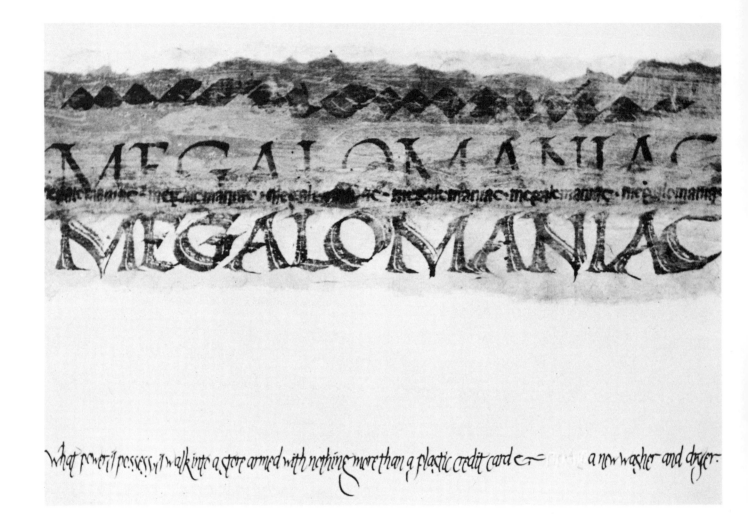

Megalomaniac
Wall hanging; written with Chinese stick ink
with 14 karat gold illumination on assorted
handmade papers using a bamboo pen

11 × 8.25 in. (27.94 × 20.96 cm)

Curtis Anderson
New York, New York
U.S.A.

In the name of Allah, the Compassionate, the Merciful.

When the sun ceases to shine; when the stars fall down and the mountains are blown away; when camels big with young are left untended and the wild beasts are brought together; when the seas are set alight and men's souls are reunited; when the infant girl, buried alive, is asked for what crime she was thus slain; when the records of men's deeds are laid open and the heaven is stripped bare; when Hell burns fiercely and Paradise is brought near; then shall each soul know what it has done.

In the Name of Allah
Experimental; original writing done with
Higgins Eternal ink on bond paper using a size
4 nibbed Mitchell pen. Lithographed (Chien
Collé) with a hand (Rembrandt) press on rag
and vegetable papers
14.88 × 11 in. (37.78 × 27.94 cm)

Sheila Waters
Gaithersburg, Maryland
U.S.A.

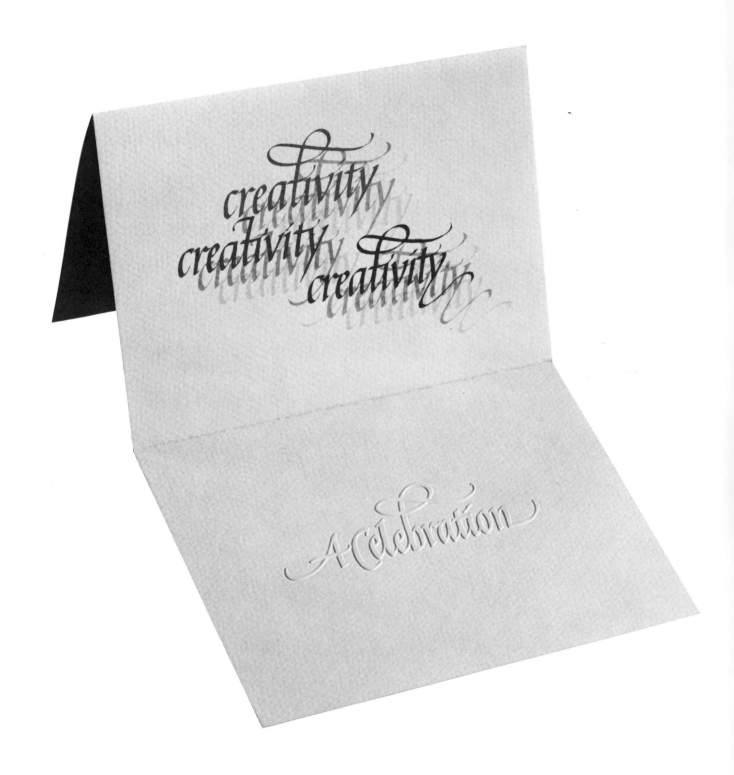

Creativity
Invitation for the Library of Congress, Washington, D.C.; written nine times with steel broad-edged pens on original camera-ready artwork (frosted mylar) with Chinese stick ink; reproduced on cover stock by four-color offset printing (by Stephenson, Inc., Washington, D.C.).

7 x 15 in. (17.78 x 38.1 cm)

Sheila Waters
Gaithersburg, Maryland
U.S.A.

the
LIBRARIAN OF CONGRESS
AND MRS. BOORSTIN
REQUEST the PLEASURE OF
YOUR COMPANY AT
DINNER
to celebrate
The Circle of
KNOWLEDGE
ON THURSDAY
the sixth of december
at eight o'clock
in the great hall of
the library of
congress

R·S·V·P BLACK TIE

The Circle of Knowledge: An Exhibition in
the Great Hall of the Library of Congress
Invitation card; written with a steel pen and
Chinese stick ink on bond paper; offset litho
printed on paper
4.94 x 7.69 in. (12.55 x 19.53 cm)

Hans-Joachim Burgert
Berlin
West Germany

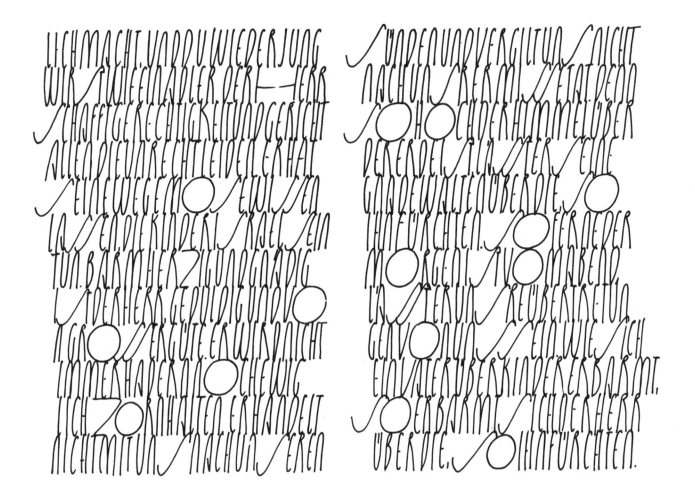

Untitled
Portion of "Lobe den Herrn"
Pages from "Genesis" (hand-press book);
written in ink on handmade rag paper and
offset printed

12.25 × 9.63 in. (31.11 × 24.45 cm)

Lothar Hoffmann
Harper Woods, Michigan
U.S.A.

Über die Anfänge der Buchdruckerkunst und die dazu erforderlichen Überlegungen und Erfindungen sind wir nur mangelhaft unterrichtet. So kommt es, daß selbst der Mann, der als ihr Schöpfer gilt, nicht unbestritten ist. Man tut Johannes Gutenberg sicher kein Unrecht, wenn man sagt, daß er sich der Größe seiner Erfindung, wenigstens im Anfang, nicht bewußt war. Darf man doch nicht mit heutigen Voraussetzungen an die Beurteilung mittelalterlicher Erscheinungen und mittelalterlicher Menschen gehen. Der Begriff der Persönlichkeit, ihres Eigenrechtes und ihrer wirtschaftlichen Freiheit war etwas Unbekanntes. Die Zunft mit ihrer Enge und Begrenztheit beherrschte durchaus die Wirtschaft und verbot dem Individuum jede eigene Entfaltung. Eine Erfindung, die über das umgrenzte Handwerk hinausging und so zur Fabrikation wurde oder in Bezirke des Großhandels vorstieß, begegnete von vornherein Mißtrauen und wurde von jeder geschlossenen Zunft bekämpft. Da es außerdem keinen Urheberschutz gab, die gelegentlichen Privilegien kirchlicher oder landesherrlicher Art waren vielfach wirkungslos, mußte jede Entdeckung, die einen technischen Fortschritt oder eine wirtschaftliche Ersparnis bedeutete, ängstlich geheimgehalten werden. Das ist ein Grund für das Fehlen aller Unterlagen aus der Zeit Gutenbergs, ja aus den frühen Jahrzehnten des Buchdrucks. Stammt doch das erste Lehrbuch der Druckkunst aus dem Jahr 1529. Die Einengung des Persönlichkeitsbegriffs ist wohl auch die Veranlassung, daß weniger der Einzelmensch in der Leistung hervortritt als die Werkstatt. Wir wissen von vielen großartigen Kunstwerken des Mittelalters nicht den Namen des Schöpfers, er trat durchaus hinter dem Werk und dem Werkgedanken zurück. So sehen wir auch in den kümmerlichen Aktenstücken, aus denen wir uns Gutenbergs Leben aufzubauen suchen, daß er sowohl in Straßburg wie in Mainz in Werkgemeinschaften lebte. Zu einem Teil ist das gewiß auf finanzielle Gründe zurückzuführen, Gutenberg war nicht begütert genug, um das große Anlagekapital selbst zu beschaffen. Aber die Werkstatt war als solche weit mehr die Keimzelle der Erfindung als die Persönlichkeit Gutenbergs.

Experimental Sheet
Experimental; written in ink on gray Ingres
paper with a Soennecken steel nib, square,
No. 1
12 × 17.5 in. (30.48 × 44.45 cm)

R. K. Joshi
Bombay
India

॥श्री॥राम॥

ब्राह्मणें बाळबोध अक्षर घडसून करावें सुंदर जें देवतांचि चतुर। समाधान पावती ॥१॥

वाटोलें सरेलें मोकळें। वोतलें मसीचें काळें। कुळकुळीत वोळी चालिल्या दाळें। मुळमाळा जैशा ॥२॥

अक्षरमात्र तितुकें नीट। नेमस्त पेस काने नीट आडव्या मात्रा त्याही नीट। आकुळीं वेलांट्या॥३॥ पहिलें अक्षर जें काढिलें। ग्रंथ संपेतों पाहात गेलें। येका टांकेंचि लिहिलें। ऐसें वाटे॥ ॥४॥ अक्षराचें काळेपण टांकाचें ठोंसरपण। तैसेंचि वळण वांकण। सारिखेंची ॥५॥

Portion of Treatise on Calligraphy by
Saint Ramadasa, 17th Century
Wall hanging; written in India ink on paper with
flat-tipped metal pen
Original size of letters is .25 and .5 in.
(6.4 and 12.7 mm)

80

Barbara Getty
Portland, Oregon
U.S.A.

The system of writing
which we have inherited
from the Romans
has had an influence
in shaping our
civilization which it is
impossible to measure.

It is not without
significance
that the nations which use
the Roman system
of writing
are the most advanced
in the world.

In no field
is our debt to Rome
greater than
in that
of writing.

ULLMAN

ABC
Poster for classroom demonstration showing
contrast of size in layout; Chinese chop-
vermillion ink on Strathmore paper, "ABC"
written with Bouwsma handmade brass pen,
small lettering done with Brause metal nib
11 × 16.5 in. (27.94 × 41.91 cm)

Yoko Shindoh
Tokyo
Japan

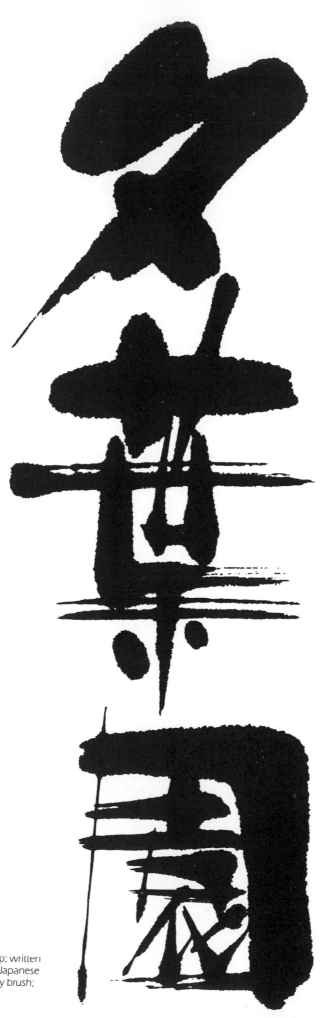

Yubaen
Logo and sign for Japanese tea shop; written
with black Sumi ink on Gashenshi (Japanese
paper) using a traditional calligraphy brush;
offset printed

82 19.69 x 19.69 in. (50 x 50 cm)

Toshio Fukuyama
Muko-City, Kyoto-Fu
Japan

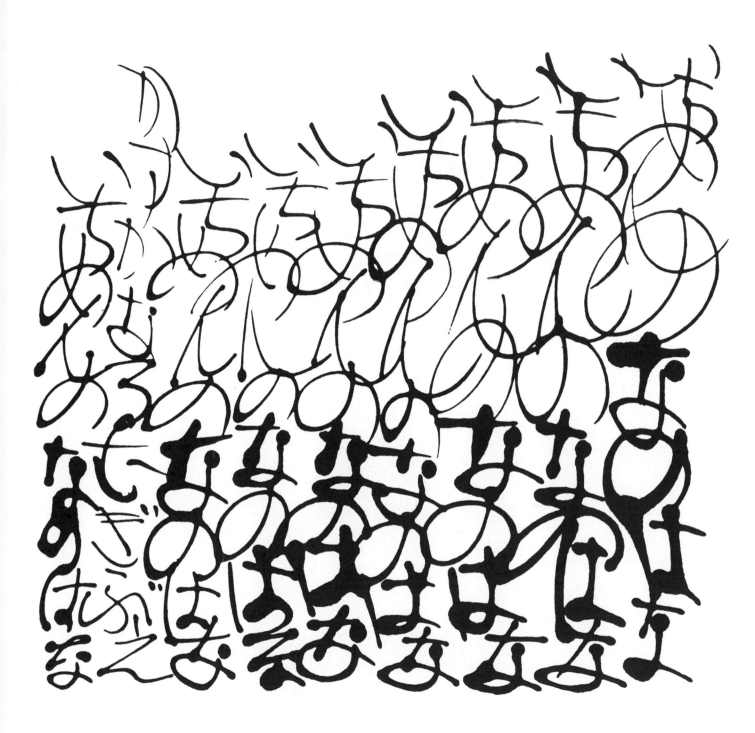

Paragraph of Japanese Poem
(Rape Flower) "A"
Wall hanging; written with Sumi ink on Washi
(Japanese paper) with a Fude (Japanese brush)
20.28 × 28.66 in. (51.5 × 72.8 cm)

Heinz Schumann
Karl Marx Stadt
German Democratic Republic

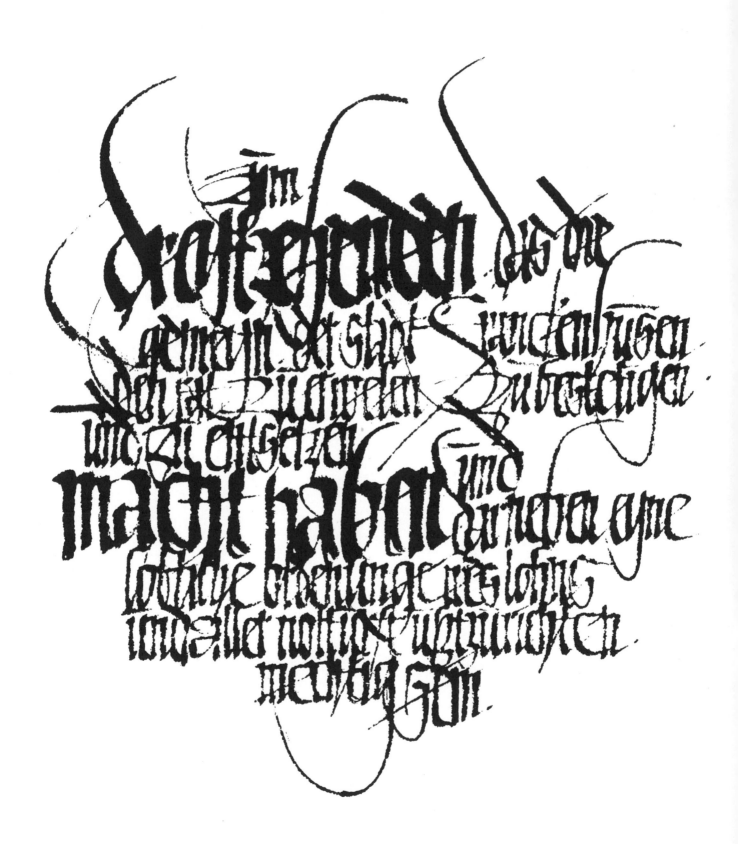

Untitled
Calligraphic study; written on handmade paper

7.87 × 9.84 in. (20 × 25 cm)

Tim Girvin
Seattle, Washington
U.S.A.

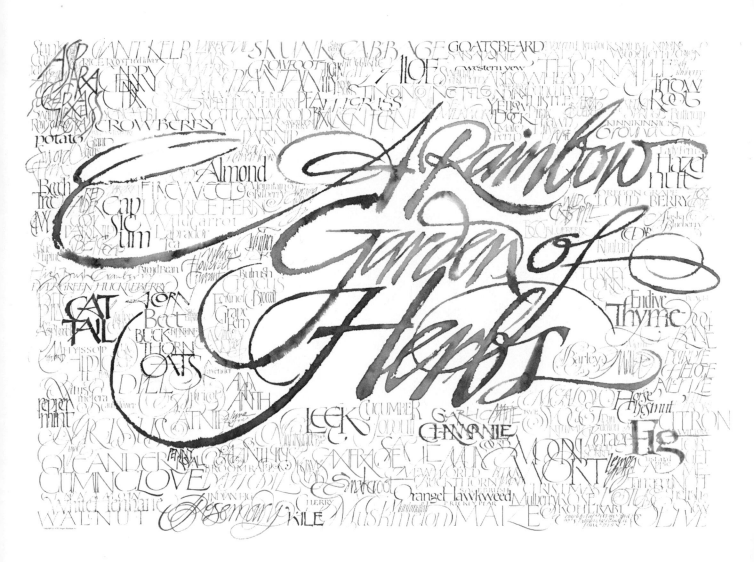

A Rainbow Garden of Herbs
Magazine insert and poster; written in hand-
ground pigments, various inks, and watercolor
on J.B. Green handmade paper with brushes,
reed, quill, bamboo, and steel pens
35.13 × 23.13 in. (89.22 × 58.74 cm)

Fritz Eberhardt
Harleysville, Pennsylvania
U.S.A.

Ein Unnütz Leben ist ein Früher Tod
Broadside; written with watercolor on Royal
Vellum rag paper with steel brush and
calligraphic pen

86 24.5 × 19.5 in. (62.23 × 49.53 cm)

Claude Dieterich
Lima
Peru

Tras el vivir
y el soñar
está Antonio Machado
lo que mas importa
despertar

Tras el vivir y el soñar
Wall hanging; written in black and brown India
ink on watercolor paper with Speedball nib
19.69 × 12.6 in. (50 × 32 cm)

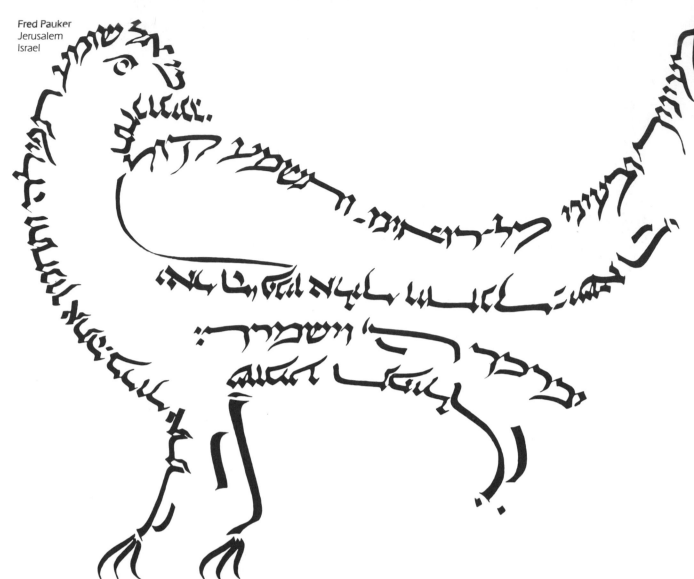

Fred Pauker
Jerusalem
Israel

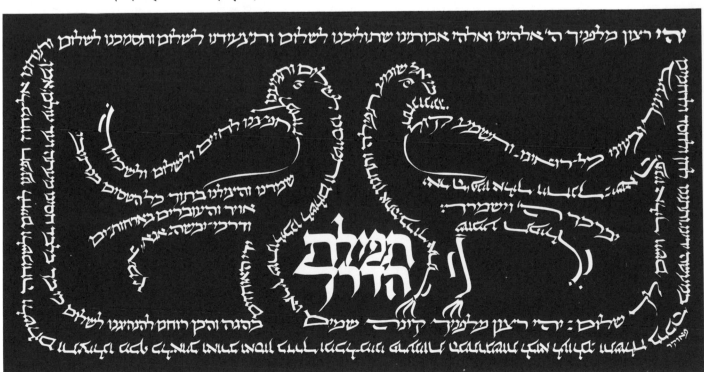

Prayer Before Setting Out on a Journey (and detail)
El Al Israel Airlines travel folder; written in India
ink on Cartridge paper with broad pen

27.56 × 13.78 in. (70 × 35 cm)

Yoko Shindoh
Tokyo
Japan

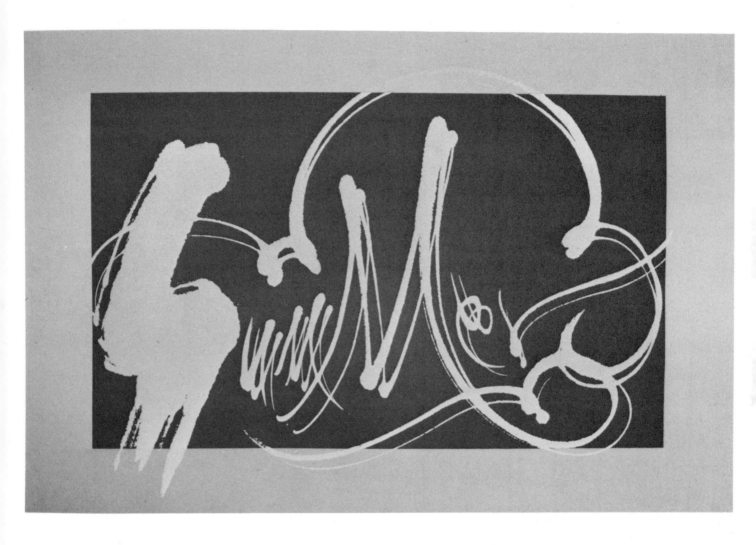

Summer
Exhibition piece written with the image of the
violence of the summer sea, large cloud mass,
and splashing wave; black Sumi ink
on Gasenshi (Japanese paper) using a Japanese
calligraphy brush; silk-screen printed
13.39 x 9.06 in. (34 x 23 cm)

Marcy Robinson
Nutley, New Jersey
U.S.A.

As every
THREAD
OF GOLD
IS VALUABLE,
so is every
MOMENT
OF TIME.

JOHN MASON

Quotation by John Mason
Experimental; written with Chinese liquid ink on
charcoal paper with a William Mitchell broad-
edge pen
90 9.25 × 8.5 in. (23.5 × 21.59 cm)

Marcy Robinson
Nutley, New Jersey
U.S.A.

We may live without
Owen Meredith – poetry, music, and art;
we may live without conscience, and
live without heart; Lucille – Part 1, Canto 2.
we may live without friends;
we may live without books,
But civilized man cannot
live without Cooks.

Untitled
Experimental; written with a Speedball broad-
edged pen on charcoal paper with Chinese
liquid ink
9.5 x 5.38 in. (24.13 x 13.65 cm)

Volkmar Brandt
German Democratic Republic

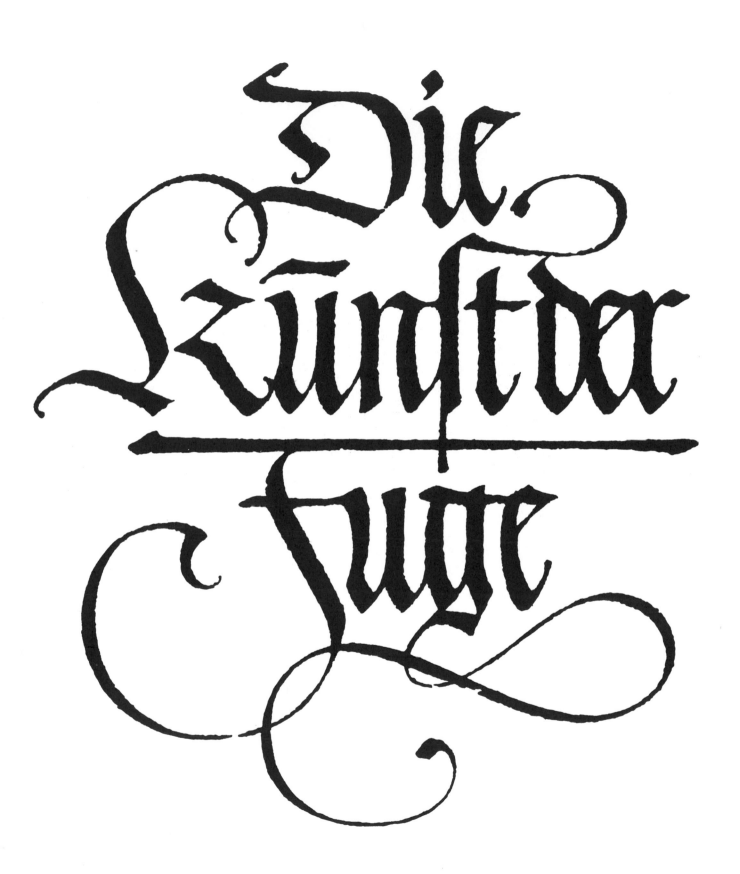

Poster; written with a brush
11.63 × 16.13 in. (29.53 × 40.96 cm)

Ed Benguiat
New York, New York
U.S.A.

The New York Times

The New York Times
Logo; lettered in ink on Strathmore paper with a
crow quill
24 × 24 in. (60.96 × 60.96 cm)

Raphael Boguslav
Newport, Rhode Island
U.S.A.

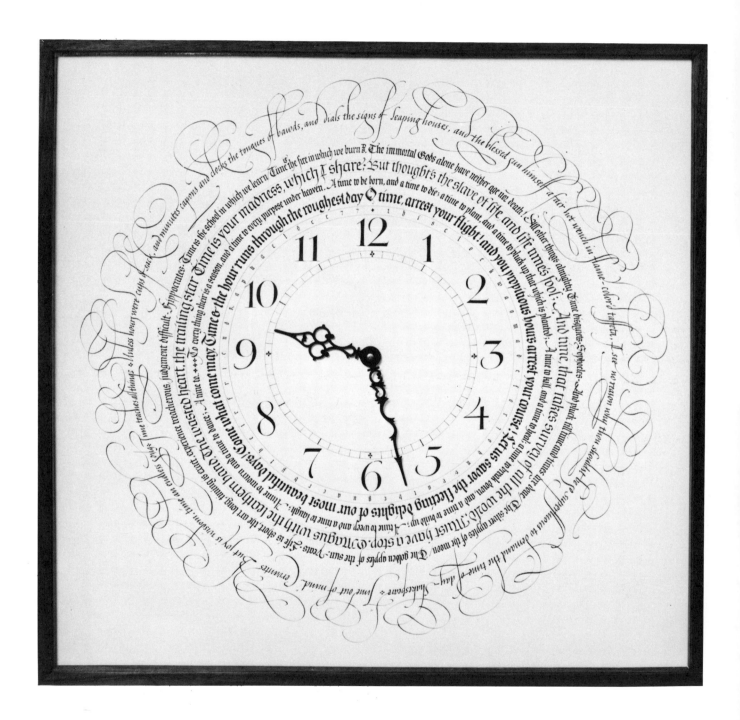

Clock
Wall hanging; written in ink on Strathmore
Fairfield vellum finish paper with fountain pens
18.63 × 19 in. (47.31 × 48.26 cm)
(frame included)

Hal Fiedler
Bayside, New York
U.S.A.

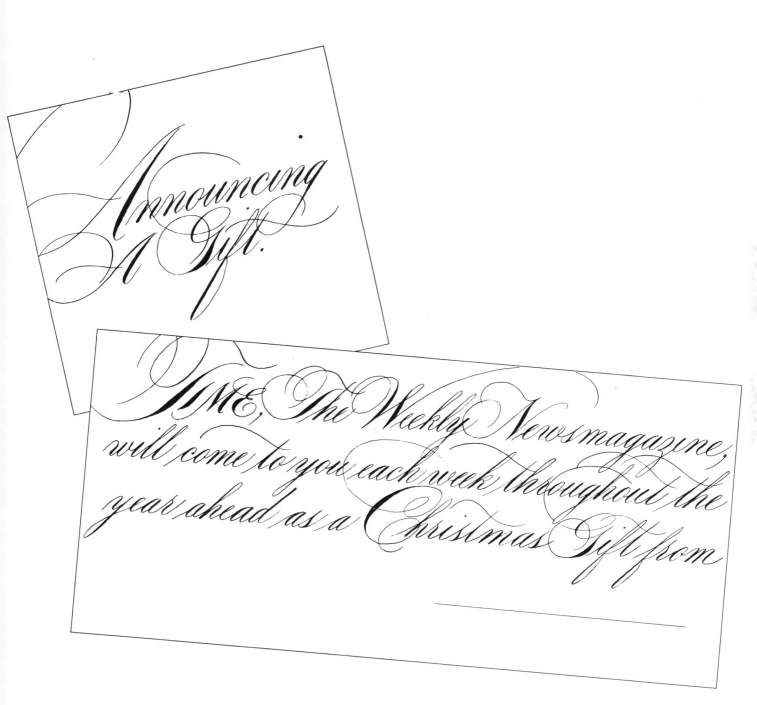

Gift Announcement
Announcement card; ink on bond paper
with pen
Open size: 11.75 × 5.5 in. (29.85 × 13.97 cm)

Georgina Artigas
Miami, Florida
U.S.A.

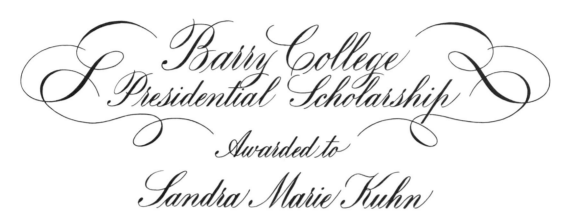

Barry College
Presidential Scholarship

Awarded to

Sandra Marie Kuhn

In recognition of academic excellence
Barry College is proud to present this award to a student
who will add scholarship, loyalty and service
to the college community.

Sister M. Trinita Flood, O.P. – President Barry College

Georgina Artigas

Diploma for Barry College
Diploma for Presidential Scholarship; original
written with stick ink on Savin paper with
Joseph Gillotts #303 and Principality #1 pens
11 × 8.5 in. (27.94 × 21.59 cm)

Paul Standard
New York, New York
U.S.A.

Hear, O Israel!

The Lord is our God, the Lord alone!

Israel has long professed this Shema,
and Rabbi Louis Finkelstein's greatest privilege and service has
been his faithfulness to it – in his own personal Jewishness, and
particularly, his love of the Scriptures and unflagging participation
in the tradition of his people's scholarship. His steadfast personal
testimony, even after the horrors of World War II, that the one Lord
is a Lord of faithfulness and loving kindness, has caused all of us to
know the Lord better. His active dedication to the principle that
the one Lord is the one Father of many different children has caused
all of us to know one another better. As theologians we recognize in
Rabbi Finkelstein the truth that the profoundest theology is service
and faithfulness. As Jesuits we see in him an embodiment of
Ignatius Loyola's ideal of the magis. As students we learn again
from him the teaching of Akiba that worship is an expression of love,
and study the highest form of worship. Through his study he has
served the Lord. We consider, then, that we serve the Lord by asking

Rabbi Finkelstein to receive from us the Doctorate of Humane Letters,

honoris causa.

Woodstock College
New York City
April 12, 1972

PRESIDENT

Citation for Rabbi Finkelstein from Woodstock
Jesuit Community in New York City
Wall hanging; written with broad-edged pens
on Bodleian handmade paper
13 x 16 in. (33.02 x 40.64 cm)

Lothar Hoffmann
Harper Woods, Michigan
U.S.A.

über die anfänge der buchdruckerkunst und die dazu er
forderfähigen ueberlegungen und erfindungen sind wi
wir nur mangelhaft unterrichtet· so kommt es· daß selb
selbst der mann· der als als ihr schöpfer gilt· umstritten i
ist· man tut johannes gutenberg sicher kein unrecht· wenn
man sagt· daß er sich der größe seiner erfindung· wenigste
ns im anfang· nicht bewußt war· darf man doch nicht mi
mit heutigen voraussetzungen an die beurteilung mittela
alterlicher erscheinungen und mittelalterlicher menschen
gehen· der begriff der persönlichkeit· ihres eigenrechts und
ihrer wirtschaftlichen freiheit war etwas unbekanntes· d
die zunft mit ihrer enge und begrenztheit beherrschte dur
durchaus die wirtschaft· eine erfindung· die über das nor
mal handwerkliche hinausging und so zur fabrikation
wurde oder in die bezirke des großhandels vorstieß· begegn
nete von vornherein mißtrauen und wurde von jeder beh
offenen zunft bekämpft· da es außerdem keinen urheberse
schutz gab· mußte jede entdeckung ängstlich geheimgeh
gehalten werden· auch das ist ein grund für das schlecht al
ler unterlagen aus der zeit gutenbergs· stammt doch das e
erste recht ansehnbare lehrbuch der druckkunst aus dem ja
jahr eintausendfünfhundertneunundzwanzig· die einzig
ung des begriffs der persönlichkeit ist wohl auch die veran
lassung· daß weniger der einzelmensch in der leistung her
vortritt als die werkstatt· wilhelm lange· der buchdruck·

Experimental Sheet
Experimental; written in ink on natural paper
with Soennecken steel nib, square, No. 4½;
shown in reverse

11 × 17.5 in. (27.94 × 44.45 cm)

Kay Atkins
Middletown, Rhode Island
U.S.A.

IN·THE·STILLNESS·OF·YOUR·QUIET·SEE·THE ENDLESS·MARCH·OF·THE·RHYTHM·OF·MAN

Adam de la Halle, Issac Albeniz, Tommaso Albinoni, Malcolm Arnold, Georges Aurıc, Carl Philıpp Emmanuel Bach, Johann Christoph Bach, Johann Sebastian Bach, Mıly Balakırev, Samuel Barber, Béla Bartók, Arnold Bax, Ludwıg van Beethoven, Vincenzo Bellini, Richard Rodney Bennett, Alban Berg, Hector Berlioz, Leonard Bernstein, Georges Bizet, Arthur Bliss, Ernst Bloch, John Blow, Luigi Boccherini, Alexander Borodin, Nadia Boulanger, Pierre Boulez, Johannes Brahms, Benjamin Britten, Max Bruch, Anton Bruckner, Ferruccio Benvenuto, Dietrich Buxtehude, William Byrd, Giulio Caccini, John Cage, Giacomo Carissimi, Emilio de Cavaliero, Pietro Francesco Cavalli, Marcantonio Cesti, Luigi Cherubini, Dale Roy Sparlin, Domenico Cimarosa, Samuel Taylor Coleridge, Aaron Copland, Arcangelo Corelli, Francois Couperin, Cui César, Achille-Claude Debussy, Léo Delibes, Frederick Delius, Josquin Desprès, Gaetano Donizetti, John Dowland, Guillaume Dufay, Paul Dukas, John Dunstable, Antonın Dvořák, Edward Elgar, Manuel de Falla, Jules Farnby, Gabriel Urbain Fauré, César Auguste Frank, Girolamo Frescobaldi, Andrea Gabrieli Giovanni, George Gershwin, Carlo Gesualdo, Orlando Gibbons, Alexander Glazunov, Mikhail Glinka, Christoph Willibald von Gluck, Alexander Goehr, Charles Francois Gounod, Percy Aldridge Grainger, Enrique Granados, Edvard Hagerup, Jacques Francois Halévy, George Frideric Handel, Joseph Franz Haydn, Hans Werner Henze, Paul Hindemith, Gustav Theodore Holst, Arthur Honegger, Johann Nepomuk Engelbert Humperdinck, Jacques Ibert, Vincent d'Indy, John Ireland, Charles Ives Leoš Janáček, Joseph Joachim, John of Fornsete, Jerome Kern, Aram Khatthaturian, Zoltán Kodaly, Ernst Krenek, Rodolphe Kreutzer, Constant Lambert, Francesco Landını Francesco, Roland de Lassus, Ruggiero Leoncavallo, Léonin, Ferencz Liszt, Jean-Baptist Lully, Edward Macdowell, Gustav Mahler, Pietro Mascagni, Jules Massenet, Etienne Nicolas Méhul, Felix Mendelssohn, Olivier Messiaen, Giacomo Meyerbeer, Darius, Claudio Monteverdi, Wolfgang Amadeus Mozart, Modeste Mussorgsky, Karl Otto Nicolai, Carl August Nielsen, Jean de Ockeghem, Jacques Offenbach, Johann Pachelbel, Ignacy Jan Paderewski, Niccolò Paganini, Giovanni Pierluigi Palestrina, Hubert Parry, Jacopo Peri, Pérotin, Francis Poulenc, Serge Prokofiev, Giacomo Puccini, Henry Purcell, Serge Rachmaninov, Jean Philippe, Maurice Ravel, Max Reger, Nikolai Rimsky Korsakov, Gioacchino Antonio Rossini, Camille Saint Saëns, Erik Satie, Alessandro Scarlatti, Domenico Scarlatti, Arnold Schoenberg, Franz Peter Schubert, Robert Alexander Schumann, Heinrich Schütz, Alexander Scriabin, Dmitri Shostakovich, Jean Sibelius, Bedřich Smetana, Louis Spohr, Charles Villiers Stanford, Karlheinz Stockhausen, Strauss, Richard Strauss, Igor Stravinsky, Arthur Sullivan, Jan Sweelinck, Thomas Tallis, John Taverner, Peter Ilyitch Tchaikovsky, George Philipp Telemann, Michael Tippett, Giuseppe, Joaquin Turina, Edgar Varèse, Ralph Vaughan Williams, Giuseppe Verdi, Tomas Luis de Vittoria, Hector Villa-Lobos, Antonio Vivaldi, Richard Wagner, William Walton, Carl Maria von Weber, Kurt Weill, John Wilbye, Adriaan Willaert, Malcolm Williamson, Hugo Wolf, Iannis Xenakis, Adam de la Halle, Issac Albéniz, Tommaso Albinoni, Malcolm Arnold, Georges Aurıc, Carl Philipp Emmanuel Bach, Johann Christoph Bach, Johann Sebastian Bach, Mıly Balakırev, Samuel Barber, Béla Bartók, Arnold Bax, Ludwig van Beethoven, Vincenzo Bellini, Richard Rodney Bennett, Alban Berg, Hector Berlioz, Leonard Bernstein, Georges Bizet, Arthur Bliss, Ernest Bloch, John Blow, Luigi Boccherini, Alexander Borodin, Nadia Boulanger, Pierre Boulez, Johannes Brahms, Benjamin Britten, Max Bruch, Anton Bruckner, Ferrucio Benvenuto, K

1980 Pentalic-Taplinger Music Calendar
Society of Scribes Calendar; written with Oxide
of Chromium, Designers Gouache and Pelikan
fount India ink on paper using #6 William
Mitchell Round Hand and Pelikan
Broad pens
23.94 × 17.44 in. (60.81 × 44.3 cm)

Kennedy Smith
Netherhampton, Salisbury, Wiltshire
England

:ʌʌʌ·x·BCDEFCHILMNOPQRSTUXZABCDEFCHILMNOPQR
STUXZ ANCIENT UNCIALS AS WRITTEN IN MSS OF THE SEVENTH AND EIGHTH CENTURIES
:ABBCCDDEFCHILMNOPQRSTUXZ SEMPER HABERELO
:ABCDEFGbIJKLMNOPQRSST
UVWXYZEFCLAFGELDW AN ALPHABET KEEPING CLOSE TO THE ANCIENT FORMS
AABCDEFGbIJKLMNOPQRS:
TTUVWXYZ AN ALPHABET USING SIMPLER FORMS

UNCIALS

FOR REFERENCE AT SSI WORKSHOP JANUARY 1980 Kennedy Smith

Uncials
"Uncial Workshop" reference sheet; written in
nonwaterproof ink on paper with quill (small
letters), steel pen (alphabets), and homemade
wooden pen (large letters)

14 × 10 in. (35.56 × 25.4 cm)

Morris Zaslavsky
Los Angeles, California
U.S.A.

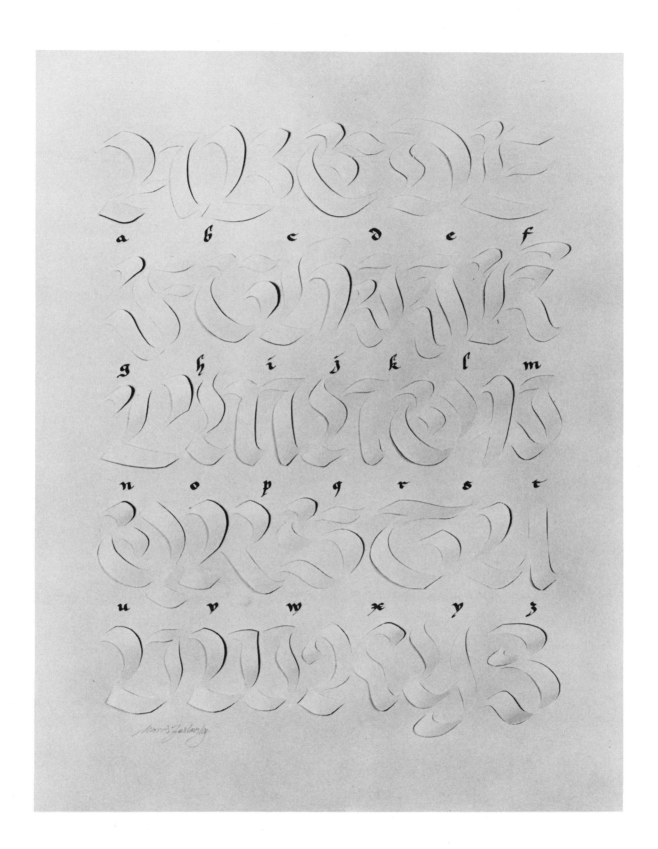

Alphabet
Wall hanging; watercolors on Rives paper with
flat-edge steel pen and X-acto knife
15.63 × 19.69 in. (39.69 × 50 cm)

Friedrich Poppl
Wiesbaden
West Germany

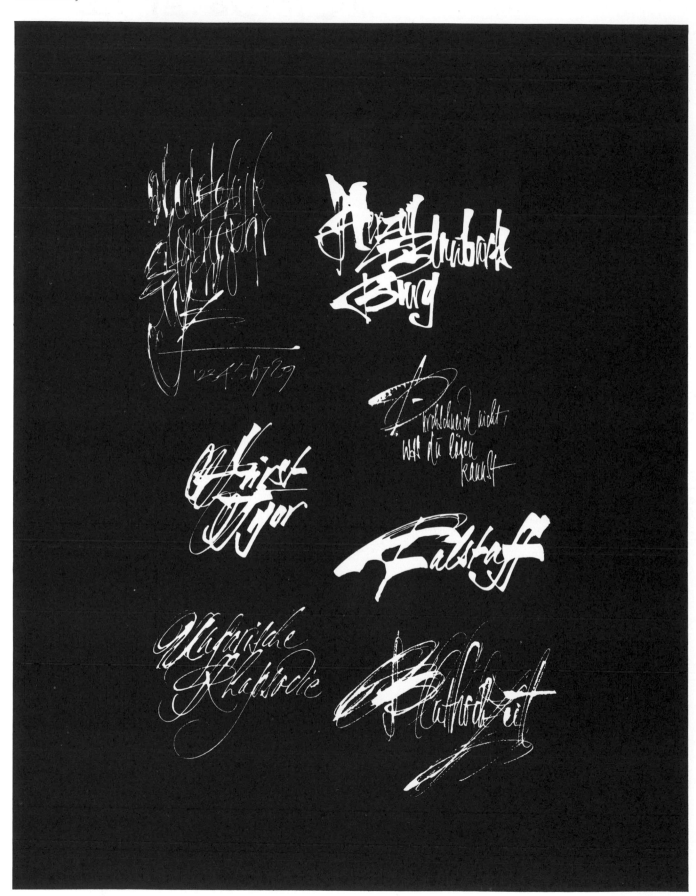

Kalligraphische Studien
Experimental work, montage of various word
designs; written with pen and brush

15.75 × 19.69 in. (40 × 50 cm)

Alvin Y. Tsao
Taipei
Taiwan

Chang Ch'ien Pei (of Han Dynasty)
Wall hanging; Chinese ink on rice paper with
Chinese brush
18 × 53.25 in. (45.72 × 135.26 cm)

Friedrich Peter
North Vancouver, British Columbia
Canada

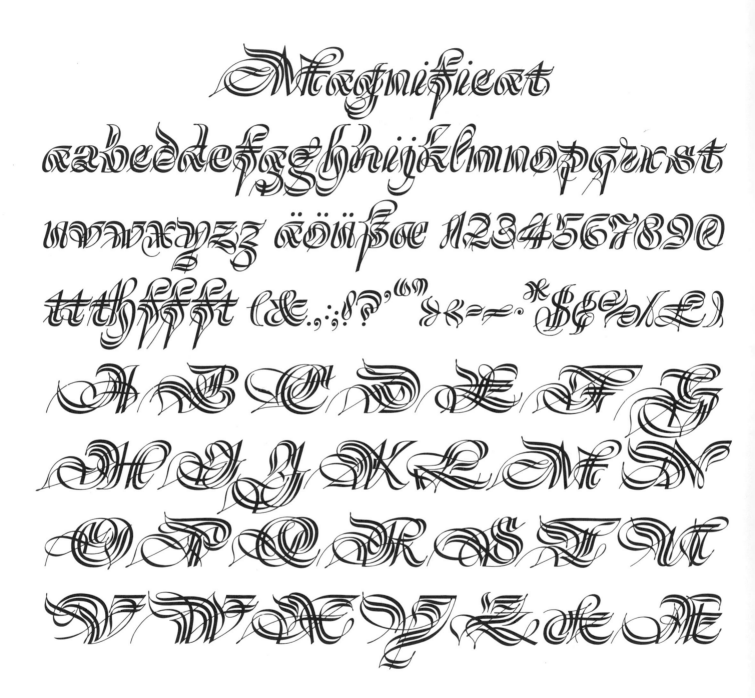

Magnificat (Letraset)
Experimental typeface design developed for
1973 Letraset International typeface design
contest, 2nd place winner; original writing with
designers colors on illustration board,
preliminary drawings done with pen, final art
with brush
Typeface named after the Magnificat by St. Mary
(Luke 1:46-55) as an expression of praise and
gratitude to the Lord

104 ca. 30 × 20 in. (76.2 × 50.8 cm)

Jacqueline Svaren
Portland, Oregon
U.S.A.

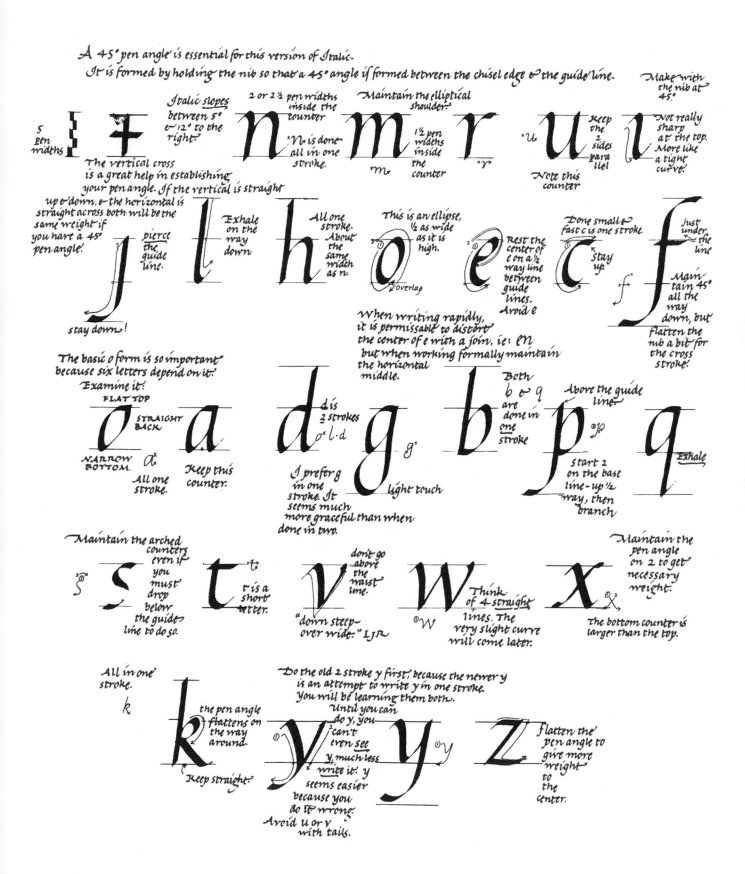

Page from "Written Letters"
Book; pen and ink reproduced by multilith;
original written on bond paper with Speedball
C-2 pen and clipped crow-quill
10.75 × 12.75 in. (27.31 × 32.39 cm)

John Weber
Northfield, Illinois
U.S.A.

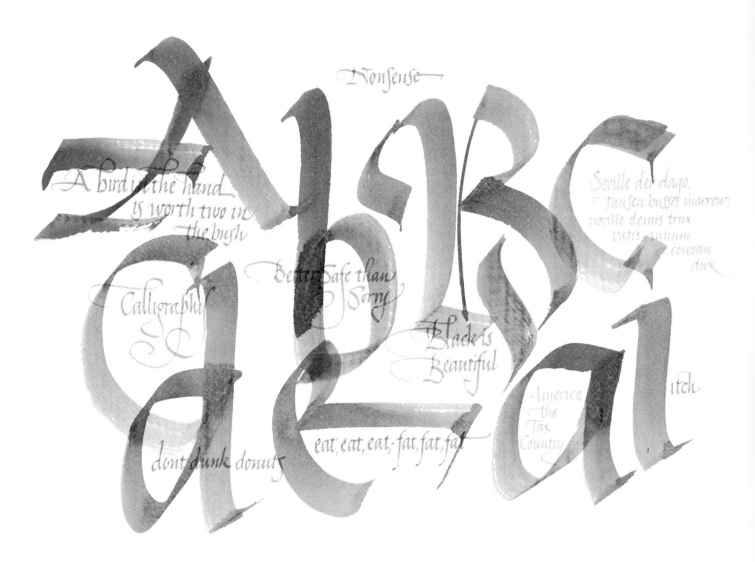

Experimental
Experimental; written in Higgins India ink
diluted with water on textured printing paper
with chisel-point design pens and artist's
sanding stick with felt attached to edge
106 22 × 16 in. (55.88 × 40.64 cm)

Kerstin Anckers
Stockholm
Sweden

åbcdefghïjk

mnöpqrstu

vwxyz ;?!&

1234567890

Bittida må vi gå till vingårdarna,
för att se om vinträden har slagit ut,
om knopparna har öppnat sig,
om granatträden har fått blommor.
Där vill jag ge min kärlek åt dig.

Alphabet and exercise of it
Education; written with chisel-edged pen on
wood-free matt cartridge
14.63 x 9.13 in. (37.16 x 23.19 cm)

Erkki Ruuhinen
Helsinki
Finland

Top left:
From "Ex Libris" series: Hannu Pousi
Bookplate; written on white sketch paper with
a brush and offset printed
Bookplate size: 2.94 × 2.94 in. (7.47 × 7.47 cm)
Original art: 9.84 × 9.84 in. (25 × 25 cm)

Top right:
From "Ex Libris" series: Tuomas Leppihalme
Bookplate; written on white sketch paper with
a brush and offset printed
Bookplate size: 2.25 × 2.81 in. (5.72 × 7.14 cm)
Original art: 9.84 × 13.78 in. (25 × 35 cm)

Bottom:
Syntymapaivana (Birthday Card)
Birthday card; written with black Pelikan
drawing ink on white sketch paper with a
Brause nib and offset printed
Card size; 11.63 × 8.25 in. (29.53 × 20.96 cm)
Size of original art: 16.54 × 11.69 in.

Patricia Weisberg
New York, New York
U.S.A.

JULIET:
*Love's heralds
should be thoughts,
which ten times
faster glide
than the sun's
beams*

ROMEO & JULIET ACT II SCENE V

Quotation from "Romeo and Juliet"
Page for "Calligraphers Engagement Calendar
1980," published by Pentalic-Taplinger, New
York; written with Higgins Eternal Ink on bond
paper with a Mitchell pen; printed in brown and
black on white
8.5 × 8.5 in. (21.59 × 21.59 cm)

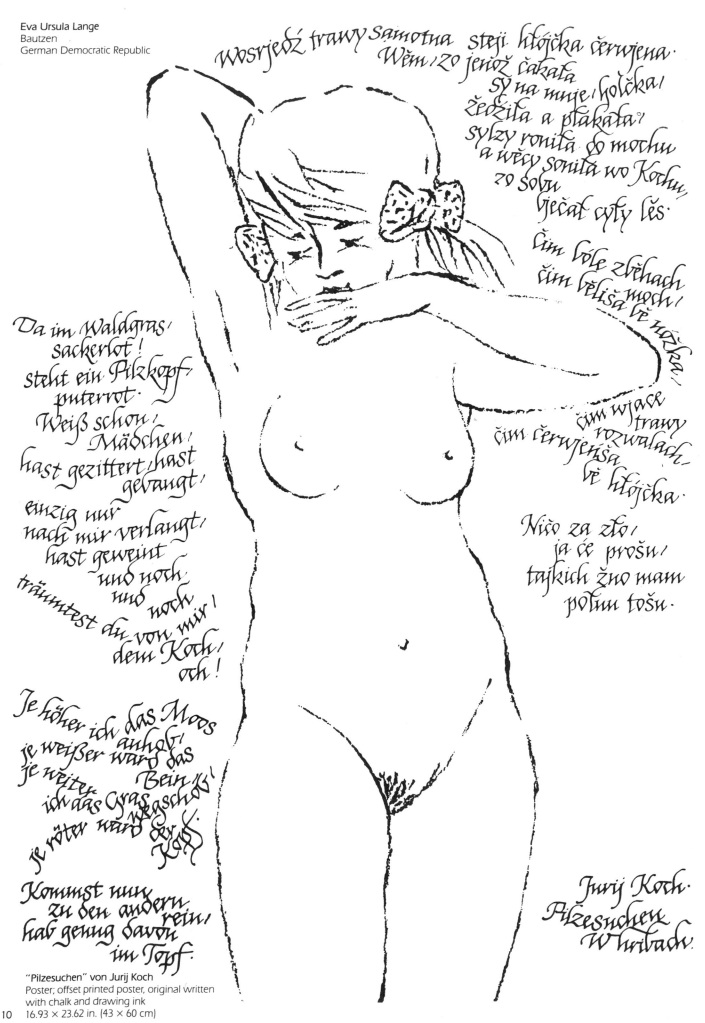

Eva Ursula Lange
Bautzen
German Democratic Republic

Wosrjedź trawy Samotna steji hłójčka čerwjena.
Wěm, zo jenož čakała
sy na mnje, holčka,
žedžila a płakała,
sylzy ronila do mochu
a wěcy sonila wo Kochu,
zo sołn
vječał cyły lěs.

čim vóle zvěhach moch,
čim bělša vě nóžka.

čim wjace trawy rozwalach,
čim čerwjeńša
vě hłójčka.

Ničo za zło,
ja će prošu,
tajkich žno mam
połnu tošu.

Da im Waldgras,
sackerlot!
steht ein Pilzkopf,
puterrot.
Weiß schon,
Mädchen,
hast gezittert, hast
gebangt,
einzig nur
nach mir verlangt,
hast geweint
und noch
und
noch
träumtest du von mir,
dem Koch,
och!

Je höher ich das Moos
anhob,
je weißer ward das
Bein,
je weiter
ich das Gras
wegschob,
je röter ward der
Kopf.

Kommst nun
zu den andern
rein,
hab genug davon
im Topf.

Jurij Koch.
Pilzesuchen
W hribach.

"Pilzesuchen" von Jurij Koch
Poster; offset printed poster, original written
with chalk and drawing ink
110 16.93 × 23.62 in. (43 × 60 cm)

Crous-Vidal
Boulogne-Billancourt
France

Elysée

Herbert Sahliger
Munich
West Germany

Incunabula narrat

Unwirklich durchscheinen mich leuchtende Farben
und Töne und Bilder: die Fülle der Worte·
Papier·mich Papier einer redlichen Sorte·
nur allzusehr zugetan·allzusehr dienend
dem Zweck und den Zeiten·

Papier·Pergament trägt das Gold und den Purpur·
und keiner·der achtet die wirklichen Lasten?
Verschmähung ist Stärke und Macht ist das Lügen·
und ich soll das tragen in heiterer Blüte·
ich·weißer Papierstoff?

Gedichtmaeppchen
Poem; written on Pergament (animal skin) with
rough surface using a turkey feather

3.94 × 6.3 in. (10 × 16 cm)

Karlgeorg Hoefer
Offenbach am Main
West Germany

Albert Einstein
Appell an die Völker der Erde

Hinter geheimnisvollen Mauern werden in fieberhafter Eile die Mittel einer Massenvernichtung vollendet. Wenn dieses Ziel erreicht ist, tritt die radioaktive Verseuchung des Luftraumes und damit die Zerstörung jeglichen irdischen Lebens in den Bereich der technischen Möglichkeit. Alles scheint sich diesem verhängnisvollen Ablauf der Dinge zu fügen. Jeder Schritt erscheint als die unausweichliche Folge des vorhergehenden. Am Ende des Weges zeichnet sich immer deutlicher das Gespenst der allgemeinen Vernichtung ab. Wir können nur unablässig immer und immer wieder warnen. Wir können in unserem Bemühen nicht erlahmen, den Völkern der Welt, zumal ihren Regierungen, das unerhörte Unglück bewußt zu machen, das sie mit aller Bestimmtheit heraufbeschwören, wenn sie ihre Haltung gegeneinander und ihre Auffassung von der Zukunft nicht grundlegend ändern. Unserer Welt droht eine Krise, deren Umfang anscheinend denen entgeht, in deren Macht es steht, große Entscheidungen zum Guten oder zum Bösen zu treffen. Die entfesselte Macht des Atoms hat alles verändert — nur nicht unsere Denkweisen. Auf diese Weise gleiten wir einer Katastrophe ohnegleichen entgegen. Wir brauchen eine wesentlich andere Denkart, wenn die Menschheit am Leben bleiben soll. Diese Drohung abzuwenden, ist eines der vordringlichsten Anliegen unserer Zeit geworden.

Albert Einstein: Appel an die
Völker der Erde
Poster; written with India ink on Japanese paper
with Antiqua surface using a broad-edged pen
22 × 29.75 in. (55.88 × 75.57 cm)

Darlene
Lake Geneva, Wisconsin
U.S.A.

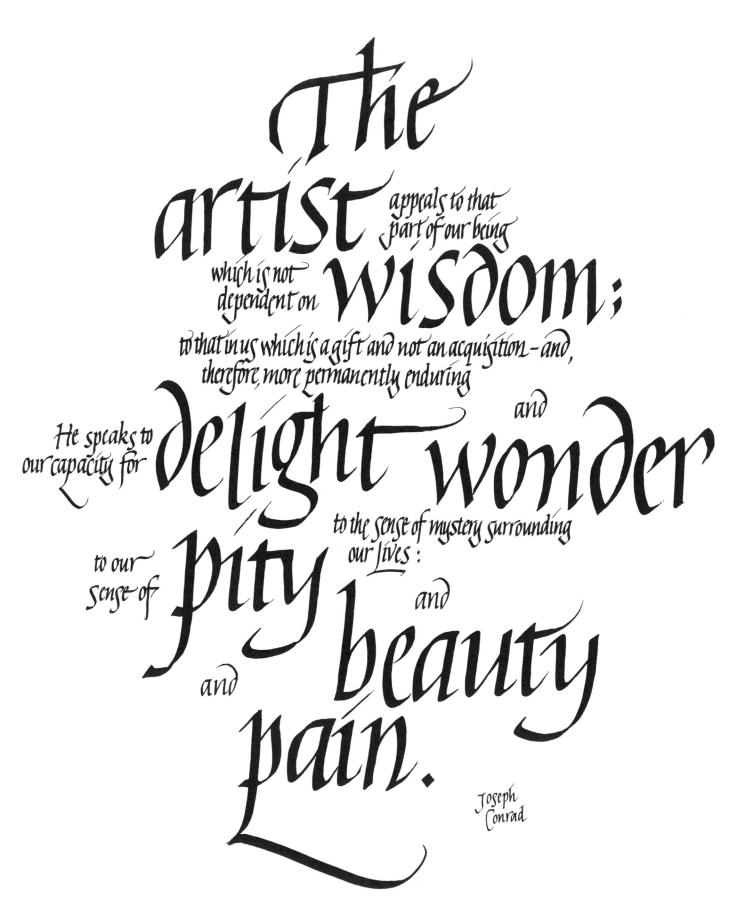

The
artist appeals to that
part of our being
which is not
dependent on wisdom;
to that in us which is a gift and not an acquisition – and,
therefore, more permanently enduring
He speaks to
our capacity for delight and wonder
to the sense of mystery surrounding
to our our lives :
sense of pity and
and beauty
pain.

Joseph
Conrad

The Artist Appeals to That Joy of Our Being
Experimental; written with Chinese ink on
cream paper with an edged pen

14 × 17 in. (35.56 × 43.18 cm)

Jeanyee Wong
New York, New York
U.S.A.

This is the day
which the Lord has made;
let us
rejoice
and
be glad
in it.

PSALM 118:24

Let Us Rejoice and Be Glad in It
Wall hanging; written in red Winsor & Newton
Gouache and Pelikan 4001 black ink on paper
with a Mitchell square-cut nib pen
9.88 × 12.88 in. (25.08 × 32.7 cm)

Stanley R. Knight
Shirley, Solihull, West Midlands
Great Britain

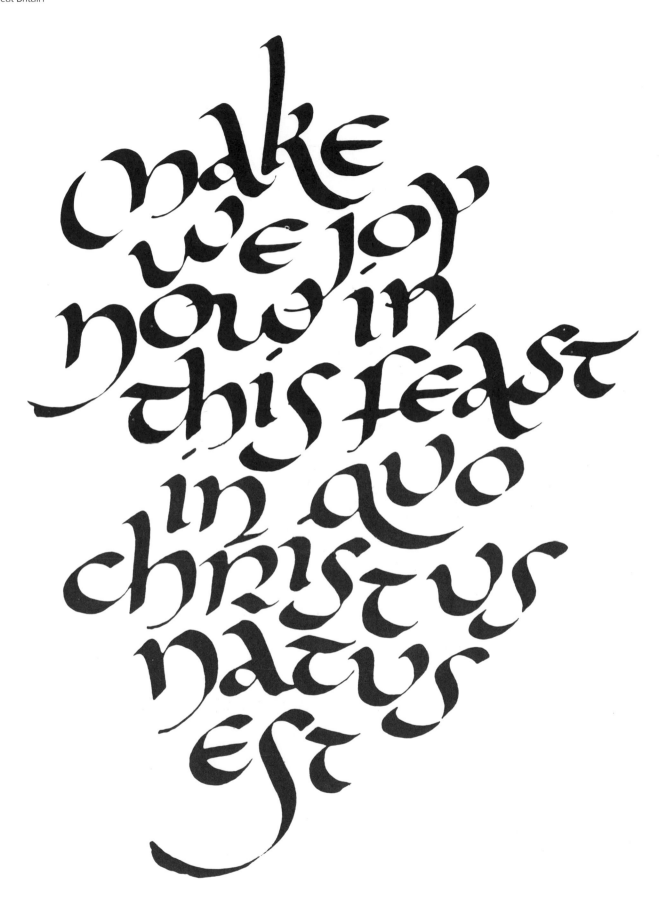

Make We Joy
Wall decoration; screen print on paper, written
with broad-edge pen

9 × 12 in. (22.86 × 30.48 cm)

Victoria Hoke
Oakland, California
U.S.A.

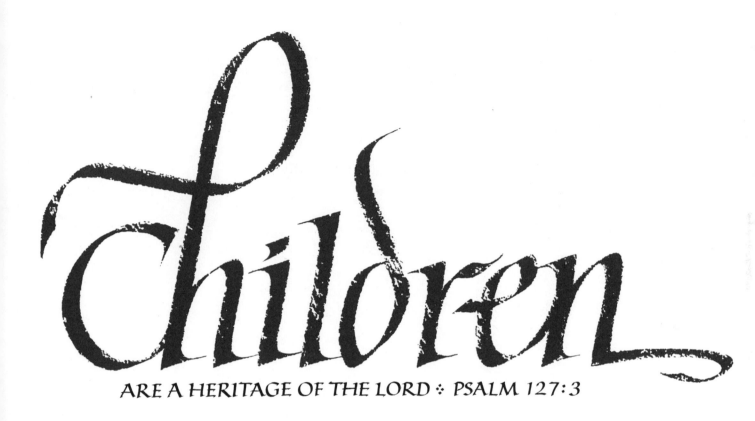

Children

ARE A HERITAGE OF THE LORD ÷ PSALM 127:3

Psalm 127:3
One of a series of scriptural wall prints;
lithographic reproduction in brown and blue ink
on salmon-colored textured and smooth papers;
original written in ink with Bouwsma brass pen
and Brause nib
17 × 10 in. (43.18 × 25.4 cm)

Jerry Kelly
Jamaica, New York
U.S.A.

PRESENTED TO
GEORGE FRENKEL
*ON OUR 100TH
ANNIVERSARY*
WITH
APPRECIATION
FROM EMPLOYEES·
EXECUTIVES &
ASSOCIATES OF
FRENKEL & CO·

Appreciation to George Frenkel
Certificate of appreciation; written in Winsor &
Newton Gouache and 24 karat shell gold on
Fabriano Roma paper with a Mitchell pen
17.5 × 16.5 in. (44.45 × 41.91 cm)

Friedrich Neugebauer
Bad Goisern
Austria

Brueghel
Book; written on handmade paper with a quill
13.39 × 8.27 in. (34 × 21 cm)

Motoaki Okuizumi
Tokyo
Japan

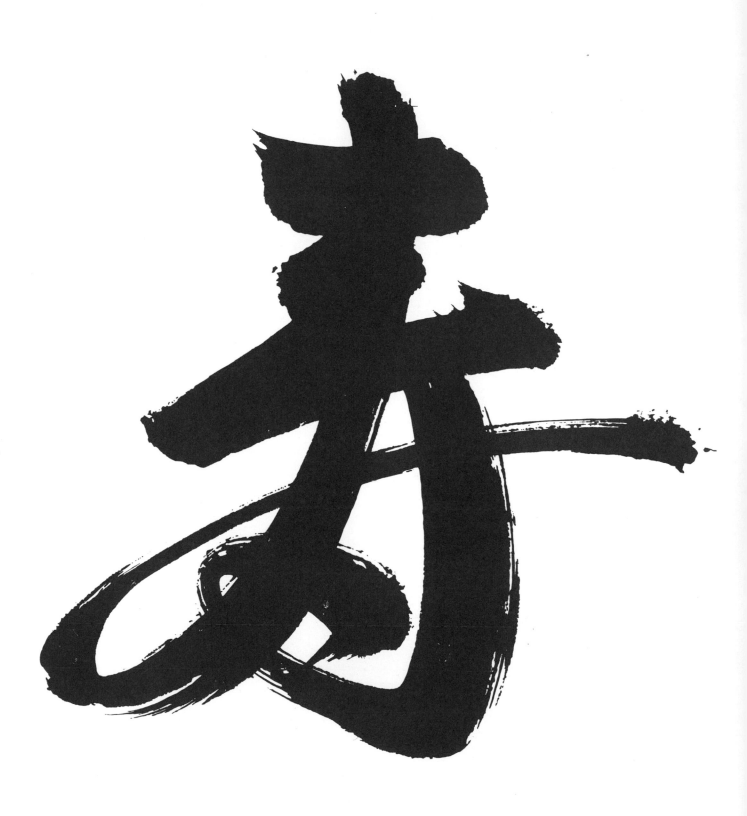

Kotobuki
Poster logo; written in Japanese black ink with
handmade brush
7.75 × 7.75 in. (19.69 × 19.69 cm)

Osamu Kataoka
Tokyo
Japan

一九七四年元旦

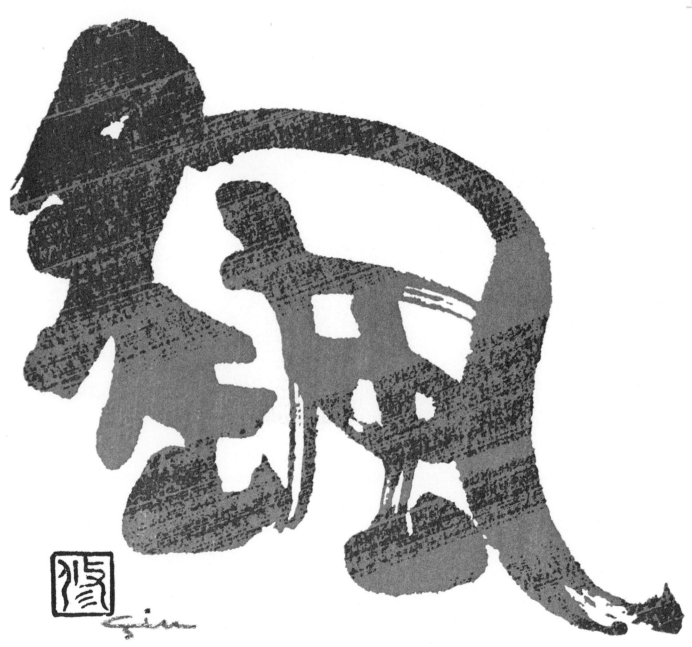

New Year's Card
Greeting card; written with Japanese writing
brush and offset printed on paper
7.81 x 8.56 in. (19.84 x 21.74 cm)

Osamu Kataoka
Tokyo,
Japan

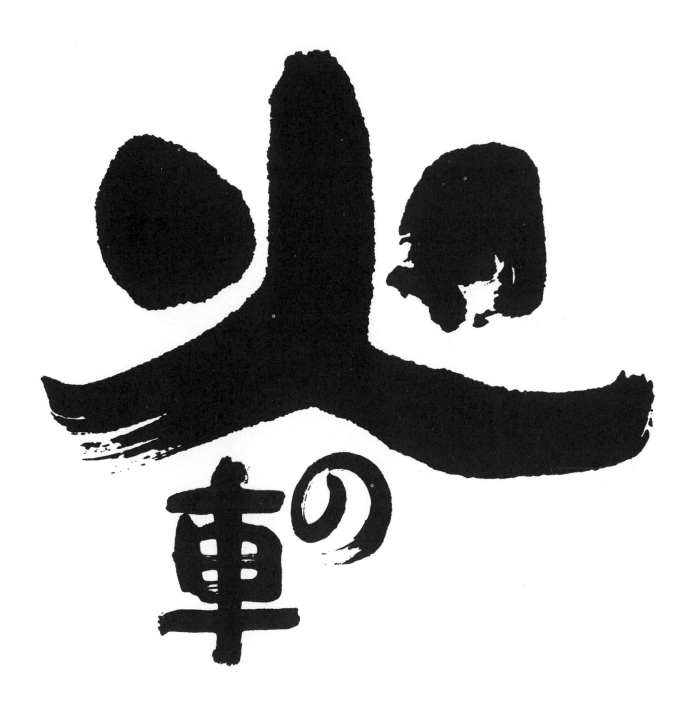

Small Restaurant "Hi-No-Kuruma"
Logo for match box, envelope for disposable
chopsticks, and coaster; written with Japanese
writing brush and offset printed on paper;
coaster is dyed cotton

6.38 x 6.38 in. (16.19 x 16.19 cm)

Stan Brod
Cincinnati, Ohio
U.S.A.

"Good" and "Peace"
Experimental painting; written with black acrylic
paint on watercolor board with 6-in. (15.2-cm)
wide Camels Hair brush
20 × 30 in. (50.8 × 76.2 cm)

Kazuo Hashimoto
Tokyo
Japan

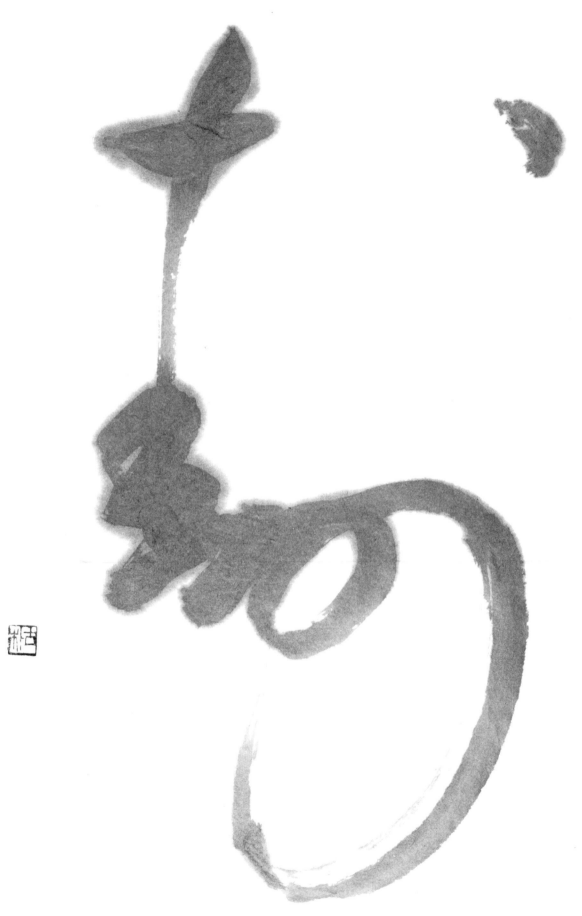

Form of Character (Kotobuki or Yorokobi)
Poster/wall hanging; written on Japanese paper
with a writing brush
13.39 × 19.69 in. (34 × 50 cm)

Kazuo Hashimoto
Tokyo
Japan

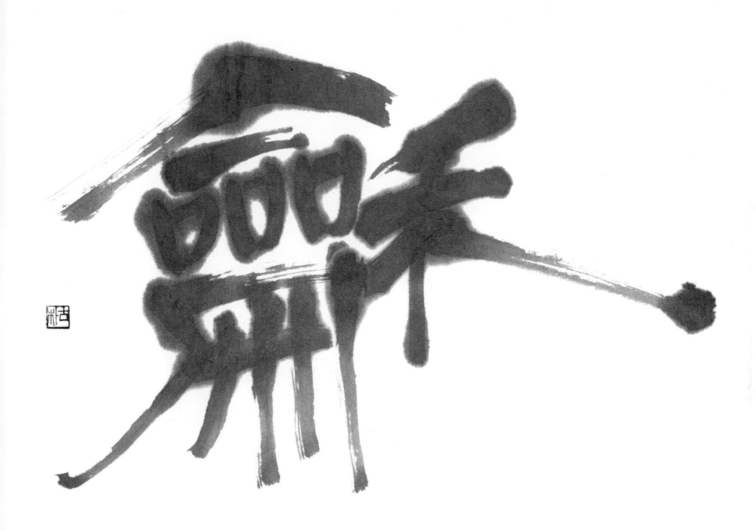

Form of Character (Yawaragu)
Poster/wall hanging; written on Japanese paper
with a writing brush
19.69 × 13.39 in. (50 × 34 cm)

Denis Paul Lund
New York, New York
U.S.A.

CHRISTMAS at the Cathedral starts early this year!

The Play of St. Nicholas

Produced by Frederick Renz with
members of the Ensemble for Early Music

A medieval Christmas pageant
in the world's largest Gothic cathedral.

Thursday, December 6 — 8 p.m.
Friday, December 7 — 8 p.m.
Saturday, December 8 — 4 p.m.
Saturday, December 8 — 8 p.m.
Sunday, December 9 — 4 p.m.

Tickets: $12, $8 & $5
please call 678-6944

THE EARTH'S SACRED VOYAGE
Energy and Human Responsibilty

Every Sunday through December 23rd, at the
11 a.m. liturgy - talks by the world's greatest
scientists, economists, and practical 'doers'.

NOV. 18th: A NEW HEAVEN AND A NEW EARTH – Howard Thurman

NOV. 25th: WORLD ENERGY STRATEGIES – Amory Lovins

DEC. 2nd: NEW ALCHEMY: INTEGRATING FOOD GROWING WIND AND SUN – John Todd and Nancy Jack Todd

DEC. 9th: THE POLITICS OF RECONCEPTUALIZATION – Hazel Henderson

DEC. 16th: ENERGY ALTERNATIVES: REALITY OR WISHFUL THINKING? Theodore B. Taylor

DEC. 23rd: EARTH AS GOD'S BODY – The Very Reverend James Parks Morton

Richard Westenburg conducts The Cathedral Singers

Afterwards, discuss practical applications with our
speakers over lunch. You bring your brown bag.

Christmas Eve-December 24th

5 P.M. - The Nine Lessons and the Blessing of the Creche.
The Cathedral Choristers and Men
sing Scheidt, Praetorius, and Matthias

Midnight Mass - 10:30 p.m.

Solemn Procession, Liturgy, and Sermon
The Bishop of New York
The Cathedral Singers, Choristers,
and chamber orchestra conducted by
Richard Westenburg

Charpentier's MESSE DE MINUIT and
Christmas Motets. Paul Halley, Organ

The Cathedral of St. John the Divine

1047 Amsterdam Avenue at 112th Street · New York, New York 10025 · (212) 678-6888 ·
The Cathedral is convenient to the IRT subway, Broadway at 110th Street; and to the #4 and #104 buses. Ample Parking

Paul Moore, Jr. James Parks Morton
The Bishop of New York Dean of the Cathedral

CHRISTMAS

The Play of St. Nicholas

Produced by Frederick Renz with
members of the Ensemble for Early Music

A medieval Christmas pageant
in the world's largest Gothic cathedral.

Christmas Comes Early This Year (and detail)
Poster for public transportation; written in ink on
white bond paper with Mitchell pens

126 27.88 × 10.88 in. (70.8 × 27.62 cm)

Sandra Kay Dixon
Mayfield Heights, Ohio
U.S.A.

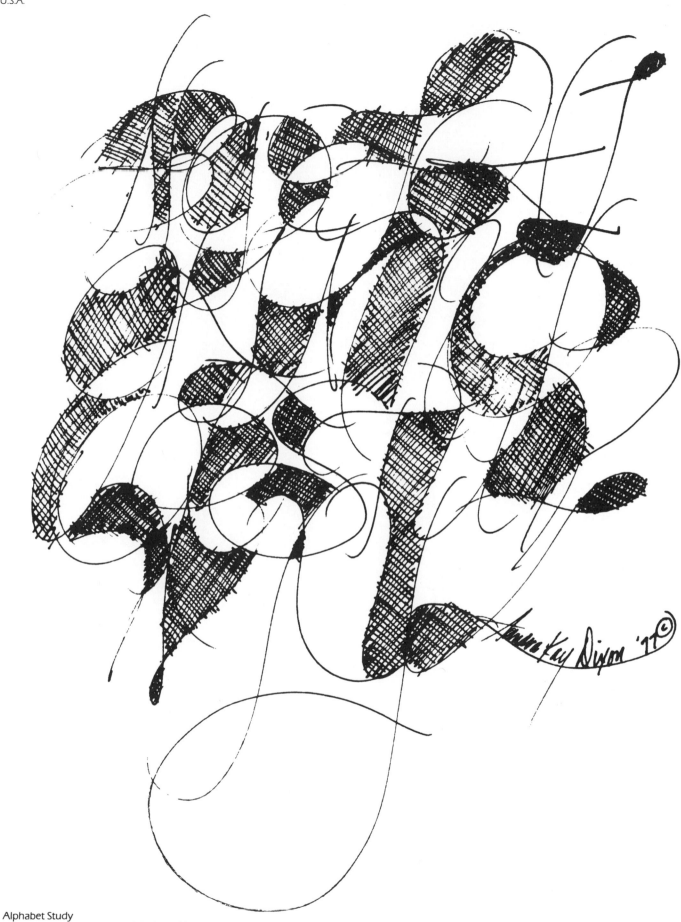

Alphabet Study
Experimental; freely written alphabet with pen
crosshatching on newsprint with fine felt tip
marker
8 × 10 in. (20.32 × 25.4 cm)

Gun Larson
Klagstorp
Sweden

Simon & Schuster Catalog Cover
Catalog cover used from 1976 to 1979, numerals
and color changed each year; written in ink on
paper with Soenneken broad pen

8.5 × 11 in. (21.59 × 27.94 cm)

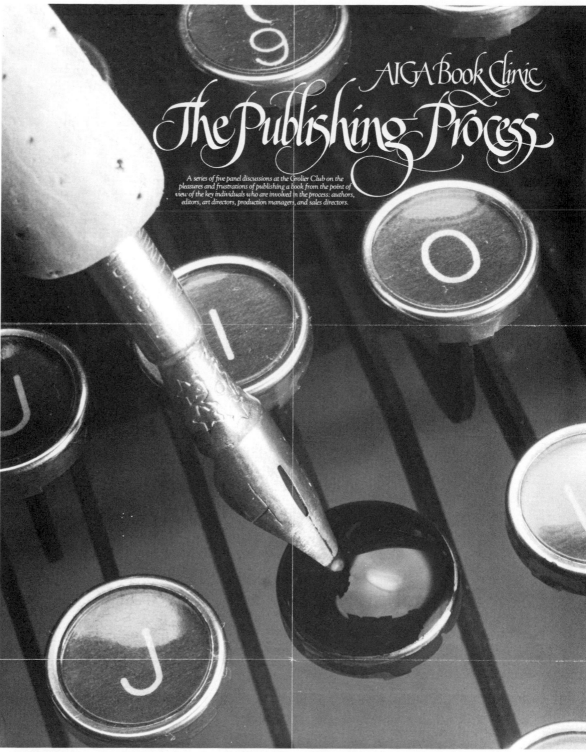

AIGA Book Clinic

The Publishing Process

A series of five panel discussions at the Grolier Club on the pleasures and frustrations of publishing a book from the point of view of the key individuals who are involved in the process: authors, editors, art directors, production managers, and sales directors.

AIGA Book Clinic

Poster for the American Institute of Graphic Arts; written in ink on vellum with Soenneken broad pen
17 x 26.75 in.
(43.18 x 67.95 cm)

Wednesday, February 14 Authors	Wednesday, February 21 Editors	Wednesday, February 28 Art Directors	Wednesday, March 14 Production	Wednesday, March 21 Sales	Book Clinic Information
Thomas Hoving Former Director of The Metropolitan Museum of Art and the author of Tutankhamun: The Untold Story, published by Simon and Schuster, Inc.	**Paul Anbinder** President Nelson A. Rockefeller Publications	**Barbara Bertoli** Art Director Avon Books	**Helen Barrow** Design and Production Consultant	**Burt Britton** Managing Director Books & Co.	**Place:** Grolier Club 47 East 60th Street New York, N.Y. 10021
Jane Kramer Writer for The New Yorker and the author of The Last Cowboys, published by Harper & Row, Publishers, Inc.	**Charles Elliott** Senior Editor Alfred A. Knopf, Inc.	**Seymour Chwast** Illustrator and Designer Push Pin Studio	**George Davidson** Director of Production Harry N. Abrams, Inc.	**Jane Becker Friedman** Publicity Director Alfred A. Knopf, Inc.	**Time:** 5:00–7:00 P.M. **Reservations:** AIGA 1059 Third Avenue New York, N.Y. 10021 Tel. PL 2-0813
John Leonard Columnist for The New York Times and the author of Private Lives, published by Alfred A. Knopf, Inc.	**Erwin A. Glikes** Vice President and Publisher Trade Dept. Harper & Row Publishers, Inc. President and Publisher, Basic Books, Inc.	**Bea Feitler** Free Lance Designer and Consulting Art Director, Condé Nast Publications	**Gene Gordon** Director of Trade Production Harcourt Brace Jovanovich, Inc.	**Paul Ohran** Director of Stores Brentano's, Inc.	Because of space limitations, we suggest you reserve early **Rates:** Members: Series Subscription: $20.00
	Paul Steiner President Chanticleer Press, Inc.	**Alex Gotfryd** Art Director Doubleday & Co., Inc.	**Ellen McNeilly** Manager, Production Operations Alfred A. Knopf, Inc.	**Susan J. Petersen** Vice President, Marketing Ballantine Books	Individual Ticket: $5.00 Non-Members: Series Subscription: $30.00 Individual Ticket: $7.00 Make checks to: AIGA BOOK CLINIC
	Thomas A. Stewart Senior Editor Harcourt Brace Jovanovich, Inc.	**Harris Lewine** Art Director, General Books Harcourt Brace Jovanovich, Inc.	**Sidney Rapoport** President Rapoport Printing Co.		**Committee:** Chairwoman: Lidia Ferrara AIGA President: Richard Danne AIGA Exec. Director: Caroline Hightower AIGA Coordinator: Victoria Bartlett
	Nan A. Talese Senior Editor Simon & Schuster, Inc.	**Jean-Claude Suarès** Design Director New York Magazine	**Irene Yuss** Vice President The New American Library, Inc.		**Graphic Credits:** Art Director: Lidia Ferrara Photograph: Neal Slavin Lettering: Gun Larson Mechanical: Joe Ramer, Inc. Composition: TypoGraphic Innovations, Inc. Paper: Champion Papers Printing: Longacre Press, Inc.

Teri Kahan
Newport Beach, California
U.S.A.

Con Brio
String Quartet

MEMBERS OF THE ORANGE COUNTY
YOUTH SYMPHONY

Kathy McMillan VIOLIN

Carolyn Jillson VIOLIN

Donna Baker VIOLA

Maria Lane CELLO

Con Brio String Quartet
Poster designed as class demonstration with no
preliminary layout; written in Sumi ink on mat
board with brass and steel pens

24 × 24 in. (60.96 × 60.96 cm)

Raphael Boguslav
Newport, Rhode Island
U.S.A.

Altimira
Wine label; written in ink and white gouache
with a brush
4 × 4.25 in. (10.16 × 10.8 cm)

Chris Brand
Breda
Netherlands

Ex Libris
Bookplate for the Fulbright Library of American
Studies in Belgium/Royal Library Brussels;
written on paper with a broad feather

2.2 × 1.46 in. (5.6 × 3.7 cm)

Otto Hurm
Vienna
Austria

Max Reinhardt und Salzburg
Poster for Salzburger Festival (Salzburger
Festspiele); original in gouache on paper
with pen
16.54 × 23.62 in. (42 × 60 cm)

Kevin Elston
Oakland, California
U.S.A.

Calligraphica

Put colour to the pen
Awareness to the eye and hand
& Notions to rest···then let the magic dance begin

Calligraphica
Experimental; gouache on cover stock with
chisel-edged brush
24 × 16.5 in. (60.96 × 41.91 cm)

Raymond Franklin DaBoll
Batesville, Arkansas
U.S.A.

THIS IS A SPECIMEN SHEET OF Calligraphy;
Disciplined freedom is the Essence of it
{ AS OF ANY OTHER JUST FORM OF GOVERNMENT }

VARIOUS CALLIGRAPHICAL AUTHORITIES ARE AGREED that the best model for the instruction of handwriting is the Chancery Cursive, a style which attained its highest development in the early XVI century. Its leading exponent was LUDOVICO DEGLI ARRIGHI[1] OF VICENZA. His work was widely imitated throughout Europe but by 1800 had given place to mercantile hands that could be written with greater speed[2]. When these, with later & still speedier methods gave way to the typewriter and the business machine, handwriting as an art, fell to its nadir. Within the past fifteen years, however, there have been signs that Calligraphy is coming back, chiefly by way of Book Publishers who were the first to sense that the freedom & warmth of Humanistic writing can supplement Type, and may even replace it in full pages of text on appropriate [but rare] occasions.

This lends support to J. COBDEN SANDERSON'S contention that[3] It is the function of the Calligrapher to revive and restore the craft of the Printer to its original purity of intention and accomplishment. It is not suggested here that the earliest Types, which were naturally based on calligraphic forms,

He added that the Printer "must at the same time be a Calligrapher, or in touch with him."

should be revived, nor that calligraphic mannerisms should be imitated in modern Types, for that, as pointed out by STANLEY MORISON,[4] is artificial, and inconsistent with the nature of printing which is a branch of engraving. Rather, the plea is for an accordance such as existed between the early Printer and his Calligrapher for whatever benefits may be derived now, as then, from shared knowledge. In this connection it may be mentioned that ARRIGHI, himself, in 1523, worked as a printer in partnership with LAUTIZIO BARTOLOMEO DEI ROTELLI, the greatest engraver of his time. Directness is mandatory in the use of the Broad Pen—the Scribe's task being to make good letters with the fewest possible strokes and to maintain an even texture and temper without retouching. White is a betrayer, a sneak, and an ever present help in time of trouble. A fairly constant rate of speed also helps to hold the necessary regularity of pattern throughout the mass, whether in a single line of text or in a full page. The faster the speed the more flowing and connected the letters become, hence the term Cursive; but whether the letters are made in the Cursive or in the slower style of roman majuscule & minuscule [caps & lower case] the operation, in calligraphic parlance, is still called writing.

The above roman is based on ARRIGHI'S writing, 1520, in the colophon of the MISSALE ROMANUM.

Eastern's Atlantic Antique Laid is a crisp, crackling, genuinely watermarked paper with the looks & feel of exceptional quality. Uniform in every respect, its tub-sized surfaces take Offset, or Letterpress, or Pen equally well. Free from waves, wrinkles, or curl, and precision cut on all 4 edges, it runs easily on the press without trouble or fuss. An impressive paper worthy of the finest printing, Eastern's Atlantic Antique Laid is ideal for special jobs & for outstanding letterheads, envelopes, brochures, and folders. Specify this distinguished sheet for your best customers. Its cost is much less than its Quality would indicate.

1
ARRIGHI was equally well known as VICENTINO, a surname derived from his native village, VICENZA.

2
Calligraphy's Flowering, Decay, & Restauration by PAUL STANDARD (Society of Typographic Arts) CHICAGO, 1947

3
Ecce Mundus— The Book Beautiful LONDON, 1902. The fuller Quotation is: "When printing was young the Printer carried into type the tradition of the Calligrapher and of the Calligrapher at his best. As this tradition died out in the distance, the craft of the printer declined. It is the function of the Calligrapher to renew etc...."

4
THE ART OF Printing (The Diamant Classics) NEW YORK, 1945 A small book (4¼ x 3¼) of highly concentrated information on the relation of printing and Calligraphy, with a comprehensive Bibliography.

N.B. A definition of Calligraphy by STANLEY MORISON: Calligraphy is the art of fine writing communicated by agreed signs. If these signs or symbols are painted or are engraved on wood or on stone, we have that extension of writing known as LETTERING, ie., a large script generally formed with mechanical aids such as the rule, compass, & square. But it is the essence of handwriting that it be free from such, though not from all government, & of beautiful handwriting that it possess Style... Calligraphy may be defined as free hand in which the freedom is so nicely reconciled with order that the understanding eye is pleased to contemplate it.

YOU MAY DEPEND ON ITS FINE PRINTING QUALITIES

THIS IS A SPECIMEN SHEET OF EASTERN'S ATLANTIC ANTIQUE LAID CREAM, SUBSTANCE 24, MADE BY
Eastern Corporation ⸱ Bangor, Maine
Makers of ATLANTIC BOND and other Fine Business Papers

PRINTED IN U.S.A. - COPYRIGHT, EASTERN CORP. 1948

Disciplined Freedom
Promotional poster for Eastern's Atlantic bond papers; written on antique laid paper with a broad nib pen and quill
17 × 22 in. (43.18 × 55.88 cm)

Ismar David
New York, New York
U.S.A.

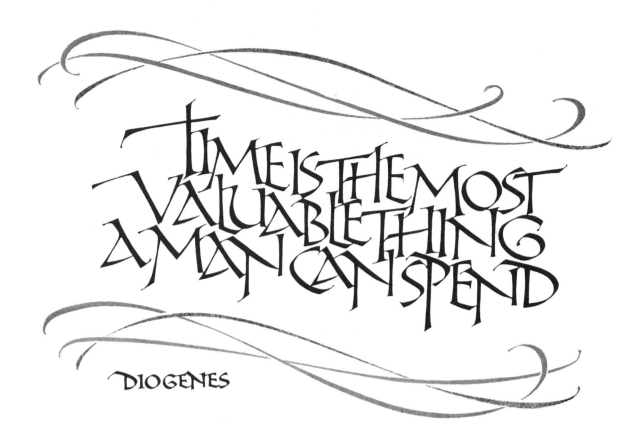

TIME IS THE MOST VALUABLE THING A MAN CAN SPEND

DIOGENES

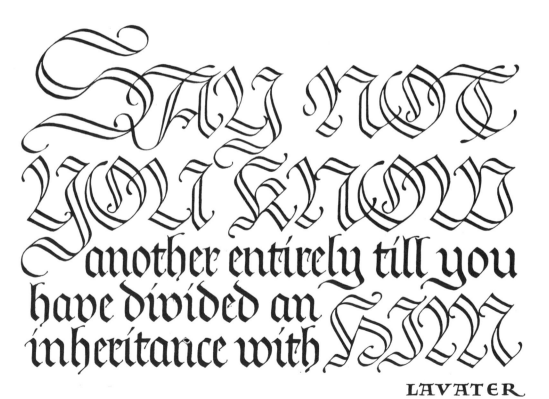

STAY NOT YOU KNOW another entirely till you have divided an inheritance with HIM

LAVATER

Compositions from Writing Book
"Our Calligraphic Heritage"
Loose leaf style example from book; print
reproduced from pen and ink drawing on paper

136 8.5 × 7 in. (21.59 × 17.78 cm)

Donald Jackson
London
England

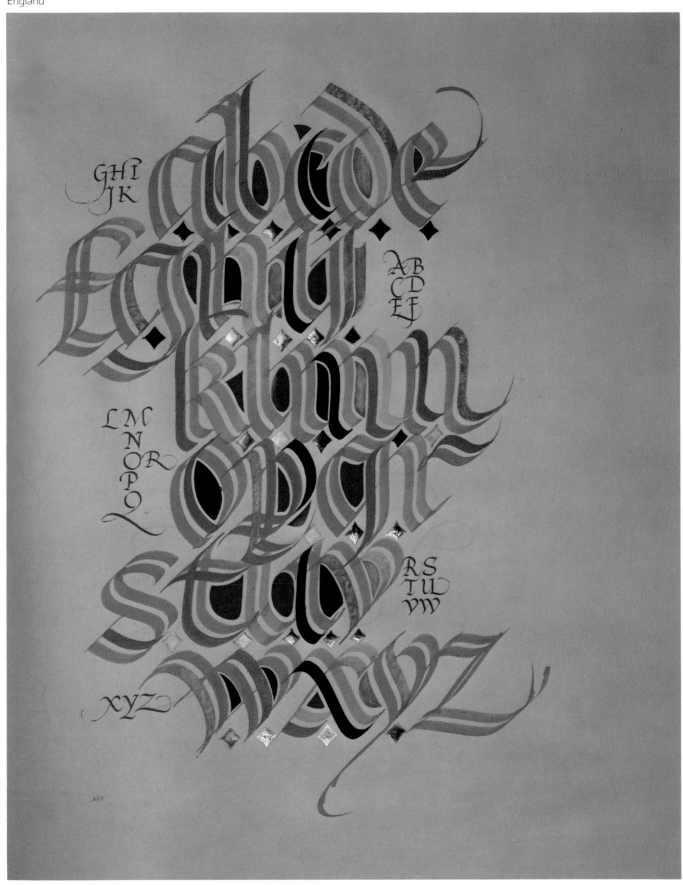

Alphabet
From handwritten collection of alphabets and illuminations; original written with reed and goose quill pens; additional colors overpainted with a brush; illumination done with gold and silver leaf
11 × 16 in. (27.94 × 40.64 cm)

Ina Saltz
New York, New York
U.S.A.

BLESS THEE
IN ALL
THE WORK
OF
THY HAND
WHICH
THOU DOEST.

from Deuteronomy 14:29 Written out by Ina Finnin 1977

Bless Thee
Decorative wall hanging; written in Winsor &
Newton Gouache on Canson paper with
Mitchell and Brause nibs

11.75 × 14.87 in. (29.85 × 37.77 cm)

Margaret E. Young
Wembley, Middlesex
England

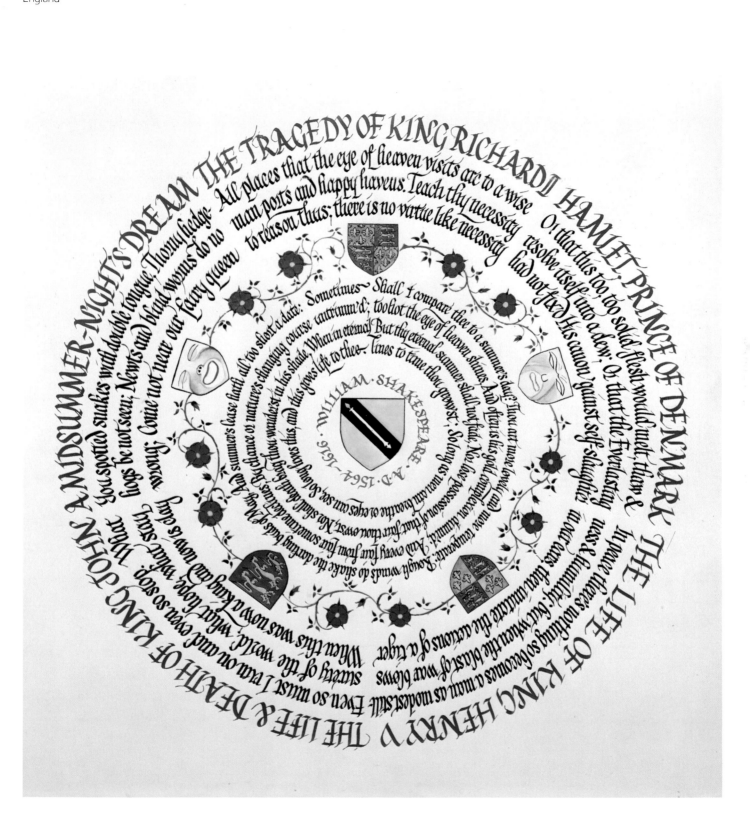

Shakespeare Rondel
Wall hanging; written in watercolor and ink on
fashion board with pens and brush
12.5 in. diameter (31.75 cm diameter)

Dot Caputi
Centerport, New York
U.S.A.

From "Walden"
Experimental book; writing done in India ink,
illustration done in watercolor on Basingwerk
paper with Mitchell pen (for lettering only)

9.25 × 13 in./page (23.5 × 33.02 cm)

Elizabeth Anderson
Portland, Oregon
U.S.A.

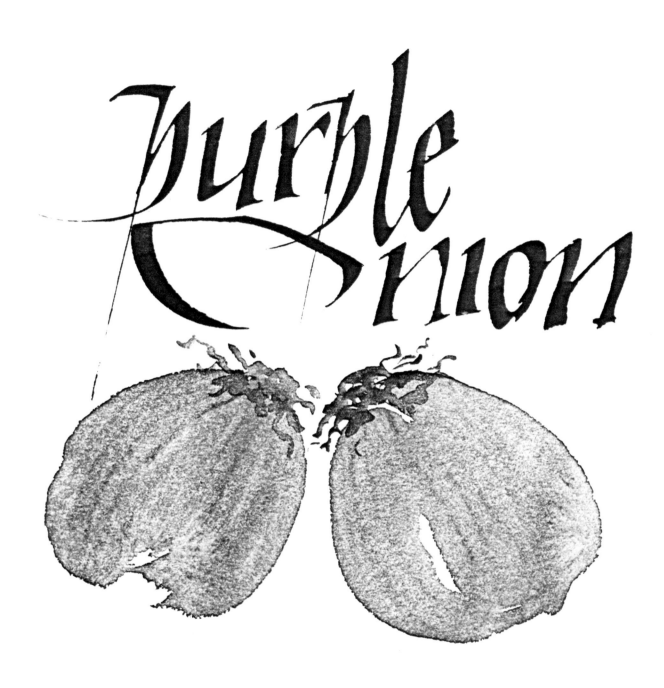

Purple Onion
Experimental; watercolor illustration originally
done on watercolor paper with a Japanese
brush and later Xeroxed onto bond paper.
Words written in ink with a steel pen
9 × 7 in. (22.86 × 17.78 cm)

Stanley R. Knight
Shirley, Solihull, West Midlands
Great Britain

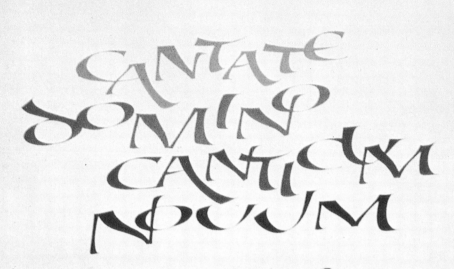

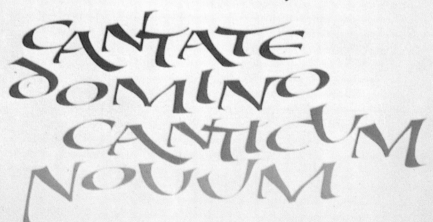

Cantate Domino
Wall panel; written with gouache and stick ink
on handmade paper with pen and brush

12 × 17 in. (30.48 × 43.18 cm)

Julio Vega
New York, New York
U.S.A.

The scene shows the rocky bed of the Rhine, with its flowing waters,
filling the entire height of the stage, the daylight scarcely filtering
through from above, the three Rhinedaughters in Wagner's Das Rhine-
gold - Woglinde, Wellgunde and Flosshilde, disport themselves merri-
ly swimming about, and diving from rock to rock, while in its pristine
innocence the Rhinegold slumbers securely, their play is interrupted
by the approach of Alberich of the tribes of Nibelheim in the bowels
of the earth, hideous and uncouth, he seeks to win the pleasures of
love from the nymphs, but through tantalizing him by their banter
they elude their awkward pursuer, who sups about on the slimy rocks
until his gaze is attracted by an increasing brilliance which glows
from a rocky eminence, it is the Rhinegold, which presently shines forth
dazzlingly in the rays of the rising sun, and around which the maidens
circle with joyous shouts, suddenly, a bright gleam strikes through the
waters from above, lighting up on a high rock, it increases to a blind-
ing glow.
Woglinde - look, sisters! the rising sun smiles into the depths.
Wellgunde - through the green flood it greets the blissful sleeper.
Flosshilde - now it kisses its eyes to open them.
Wellgunde - (pointing to the Rhinegold lit up by the shaft of sunlight.)
see, it is smiling in gleaming brightness.
Woglinde - down through the waves streams its radiant beam!
all - Rhinegold, Rhinegold! gleaming joy, how bright and gloriously
thou dost laugh! glowing brightness, thou dost glisten in the waves!
wake friend, wake full of joy! delightful games we will play with
thee: the river shimmers, the waters sparkle, as we glide round div-
ing, dancing and singing in thy happy river-bed! Rhinegold! Rhine-
gold! (as the Rhinemaidens swim round the rocks, all the water
gleams with golden light.)
Alberich - what is it, you sleek creatures that gleams there and glit-
ters so?.
Rhinemaidens - where do you come from Rippian, that you have ne-
ver heard of the Rhinegold?.
Wellgunde - does the goblin not know of the eye of gold, that alter-
nately wakes and sleep?.
Woglinde - the lovely star of the waters depths, that shines glorious-
ly through the waves?.
all - see how blithely we glide in its glow! If faint-heart, you would
bathe in it, then swim and revel with us!.
Alberich - is the gold of value only for your diving play? then it
would be little use to me!.
Woglinde - he would not abuse the golden ornament if he knew all
its wonders.
Wellgunde - inheritance of the world would be won by the man who
from the Rhinegold could fashion the ring that would bestow li-
mitless power on him.
Flosshilde - our father told us so, and charged us to guard the
shining treasure wisely, that no false thief should carry it off
from the waters: so keep silent you prattly brood!.
Wellgunde - most prudent of sisters, do you accuse us? do you not know,
then, what man alone is permitted to forge the gold?.
Woglinde - only he who has renounced love's sway, only he who has
spurned the sweets of sensual enjoyment, that man alone may
attain the necessary magic to turn the gold into a ring.
Wellgunde - we are safe indeed and free from worry: since all that
lives would love and no one will shun love.
Woglinde - least of all he - the lustful goblin - for greed of love he
would perish!.

Das Rheingold
Personal project; written with gouache on
Canson paper with Mitchell nib and holder
14 × 17 in. (35.56 × 43.18 cm)

Eita Shinohara
Tokyo
Japan

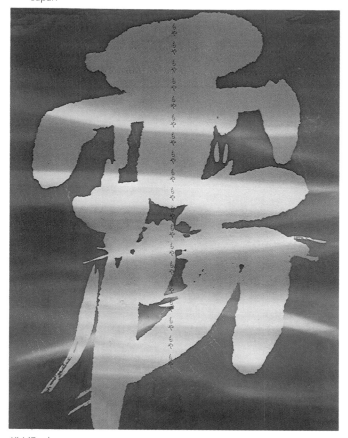

Kiri (Fog)

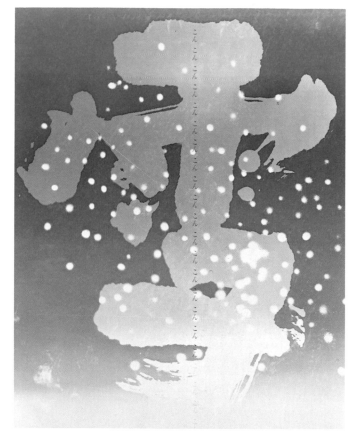

Yuki (Snow)

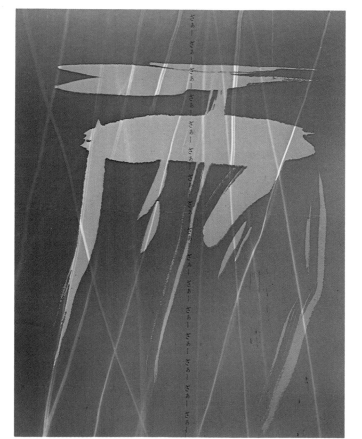

Ame (Rain)

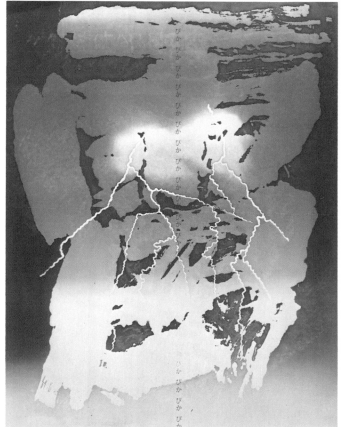

Kaminari (Thunder)

Experimental; written with a brush;
reproduced using electric print

9.83 × 11.83 in. (24.97 × 30.05 cm)

Eita Shinohara
Tokyo
Japan

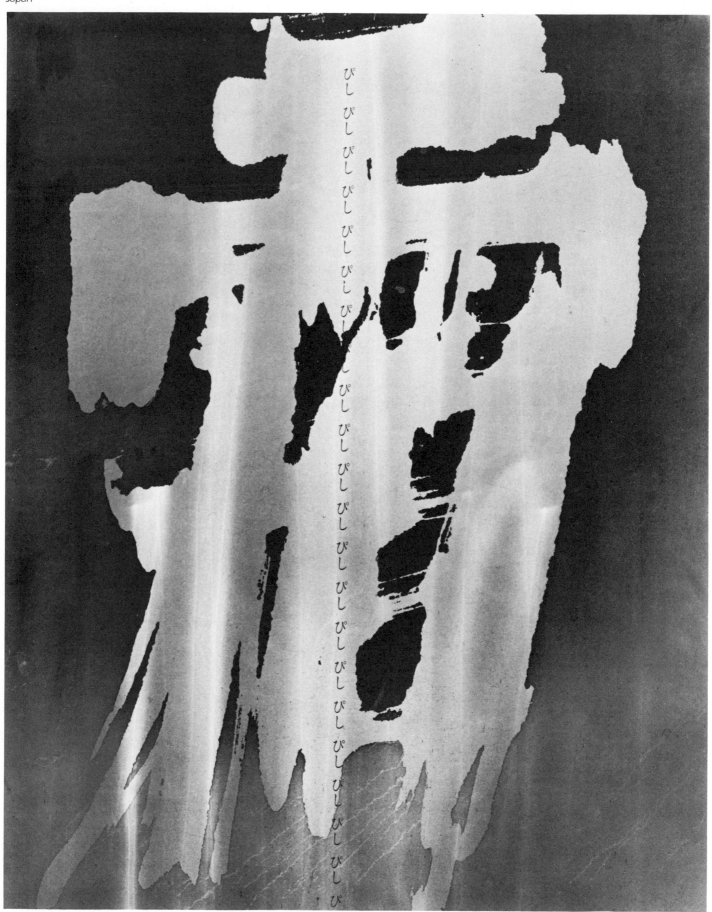

Shimo (Frost)
Experimental; written with a brush;
reproduced using electric print
9.83 × 11.83 in. (24.97 × 30.05 cm)

Thomas Ingmire
San Francisco, California
U.S.A.

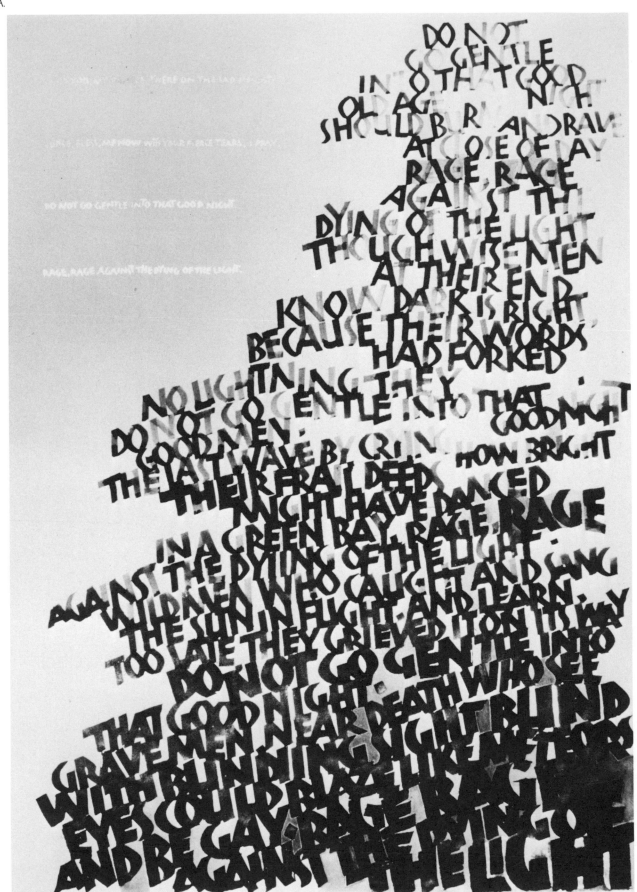

Do Not Go Gentle
Experimental wall hanging; black Sumi ink,
purple watercolor, and gold leaf on a gum
ammoniac base; written done on T. E. Edmunds
paper with reeds and quill pens

17 × 23 in. (43.18 × 58.42 cm)

Lawrence Brady
Los Alamitos, California
U.S.A.

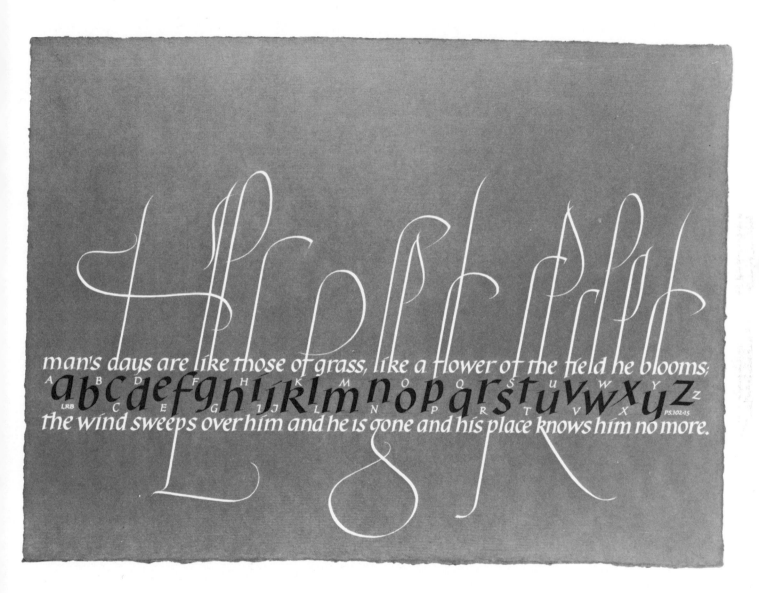

man's days are like those of grass, like a flower of the field he blooms;
abcdefghijklmnopqrstuvwxyz
the wind sweeps over him and he is gone and his place knows him no more.

Psalms 102:15
Wall hanging; written with Winsor/Newton
gouache using turkey quills and Brause nibs on
Fabriano Roma paper
26 × 19 in. (66.04 × 48.26 cm)

Werner Schneider
Wiesbaden
West Germany

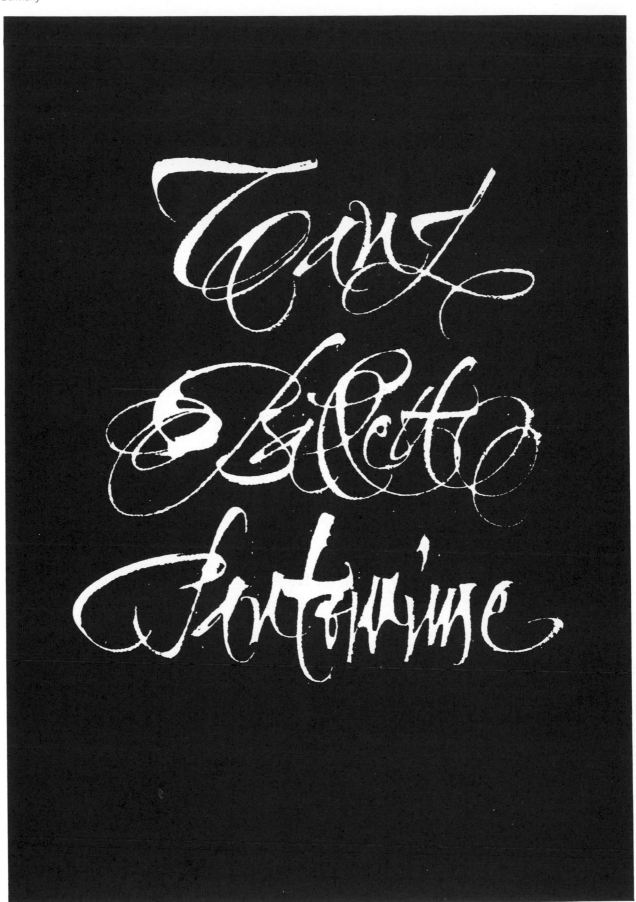

Untitled
Bookjacket; written in India ink on handmade
paper with a drawing pen

11.42 × 16.54 in. (29 × 42 cm)

Rachid Koraichi
La Marsa
Tunisia

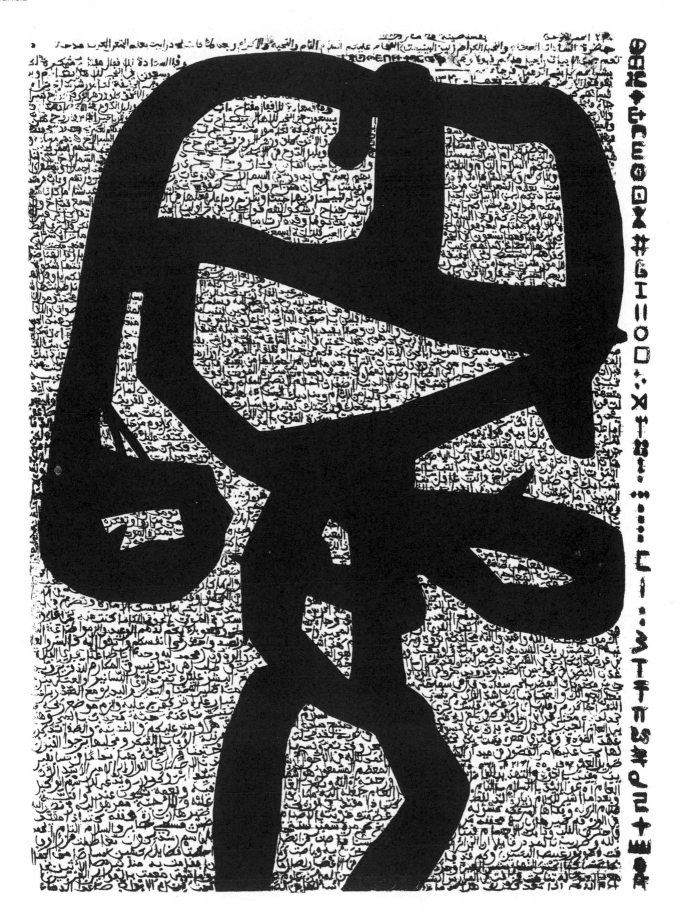

Untitled
Wall hanging; gravure print on paper
21.5 x 29.69 in. (54.61 x 75.39 cm)

Steven Skaggs
Lawrence, Kansas
U.S.A.

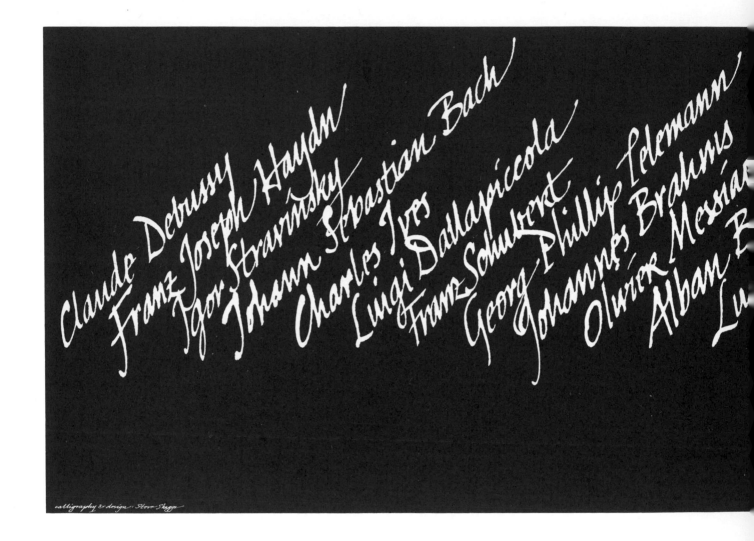

Atlanta Chamber Players Poster
Poster advertisement; reproduced
photolithography in two colors, written in
white, pink, and light blue on medium blue
background; original writing done on Vicksburg
Vellum paper with a Mitchell Italic nib
36 × 12 in. (91.44 × 30.48 cm)

Beethoven
Cowell
Arnold Schoenberg
George Crumb
Wolfgang Amadeus Mozart

diversity in chamber music

ATLANTA
CHAMBER
PLAYERS

Paul Freeman
New York, New York
U.S.A.

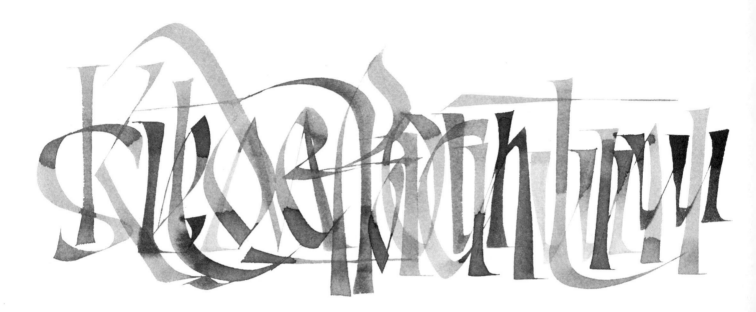

All Counters Count
Wall hanging; written with pen on paper
152 25 x 17.88 in. (63.5 x 45.42 cm)

Maury Nemoy
North Hollywood, California
U.S.A.

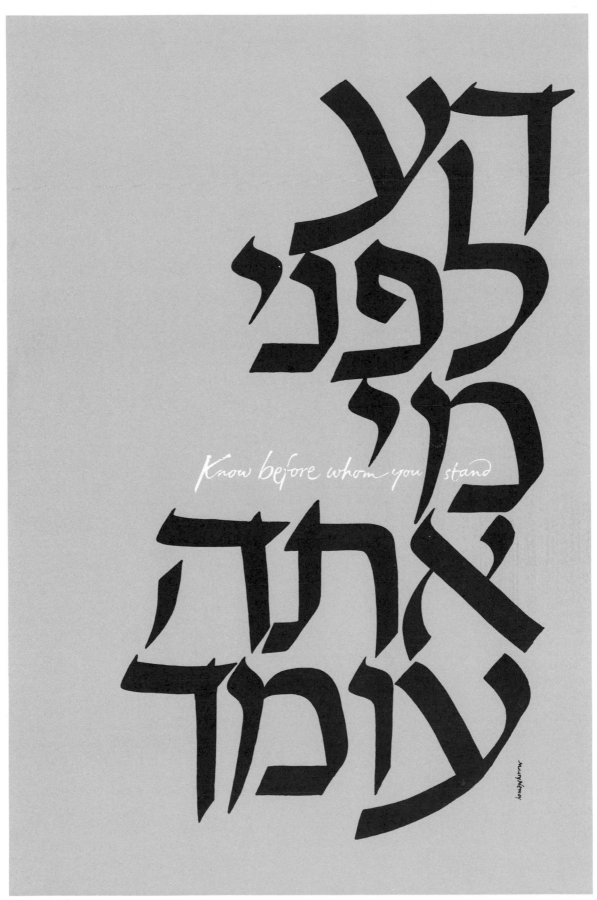

Know Before Whom You Stand
Poster; written in black ink and white tempera
poster color with a brush, silkscreened in blue
and black ink on Bristol paper
20 × 30 in. (50.8 × 76.2 cm)

Bill Taylor
Dallas, Texas
U.S.A.

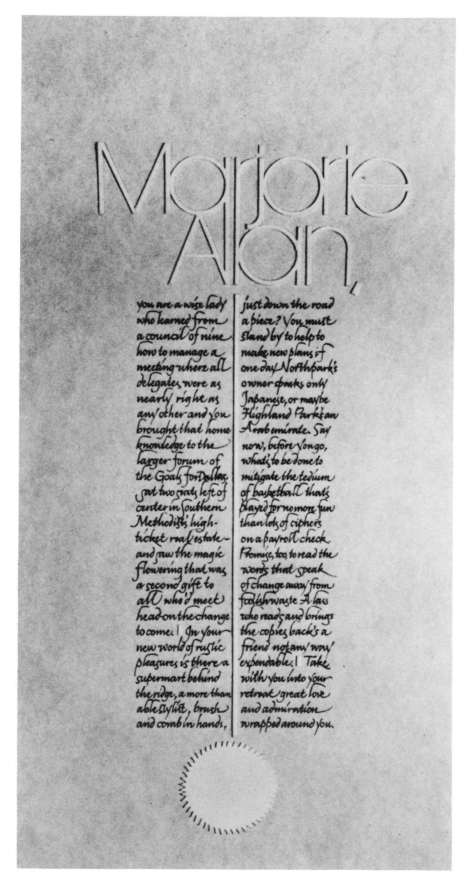

Marjorie Allan
Wall hanging; India ink, paper appliques cut
from 4-ply Strathmore Smooth art paper applied
to #65 Parchtone Cover Natural with compass
and X-acto knives and a C-6 pen. "Marjorie
Allan," center rule, paragraph indications, and
seal are appliques

Julio Vega
New York, New York
U.S.A.

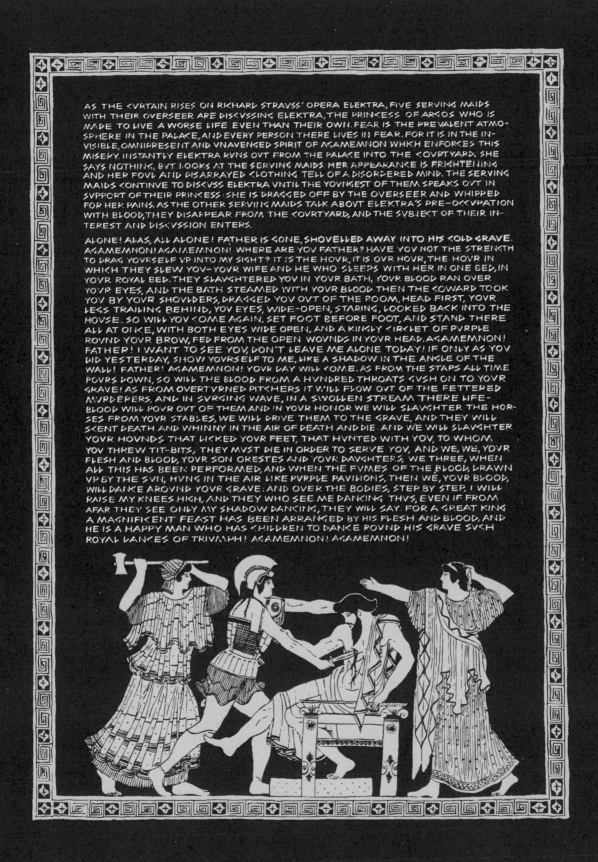

AS THE CVRTAIN RISES ON RICHARD STRAVSS' OPERA ELEKTRA, FIVE SERVING MAIDS WITH THEIR OVERSEER ARE DISCVSSING ELEKTRA, THE PRINCESS OF ARGOS WHO IS MADE TO LIVE A WORSE LIFE EVEN THAN THEIR OWN. FEAR IS THE PREVALENT ATMO-SPHERE IN THE PALACE, AND EVERY PERSON THERE LIVES IN FEAR. FOR IT IS IN THE IN-VISIBLE, OMNIPRESENT AND VNAVENGED SPIRIT OF AGAMEMNON WHICH ENFORCES THIS MISERY. INSTANTLY ELEKTRA RVNS OVT FROM THE PALACE INTO THE COVRTYARD. SHE SAYS NOTHING, BVT LOOKS AT THE SERVING MAIDS. HER APPEARANCE IS FRIGHTENING AND HER FOVL AND DISARRAYED CLOTHING TELL OF A DISORDERED MIND. THE SERVING MAIDS CONTINVE TO DISCVSS ELEKTRA VNTIL THE YOVNGEST OF THEM SPEAKS OVT IN SVPPORT OF THEIR PRINCESS: SHE IS DRAGGED OFF BY THE OVERSEER AND WHIPPED FOR HER PAINS. AS THE OTHER SERVING MAIDS TALK ABOVT ELEKTRA'S PRE-OCCVPATION WITH BLOOD, THEY DISAPPEAR FROM THE COVRTYARD, AND THE SVBJECT OF THEIR IN-TEREST AND DISCVSSION ENTERS.

ALONE! ALAS, ALL ALONE! FATHER IS GONE, SHOVELLED AWAY INTO HIS COLD GRAVE. AGAMEMNON! AGAMEMNON! WHERE ARE YOV FATHER? HAVE YOV NOT THE STRENGTH TO DRAG YOVRSELF VP INTO MY SIGHT? IT IS THE HOVR, IT IS OVR HOVR, THE HOVR IN WHICH THEY SLEW YOV-YOVR WIFE AND HE WHO SLEEPS WITH HER IN ONE BED, IN YOVR ROYAL BED. THEY SLAVGHTERED YOV IN YOVR BATH, YOVR BLOOD RAN OVER YOVR EYES, AND THE BATH STEAMED WITH YOVR BLOOD. THEN THE COWARD TOOK YOV BY YOVR SHOVLDERS, DRAGGED YOV OVT OF THE ROOM, HEAD FIRST, YOVR LEGS TRAILING BEHIND, YOV EYES, WIDE-OPEN, STARING, LOOKED BACK INTO THE HOVSE. SO WILL YOV COME AGAIN, SET FOOT BEFORE FOOT, AND STAND THERE ALL AT ONCE, WITH BOTH EYES WIDE OPEN, AND A KINGLY CIRCLET OF PVRPLE ROVND YOVR BROW, FED FROM THE OPEN WOVNDS IN YOVR HEAD. AGAMEMNON! FATHER! I WANT TO SEE YOV, DON'T LEAVE ME ALONE TODAY! IF ONLY AS YOV DID YESTERDAY, SHOW YOVRSELF TO ME, LIKE A SHADOW IN THE ANGLE OF THE WALL! FATHER! AGAMEMNON! YOVR DAY WILL COME. AS FROM THE STARS ALL TIME POVRS DOWN, SO WILL THE BLOOD FROM A HVNDRED THROATS GVSH ON TO YOVR GRAVE! AS FROM OVERTVRNED PITCHERS IT WILL FLOW OVT OF THE FETTERED MVRDERERS, AND IN SVRGING WAVE, IN A SWOLLEN STREAM THERE LIFE-BLOOD WILL POVR OVT OF THEM AND IN YOVR HONOR WE WILL SLAVGHTER THE HOR-SES FROM YOVR STABLES, WE WILL DRIVE THEM TO THE GRAVE, AND THEY WILL SCENT DEATH AND WHINNY IN THE AIR OF DEATH AND DIE. AND WE WILL SLAVGHTER YOVR HOVNDS THAT LICKED YOVR FEET, THAT HVNTED WITH YOV, TO WHOM YOV THREW TIT-BITS; THEY MVST DIE IN ORDER TO SERVE YOV, AND WE, WE, YOVR FLESH AND BLOOD, YOVR SON ORESTES AND YOVR DAVGHTERS, WE THREE, WHEN ALL THIS HAS BEEN PERFORMED, AND WHEN THE FVMES OF THE BLOOD, DRAWN VP BY THE SVN, HVNG IN THE AIR LIKE PVRPLE PAVILIONS, THEN WE, YOVR BLOOD, WILL DANCE AROVND YOVR GRAVE: AND OVER THE BODIES, STEP BY STEP, I WILL RAISE MY KNEES HIGH, AND THEY WHO SEE ME DANCING THVS, EVEN IF FROM AFAR THEY SEE ONLY MY SHADOW DANCING, THEY WILL SAY: FOR A GREAT KING A MAGNIFICENT FEAST HAS BEEN ARRANGED BY HIS FLESH AND BLOOD, AND HE IS A HAPPY MAN WHO HAS CHILDREN TO DANCE ROVND HIS GRAVE SVCH ROYAL DANCES OF TRIVMPH! AGAMEMNON! AGAMEMNON!

Elektra
Personal project; written with gouache on
Canson paper with crow quill
14 × 17 in. (35.56 × 43.18 cm)

Ahmed Moustafa
London
England

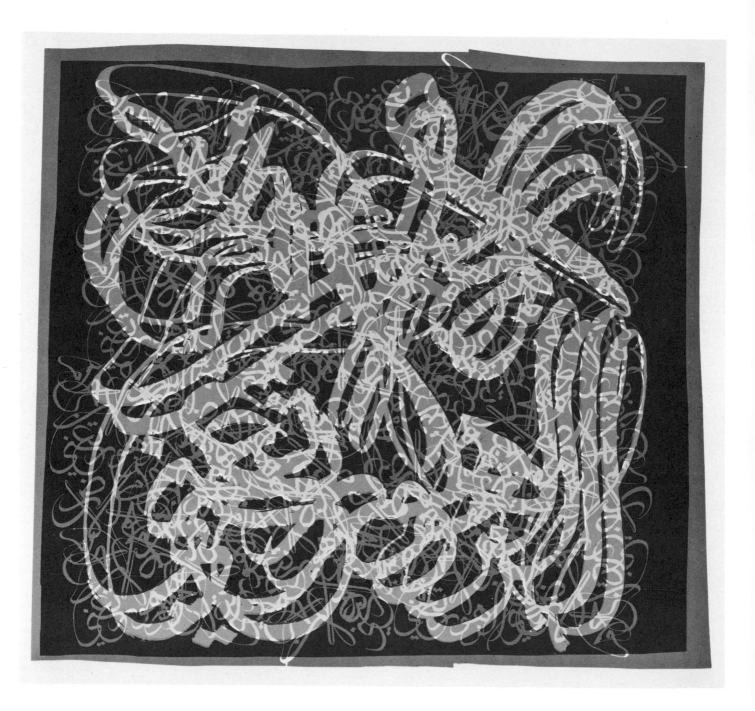

The Flowers Sing the Dreams of the Earth
Silk scarf and printed piece; written with brushes
and reed pen on handmade paper; silk-screen
printed
156 31 x 28.31 in. (78.74 x 71.91 cm)

Jerry Kelly
Jamaica, New York
U.S.A.

XLIX

Se voi poteste per turbati segni,

per chinar gli occhi o per piegar la testa,

o per esser piu d'altra al fuggir presta,

torcendo 'l viso a' preghi onesti e degni,

uscir gia mai, o ver per altri ingegni,

del petto ove dal primo lauro innesta

Amor piu rami; i' direi ben che questa

fosse giusta cagione a' vostri sdegni;

che gentil pianta in arido terreno

par che si disconvenga, e pero lieta

naturalmente quindi si diparte.

Ma poi vostro destino a voi pur vieta

l'essere altrove, provedete almeno

di non star sempre in odiosa parte.

Francesco Petrarca

Petrarca: Sonnet XLIX
Experimental; written with Higgins ink on Hayle
paper with 5½ nib Mitchell pens
12.25 × 16 in. (31.11 × 40.64 cm)

Lawrence V. Mikol
Lisle, Illinois
U.S.A.

No serious
Calligrapher
can overlook
the hand-written book.
Only there will
he find
all the questions
and only there can he prove his art.

RUDOLF KOCH

Quotation by Rudolf Koch
Experimental; written in ink and watercolor on
Strathmore buff paper with chisel-edge dip pen
14 × 14 in. (35.56 × 35.56 cm)

Karina Meister
Amsterdam
Netherlands

Puppenspieler Der alte Puppenspieler ist tot, riefen die Puppen in ihrem windigen Häuschen auf dem Pincio, die Königin, der Präsident, die Blumenkinder, der Hanswurst und das Kokodrill. Endlich können wir uns bewegen, wie wir wollen, wir zappeln nicht mehr an seinen Drähten, seine Finger stecken nicht mehr in unseren Armen, Daumen und kleiner Finger und sein Mittelfinger in unserem Kopf. Die Stücke, die wir spielen, sind nicht mehr seine Erfindung, sie fangen nicht mehr an, wenn er den Vorhang aufzieht und endet nicht mehr, wenn er ihn herunter läßt. Er kann uns, wenn wir ausgedient haben, nicht mehr in die Mülltonne tun, wir sind nicht mehr seine Kreaturen, auch nicht seine lieben Kinder, er hat keinerlei Macht mehr über uns, er ist tot. Damit schickten die Puppen sich an, ihr erstes Stück zu spielen, das 'Das Begräbnis des Puppenspielers' hieß. Sie gingen hinter der schäbigen Kiste her, der sie von Zeit zu Zeit kräftige Fußtritte versetzten. Dazu sangen sie Spottlieder und weinten heulerische Tränen, die keines besser zustande brachte als das Kokodrill. Dieses Stück gefiel den Puppen so gut, daß sie es un aufhörlich wiederholten. Den Zuschauern gefiel es auch, aber mit der Zeit wurden sie unruhig, Sie hätten gern auch einmal etwas anderes gesehn. M. L Kaschnitz

Puppenspiele
Wall hanging; blue and brown ink on Fabriano
Ingres paper with broad-edged pen
21.85 × 19.88 in. (55.5 × 50 cm)

159

Karen Kocon-Gowan
Cambridge, Massachusetts
U.S.A.

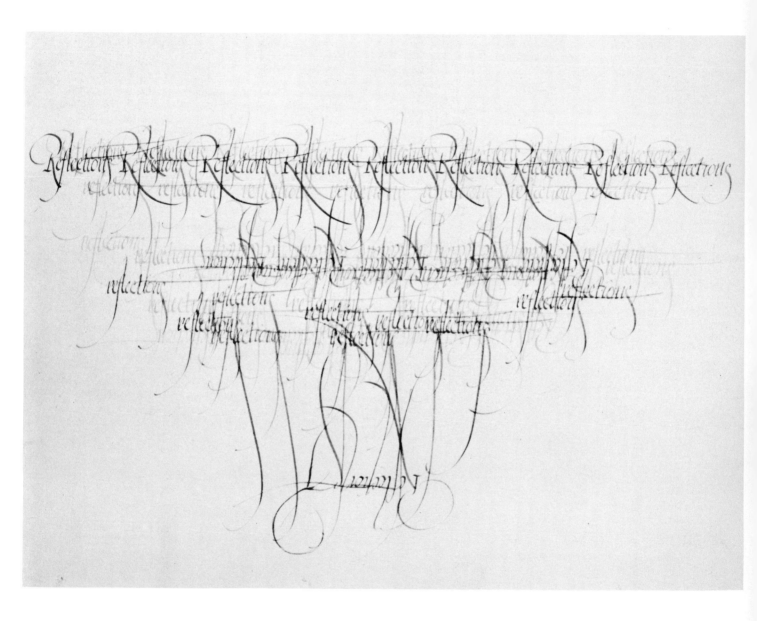

Reflections
Experimental; written in ink on Rives paper
with steel pen

25.5 × 19.38 in. (64.77 × 49.23 cm)

Martin Wilke
Berlin
West Germany

Man sagt sich oft im Leben, daß man die Vielgeschäftigkeit (πολυπραγμοσύνη) vermeiden, besonders, je älter man wird, sich desto weniger in ein neues Geschäft einlassen solle.

Aber man hat gut reden, gut sich und Anderen rathen. Älter werden heißt selbst ein neues Geschäft antreten, alle Verhältnisse verändern sich, und man muß entweder zu handeln ganz aufhören, oder mit Willen und Bewußtseyn das neue Rollenfach übernehmen.

Johann Wolfgang von Goethe

Untitled
Experimental; written on paper with a broad
nibbed pen
24.5 x 18.63 in. (62.23 x 47.31 cm)

161

Heinz Renz
Stuttgart
West Germany

Die Mattäus Passion
Experimental logo; written on white textured
board using a pen and white watercolor and
India ink with the watercolor washed away
(negative wash script)

14.5 × 11 in. (36.83 × 27.94 cm)

Henri Friedlaender
Motza Illit near Jerusalem
Israel

DE GEEST IS HET/
DIE DE EDELE EN
GOEDE MENSCHEN
SAMENHOUDT/ —

EN GEEN TIJD KAN
HEM VERNIETIGEN·

BEETHOVEN

Quotation from Beethoven
Broadsheet, later reduced and used as
illustration on exhibition invitation; written with
India ink and gouache on paper with a pen
ca. 15.75 × 13 in. (ca. 40.01 × 33.02 cm)

Claude Dieterich
Lima
Peru

Gutiérrez de Cossío y Díaz de la Redonda..."

"...Doña Rosa était la fille du neveu du premier Comte Pedro Gutiérrez de Cossío y Gómez de la Madrid et de Doña María Fernández de Celis..."

"...Cette dame avait été mariée en premieres noces a Don Jerónimo de Angulo, de qui elle eut une fille Doña María del Carmen, laquelle épousa Don Manuel Albo y Cabada, et en secondes noces elle eut une autre fille, Doña Teresa Abarca y Gutiérrez de Cossío... de son mariage avec Don Lucas de Cortázar naquit le dernier Comte Don Isidro Cortázar y Gutiérrez de Cossío qui épousa Micaela de la Puente y Querejazu, membre de l'une des plus nobles familles de Lima, fille du cinquieme Marquis de Villafuerte Avec eux le titre s'éteint, mais la proprieté conserve jusqu'à nos jours le nom des Comtes de San Isidro..."

José Galvez 1923

Et deux cents ans plus tard, les portes de cette belle demeure sont réouvertes pour notre plaisir.

"...The hacienda San Isidro is located close to the large indian village called Huadca..."

"...Documents show that the Cacique (Chief) of this region was Puglia Caxa, later baptized Martín ..."When the lands were first distributed, this area was awarded to the very noble Señor Don Nicolas de Rivera... who was later to become the first mayor of Lima, the original plans of which were drawn up by him...

"...An old plan of the Hacienda shows that it was known by the name of its former Owners Señor Tomás de Zumarán and Señor Antonio del Villar, before being named San Isidro after the title of Count Don Isidro Abarca, who purchased the Hacienda from Villar in 1777..."Abarca was married to Rosa Gutierrez de Cossío, the third Countess, the first Count was Don Isidro Gutierrez de Cossío y Díaz de la Redonda..."

"...The Señora Rosa had been married previously to Don Jerónimo de Angulo by whom she had a daughter, Doña María del Cármen, she married Don Manuel de Albo y Cabada. By her subsequent marriage she had another daughter, Doña Teresa Abarca Gutiérrez de Cossío

Los Condes de San Isidro (Menu)
Menu for a restaurant; printed in offset; original written in red and black ink on drawing board with a fountain pen
164 5.91 × 16.93 in. (15 × 43 cm)

Carla Borea
New York, New York
U.S.A.

I OPENED MY MOUTH TO MY SOUL THAT I
MIGHT ANSWER WHAT IT HAD SAID:

TO WHOM CAN I SPEAK TODAY?
BROTHERS ARE EVIL
AND THE FRIENDS OF TODAY ARE UNLOVABLE

TO WHOM CAN I SPEAK TODAY?
MEN ARE CONTENTED WITH EVIL
AND GOODNESS IS NEGLECTED EVERYWHERE

TO WHOM CAN I SPEAK TODAY?
HEARTS ARE RAPACIOUS
AND EVERYONE TAKES HIS NEIGHBOR'S GOODS

TO WHOM CAN I SPEAK TODAY?
GENTLENESS HAS PERISHED
AND VIOLENCE IS COME UPON ALL MEN

TO WHOM CAN I SPEAK TODAY?
FACES ARE AVERTED
AND EVERY MAN LOOKS ASKANCE AT HIS BRETHREN

The Man Who Was Tired of Life . . .
(ancient Egyptian text)
Self-assigned project; written in red and grey
gouache on Bodleian Cream handmade paper
with broad-edged steel pen
7.63 × 12.25 in. (19.37 × 31.11 cm)

Dorothy Dehn
Portland, Oregon
U.S.A.

The Western American Branch/Society for Italic Handwriting and the Reed College Alumni Association proudly present⟶

A juried exhibit of work by N. American calligraphers

LETTERS:

DEHN

A MANY SIDED LOVE AFFAIR

May 25 through June 20, 1979 F.O.B. Lounge, Reed College

Gallery hours: 9:00 A.M. to 5:00 P.M., Monday through Friday
The gallery will also be open on Saturday & Sunday, June 2 & 3.
RECEPTION for the artists - Friday, May 25, 7 to 9:30 P.M.

Letters
Poster; photo-offset reproduction with red ink
on gold-colored paper; original written with
pen and ink
11 × 15.5 in. (27.94 × 39.37 cm)

Gottfried Pott
Wiesbaden
West Germany

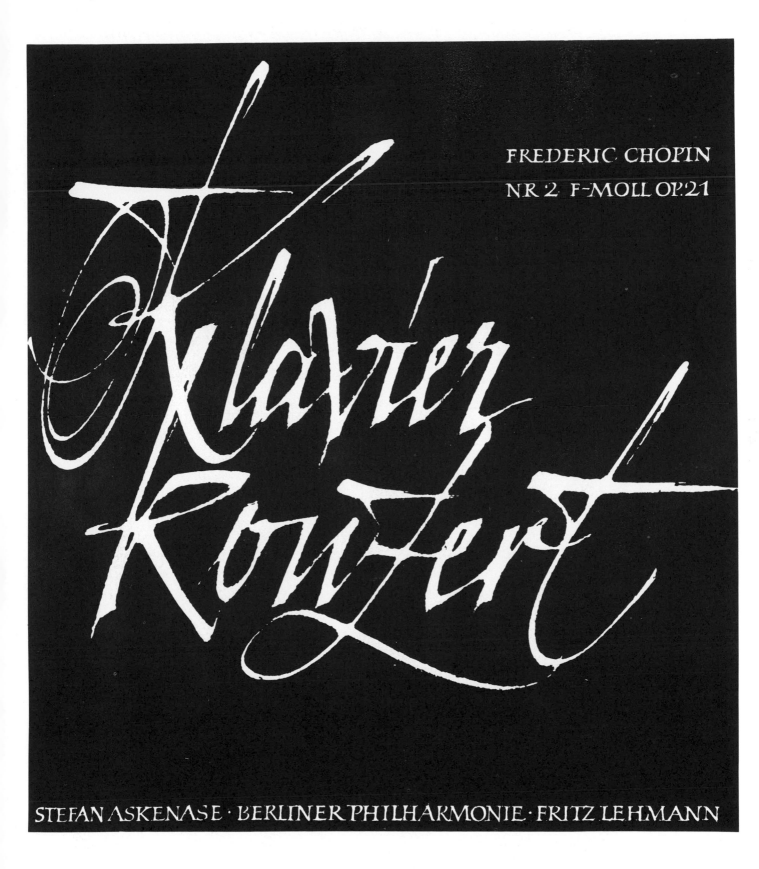

Klavier Konzert

Frederic Chopin
Nr 2 F-Moll Op. 21

Klavier Konzert

Stefan Askenase · Berliner Philharmonie · Fritz Lehmann

Klavier Konzert
Layout/cover design; written on handmade
paper with a pen
11.81 × 11.81 in. (30 × 30 cm)

Michael Podesta
Carrollton, Virginia
U.S.A.

✦ hath laid on Him the iniquity of us all.

All we like sheep have gone astray · we have turned everyone to his own way. and the Lord

Isaiah (Staff)
Picture; ink on Coronado Bristol paper with
Platignum Italic pen
9 × 12 in. (22.86 × 30.48 cm)

Hermann Kilian
Frankfurt
West Germany

Je grösser die Liebe

Darum leidet der Mensch an der Wert- und Sinnlosigkeit seines Lebens? Eigentlich nur, weil er der Liebe nicht fähig ist. Wer es vermag, einen Menschen ganz und ohne innere Zurückhaltung zu lieben, der hat dieses Leiden überwunden, denn eben in dieser Liebe hat er den Wert und Sinn seines Lebens gerettet. In der Liebe erschliesst sich das Ich im Menschen seinem Du.

Ferdinand Ebner

Je mehr der Mensch schenkt, um so grösser und stärker wird sein Herz. Wenn man Geld fortgibt, wird es weniger, wenn man mit einem Licht ein anderes anzündet, so bleibt die Flamme immer die gleiche, wieviel Kerzen man damit auch anzündet — wenn man Liebe verschenkt, dann wird die Liebe immer grösser, je mehr davon verschenkt wird. Darum ist alles Geben auch eine Gabe für den, der gibt.

Friedrich Wilhelm Foerster

Je grösser die Liebe
Book; handwritten with metal-feather; offset
printed
4.06 × 6 in. (10.32 × 15.24 cm)

Marsha Brady
Los Alamitos, California
U.S.A.

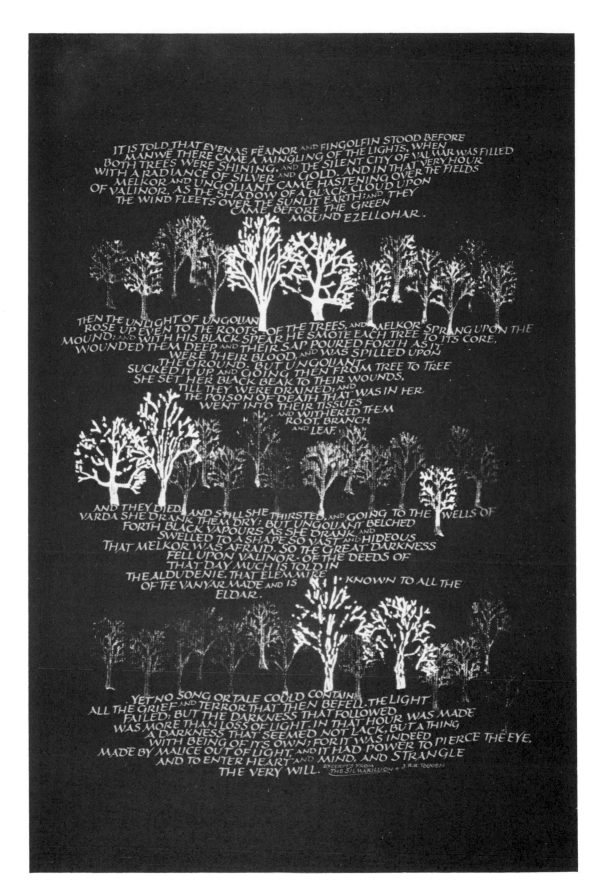

Excerpts from "The Silmarillion"
Exhibition piece; written in gouache, gold and
white gold leaf, and gold shell on black
Strathmore Charcoal paper with Brause nibs

18 × 24 in. (45.72 × 61.96 cm)

Elizabeth Anderson
Portland, Oregon
U.S.A.

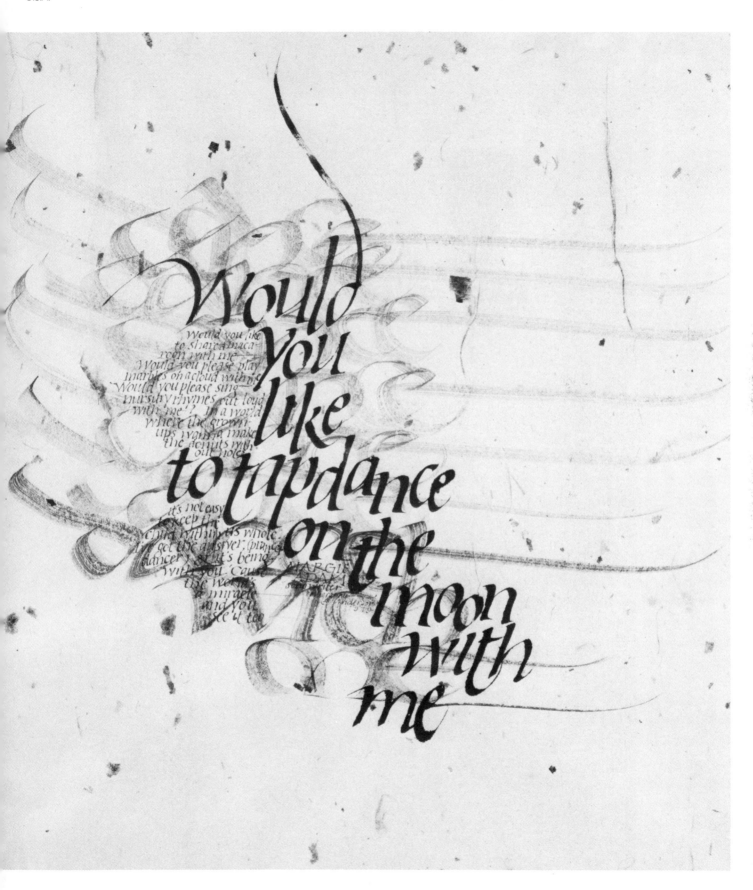

Tap Dance
Wall hanging; written in gouache, tempera, and
ink on Chiri (Japanese handmade paper) with
an edged brush and steel pens
24 × 26 in. (60.96 × 66.04 cm)

John Weber
Northfield, Illinois
U.S.A.

Mountains!
I whip my swift horse, glued to my saddle.
I turn my head startled,
The sky is three foot three above me!

山
快马加鞭未下鞍
惊回首
离天三尺三

Mountains!
Like great waves surging in a crashing sea,
Like a thousand stallions
In full gallop in the heat of battle.

山
倒海翻江卷巨澜
奔腾急
万马战犹酣

Mountains!
Piercing the blue of heaven, your barbs unblunted!
The skies would fall
But for your strength supporting

山
刺破青天锷未残
天欲堕
赖以拄其间

STA Memento to Chinese Artists
Memento given to Chinese artists on the Society
of Typographic Arts' visit to China; original
written in black India ink and wash on Xerox
paper with a C-series Speedball pen point;
printed on 24-lb Becket laid paper

15.5 × 22 in. (39.37 × 55.88 cm)

Kris Holmes
Cambridge, Massachusetts
U.S.A.

NO.M VOLGR'AVER PER BERNARD NA BERNARDA
I'M GLAD I WASN'T CALLED BERNARDA FOR BERNART,
E PER N'ARNAUT N'ARNAUDA APPELLADA,
AND THAT I WASN'T NAMED ARNAUDA FOR ARNAUT:
I GRANS MERCES, SEIGNER, CAR VOS AGRADA
BUT MANY THANKS, LORD, SINCE IT GIVES YOU PLEASURE
C'AB TALS DOAS DOMNAS M'AVES NOMMADA.
TO NAME ME SIDE BY SIDE WITH TWO SUCH LADIES.

VOIL QE'M DIGAZ
I WANT TO KNOW
CALS MAIS VOS PLAZ
YOUR TRUE OPINION:
SES CUBERTA SELADA
WHICH ONE YOU PREFER, AND WHAT'S
E.L MIRAIL ON MIRATZ,
THE MIRROR WHERE YOU STARE.

CAR LO MIRAILZ E NO VESER DESCORDA
FOR THE MIRROR WITH NO IMAGE SO DISRUPTS
TAN MON ACORD C'AB PAUC NO.L DESACORDA
MY RHYME THAT IT ALMOST INTERRUPTS IT;
MAS CAN RECORD SO QU'L MEUS NOMS RECORDA,
BUT THEN WHEN I REMEMBER WHAT MY NAME RECORDS,
EN BON ACORD TOTZ MONS PENSARS S'ACORDA.
ALL MY THOUGHTS UNITE IN ONE ACCORD.

MAS DEL COR PES
BUT I WONDER
ON L'AVES MES,
WHERE YOUR HEART IS,
QUE SA MAISO NI BORDA
FOR ITS HOUSE AND HEARTH
NO VEL, QUE LAS TAISES.
ARE HID, AND YOU WON'T TELL.

LOMBARDA, BORN C. 1190
TRANSLATED BY MEG BOGIN

Lombarda's "Tenson"
One piece of a series for an exhibition of oral
literature narrated by women; written in
gouache on Bodleian handmade paper
with a pen
18 x 24 in. (60.96 x 45.72 cm)

Ivan Boldizar
Novi Sad
Yugoslavia

Sterijino pozorje
Četvrtak, 17. aprila 1980. u 11 časova
Otvaranje izložbe
6. međunarodni trijenale
Pozorište u fotografskoj umetnosti
Izložbene prostorije Kino-kluba „Branko Bajić"
Novi Sad, Narodnih heroja 12.

~·~

Sterijino pozorje
i Galerija jugoslovenskog portreta u Tuzli
Četvrtak, 17. aprila 1980. u 12 časova
Otvaranje izložbe
Jugoslovenski pozorišni portret 1945-1980.
Izložbene prostorije Galerije Matice srpske
Novi Sad, Trg proleterskih brigada 2.

~·~

Matica srpska i Sterijino pozorje
Četvrtak, 17. aprila 1980. u 12,30 časova
Otvaranje izložbe
Antički teatar na tlu Jugoslavije
Izložbene prostorije Galerije Matice srpske
Novi Sad, Trg proleterskih brigada 2.

Sterjino Pozorje/Yugoslav Theatre Festival
Invitation; printed in brown and orange on
paper; original writing done with steel pen
174 8.26 × 11.81 in. (21 × 30 cm)

Czeslaw Borowczyk
Warsaw
Poland

Główny Komitet Kultury Fizycznej i Turystyki

1867
1967

100-lecie Sportu Polskiego

KARTA UCZESTNICTWA

OBYWATEL

jest Uczestnikiem
Uroczystego Posiedzenia Plenarnego
Głównego Komitetu Kultury Fizycznej
i Turystyki
odbywającego się z okazji
100-lecia Sportu Polskiego

Warszawa, dnia 7. lutego 1967

Przewodniczący
Głównego Komitetu Kultury
Fizycznej i Turystyki

WŁODZIMIERZ RECZEK

Introdruk 49-1.67-500-1.20

100 Lecie Sportu Polskiego
Certificate; written with pen on paper
with paper seal
8.88 × 12.63 in. (22.54 × 32.07 cm)

Jovica Veljović
Suvi Do
Yugoslavia

But in the *Art* of Calligraphy

AS IN ALL ARTS THE IDEA IN THE MIND IS THE ULTIMATE YARDSTICK BY WHICH WE EVALUATE MERIT IN THE ART·PRODUCT·THE TECHNICAL PRE·REQUISITES·TOOLS MATERIALS AND METHOD OF WORKING·THOUGH NEEDED ARE ALWAYS SUBORDINATE TO THEIR MENTAL EXEMPLAR·TECHNIQUE IS ONLY A MEANS·SKILLFULLY WROUGHT EXPRESSIONS OF INCONSEQUENTIAL IDEAS ARE MORE LIKELY TO AROUSE DISMAY THAN ADMIRATION·POORLY WRITTEN LETTERS SKILLFULLY CHISELLED ARE ALWAYS UGLIER THAN WELL·WRITTEN LETTERS POORLY CUT·SINCE A DEFECT IN THE MEANS IS LESS DAMAGING THAN A DEFECT IN THE MENTAL PATTERN FATHER CATICH

"Art of Calligraphy" by Father Catich
Experimental; written with ink on paper with a
pen and wooden stick

14.13 × 18.88 in. (35.88 × 47.94 cm)

John Woodcock
Kingswood, Tadworth, Surrey
England

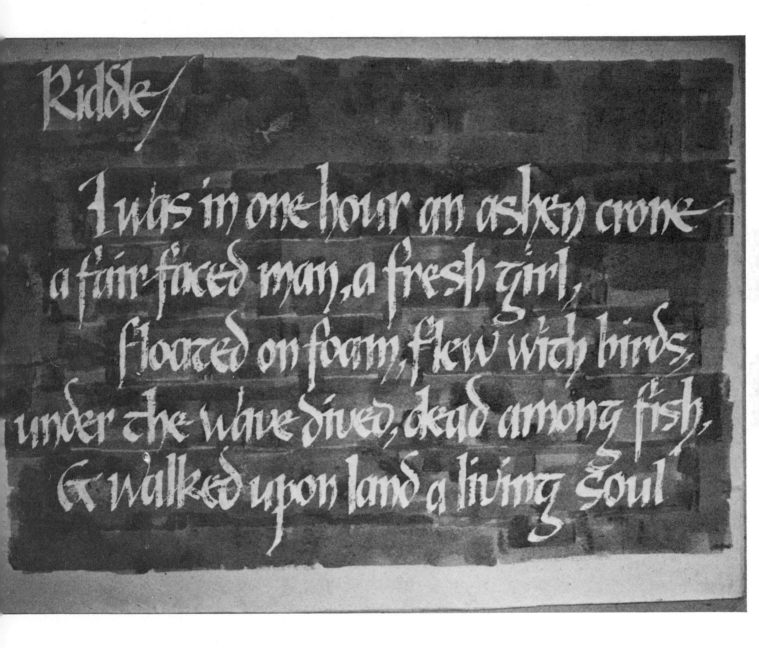

Riddle
Experimental; written in colored inks over resist
on handmade paper with a flat brush
ca. 25 × 20 in. (ca. 63.5 × 50.8 cm)

Philip Grushkin
Englewood, New Jersey
U.S.A.

We would be honored to have you attend
the Bat Mitzvah of our daughter, DENA,
on Friday evening, December 10, 1971, 8:30 p.m.
at Temple Emann-El, 147 Tenafly Road,
Englewood, New Jersey.

An Oneg Shabbat
will be held following the services, to
which you are cordially invited.

Jean and Philip Grushkin

Bat Mitzvah Invitation
Invitation; written in Eternal Black ink on Strath-
more drawing paper with a broad-edged pen

6.25 x 8.88 in. (15.88 x 22.54 cm)

Julian Waters
Gaithersburg, Maryland
U.S.A.

GO
PLACIDLY
AMID
THE
NOISE

AND REMEMBER WHAT PEACE

THERE MAY BE IN SILENCE...

DESIDERATA

Desiderata
Wall piece; written in white gouache on
Japanese paper (dyed purple on one side) with
steel broad-edged pen
7 × 8.5 in. (17.78 × 21.59 cm)

Rick Cusick
Shawnee, Kansas
U.S.A.

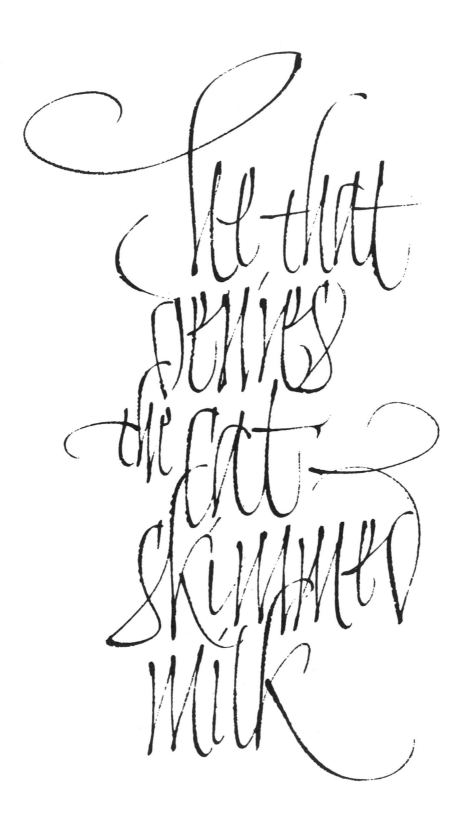

Detail from "Mouse"
From a collection of calligraphed proverbs from
The Proverbial Bestiary (published by TBW
Books); written with a Brause steel pen on
white bond paper with Japan red ink

4.75 x 7.5 in. (12.01 x 19.05 cm)

Leonid Pronenko
Krasnodar
U.S.S.R.

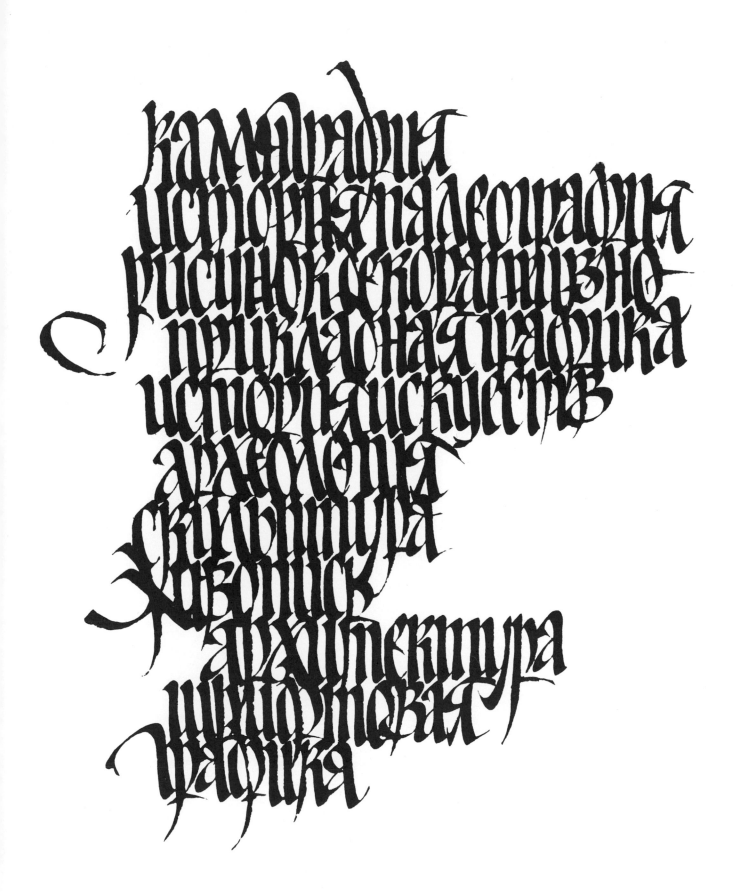

A Composition of the Names of Arts
Experimental; written on paper with a broad
pen
10.5 × 13 in. (26.67 × 33.02 cm)

Donald Jackson
London
England

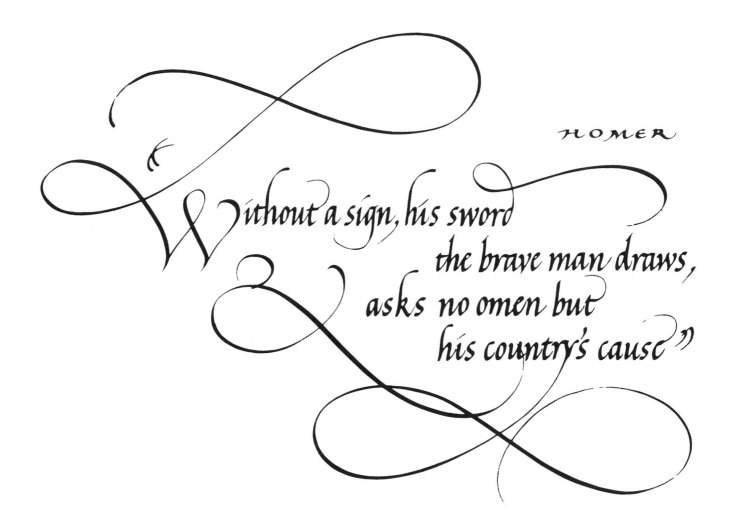

Quotaton by Homer
Experimental; written with gouache on vellum
using a goose quill
6.75 x 4.75 in. (17.15 x 12.07 cm)

Gudrun Zapf von Hesse
Darmstadt
West-Germany

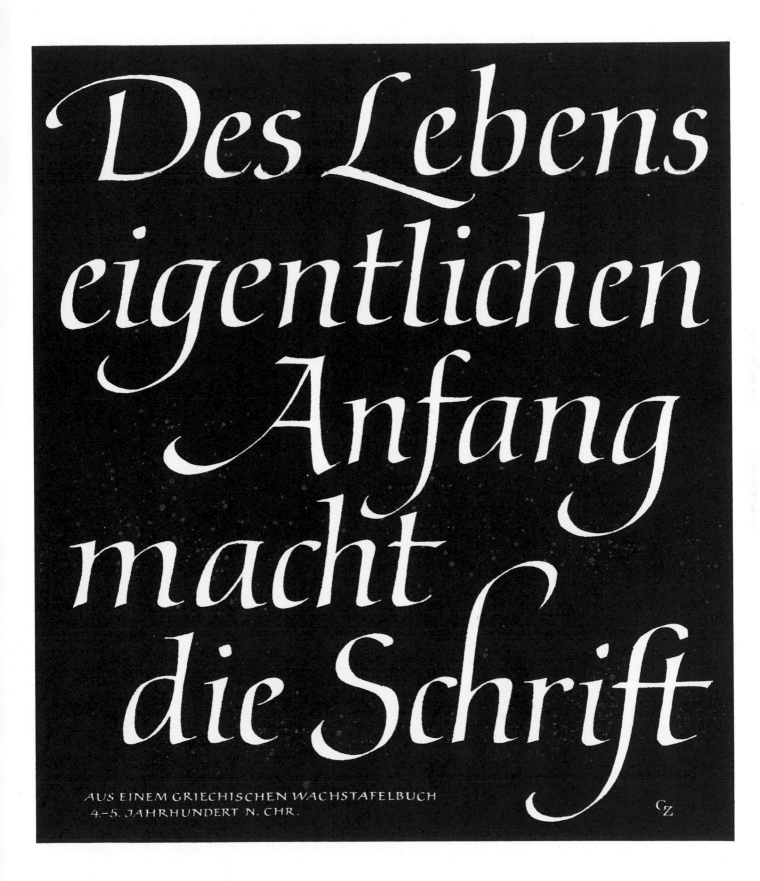

Des Lebens eigentlichen Anfang macht die Schrift (The written word is actually the beginning of life—from Greek writing tablet)
Exhibition poster; written on paper with broad-edged pen
22.83 × 25.96 in. (58 × 66 cm)

George Watson
Coalville, Leicester
England

"The Child Sleeps."

You tread the wide wise silences of sleep
 With most mousefooted wonder. None will know
How smells the breeze, what owl-soft shadows creep,
 Whose language, that you seem to listen so.
You are among your people, your own mind's
 Electric children, and their feet are bells,
No doubt, and all their laughter is the wind's
 Cool April call through woods where Childhood dwells.

Marvelling, I watch and know you are not mine
 Tonight. You are about mysterious things.
Through bright dream-drifting skies your thoughts entwine
 With inch-high banditry on silver wings.
You drive the glittering engines of the stars;
 Rollick with gibbous moons; in your great hours
Flourish a small Excalibur through wars
 Which yield you thrones as meadows yield you flowers.

O may you keep this strength for after years,
 A life apart, a ghost-enchanted land
Where you may holiday from this world's tears
 And hate and greed; and come to understand
Their is a spirit truer to a man
 Than he shows to the city. May your mind
Secretly garner glories, so men may scan
 Your face nor know the richer one behind.

J. P. Fletcher

The Child Sleeps
Page in parish church magazine; ink on paper
with a manuscript pen
184 12 × 18 in. (30.48 × 47.72 cm)

Mona Strassmann
New Canaan, Connecticut
U.S.A.

March 22, 1982

Miss Laurie Burns,
International Typeface Corp.
2 Hammarskjold Plaza
New York, New York 10017

Dear Miss Burns,
Many thanks for your invitation to submit
photos of my work for possible inclusion in your
forthcoming book.
I'm sorry I missed this opportunity but,
again, I'd like to express my thanks. Best wishes
for much success with your book. It's a great idea.

Sincerely,
Mona Strassmann

Personal Correspondence
Letter, written in Pelikan 4000 brown ink on
bond paper using a Gillot Lithographic Pen
#290
7.31 × 10.19 in. (18.57 × 25.88 cm)

BIOGRAPHIES

Alice describes herself as a "graphic designer, letter stylist, calligrapher and free spirit." She studied letter design, calligraphy, and art history at the Brooklyn Museum Art School and is well known for her work at the Pierpont Morgan Library in New York City where she designs and executes all exhibition posters, display lettering, and special calligraphic presentations. Alice teaches calligraphy at the School of Library Service at Columbia University and designs inscriptions for stone cutting and memorial walls and panels for temples, churches, libraries, and museums. When not busy working in New York City, Alice can be found clamming on Long Island.

John S. Allen, born in Belfast, Ireland, now works in New York City. A professional artist specializing in lettering and design, he studied at Pratt Institute and the Art Student's League in New York. He was awarded first prize in the Visual Graphics Bicentennial Typeface Design Competition—Freedom '76. In addition to the exhibition at the ITC Center, his work has appeared at the Pennsylvania Academy of Fine Arts and the Brooklyn Museum in New York City.

Kerstin Anckers' work ranges from Nobel Prize diplomas (she has done 70 in the past twenty years) to book jackets and monograms. She teaches lettering and has been active in developing a curriculum for handwriting education in the Swedish schools. Kerstin Anckers is from Stockholm, Sweden.

Curtis Anderson earned a Bachelor of Fine Arts degree at Cooper Union where he studied with Don Kunz. He is a founding partner of Curzon Studio in New York City.

Elizabeth Anderson, originally from Pocatello, Idaho, is a freelance lettering designer in Portland, Oregon. She has held a number of Artist-in-Residence positions in Portland since 1976 and currently teaches lettering and design at Portland State University. She earned a Bachelor of Arts degree from Whitman College and a Master of Arts in Teaching from Reed College. She has done postgraduate work at the Portland Art Museum, Portland State University, and the Oregon School of Arts and Crafts.

Georgina Artigas was born in Cuba. Before moving to the United States, she taught calligraphy (American Cursive Handwriting) and worked freelance. She later worked in the Scroll Department of Ames & Rollinson in New York City for nine years. Georgina Artigas now lives in Miami, Florida, where she has her own studio, specializing in calligraphy and illumination.

Kay Atkins, a founding member of Letter Arts Newport, earned a Bachelor of Science degree in education from Marylhurst College and a Masters in Calligraphy from Southeastern Massachusetts University, where she later taught calligraphy for three years. She also taught calligraphy for adults at the Swinburne School in Newport, Rhode Island. Born in Seattle, Washington, she currently lives in Middletown, Rhode Island.

Christel Aumann was born in Hildesheim and now lives in Munich, West Germany.

Ed Benguiat, from New York City, was one of the judges for the ITC exhibition "International Calligraphy Today." He holds a Bachelor of Arts degree in music from Brooklyn College and worked as a progressive jazz drummer for many years. He also studied at Columbia University and attended the Workshop School of Advertising Art. He has worked as designer and art director at many of the major advertising agencies and publishing companies in New York City. He is currently Vice President/Creative Director at Photo Lettering, Inc., and Vice President of the International Typeface Corporation. Ed Benguiat is a prolific type designer, with more than 300 typefaces to his credit. He teaches at the School of Visual Arts and lectures at Columbia University. In addition to all this, he still finds time to fly his own private airplane.

Adolf Bernd studied with Rudolf Koch at the Kunstgewerbe Schule in Offenbach, West Germany. He has held various exhibitions, including one in 1974 at the Klingspor Museum. Born in Kaiserslautern, Adolf Bernd now resides in Bad Münder, West Germany.

Raphael Boguslav, originally from Belle Harbor, New York, graduated from Cooper Union where he studied with Paul Standard and George Salter. He now lives in Newport, Rhode Island, where he designs logotypes, packaging, and other printed ephemera. His work has been represented in many one-person and group exhibitions. A participant in Letter Arts Newport '82, he has taught many calligraphy classes.

Ivan Boldizar, from Novi Sad, Yugoslavia, is a freelance graphic artist and graphic arts consultant with over forty years of design experience.

Carla Borea, a freelance calligrapher from New York City, graduated from Cooper Union where she studied with Don Kunz.

Czeslaw Borowczyk is from Warsaw, Poland.

Robert Boyajian worked at J. Walter Thompson Advertising for more than nineteen years. For the last nine years he has been a freelance lettering artist, designer, and calligrapher. Born in Providence, Rhode Island, he now works and lives in New York City.

Lawrence Brady is the head of the Graphic Design Department at Cerritos College where he teaches calligraphy and design. He is also a graphic consultant for Green Tiger Press (San Diego, California). Originally from International Falls, Minnesota, he now resides in Los Alamitos, California.

Marsha Brady, a graphic/design consultant for Green Tiger Press (San Diego, California), also teaches calligraphy at California State University at Long Beach and Cerritos College. She was born in Salida, Colorado, and now lives in Los Alamitos, California.

Chris Brand was born in Utrecht and is now living in Breda, The Netherlands, where he has designed the typefaces Albertina and Draguet Coptic for Monotype Corporation Ltd.

Volkmar Brandt studied with Dr. Albert Kapr at the Hochschule für Grafik in Leipzig, German Democratic Republic.

Stan Brod, a graphic designer with the Cincinnati, Ohio, design office of Lipson Associates, is also a professor of graphic design at the College of Design, Architecture and Art at the University of Cincinnati. His calligraphic prints and paintings are based on Hebrew calligraphy and incorporate the rhythm and pattern of these classic forms.

Walter C. Brzoza, from Schenectady, New York, is a reproduction lettering artist and graphic designer. He was Manager, Art Direction (Advertising) at General Electric for more than forty years.

Hans-Joachim Burgert is a calligrapher, graphic designer, painter, illustrator, sculptor, handpress printer, publisher, and teacher. He studied painting and graphic design at the Hochschule für Bildende Kunste and now teaches at the Technische Fachhochschule. He is from Berlin, West Germany.

Dot Caputi is a former designer for the silver department of Tiffany's (New York City) and has done freelance book illustration for Holt Rinehart & Winston publishers. She taught high school art and currently teaches calligraphy courses and workshops throughout Long Island, New York, in addition to being a freelance calligrapher and graphic artist. Dot Caputi was born in Glen Ridge, New Jersey, and now lives in Centerport, New York.

Crous-Vidal is a type designer and calligrapher from Boulogne-Billancourt, France.

Rick Cusick has been the Publications Designer for Hallmark Cards (Kansas City, Missouri) for eleven years and editorial and design consultant for TBW Books for seven. In addition, he is the proprietor of Nyx Editions. Rick Cusick is a member of the New York Guild of Bookworkers, Typocrafters, the Pacific Center for the Book Arts, and the American Printing History Association. Born in Stockton, California, he now lives in Shawnee, Kansas.

Raymond Franklin DaBoll was born on a farm near Clyde, New York. A graduate of Rochester Institute of Technology, he worked as a commercial artist in Chicago, where he was one of the first to use calligraphy in advertising copy. Also an author and publications designer, Raymond Franklin DaBoll lived in Batesville, Arkansas, at the time of his death in January 1982.

Darlene teaches calligraphy and works as a freelance graphic designer and artist. She is also an accomplished illustrator in the Heroic-Fantasy-Art field and "strives to unite the written work with pictorial themes." Born in Elkhorn, Darlene now lives in Lake Geneva, Wisconsin.

Ismar David is a graphic, book, architectural, and type designer, as well as a teacher and lecturer. His designs are done for printing, metal work, and stone carving. He was born in Breslau, Germany, and now works in New York City.

Sidney Day, originally from London, England, is a Fellow of the Society of Typographic Designers (United Kingdom) and a member of the Designers & Art Directors Association of London. His work has been exhibited in London at the Victoria & Albert Museum, the Crafts Centre, and the "Art & the Sea" exhibition at the ICA gallery. He now lives in Telwyn Wood in Hertfordshire, England.

Dorothy Dehn is a freelance calligrapher and graphic designer in Portland, Oregon. She also teaches calligraphy and typography at Pacific Northwest College of Art in Portland. She is originally from Bremerton, Washington.

Claude Dieterich's background is in graphic design, typography, and lettering illustration. Originally from Colmar, France, he now resides in Lima, Peru, where he is a freelance designer and calligrapher. He is a former instructor of graphic design and calligraphy at Catholic University in Lima.

Sandra Kay Dixon has been working as a

package designer for the Container Corporation of America for the last twelve years. She earned a Bachelor of Fine Arts degree from Ohio University. Born in Painesville, Ohio, she lives in Mayfield Heights, Ohio, and is a member of the Western Reserve Calligraphers.

Fritz Eberhardt was born in Beuthen, Silesia. He now lives in Harleysville, Pennsylvania, where his work alternates between lettering for bookbinding and pure calligraphy. He believes that "Disciplined exercises in calligraphy develop a smarter perception of all elements of graphic design."

Kevin Elston has worked as a graphic and environmental designer. He lives in Oakland, California, and is on the faculty of the California College of Arts and Crafts where he teaches calligraphy and design.

Jean Evans is a scientific draftsperson, calligrapher, and former coach and world class tennis player. Her calligraphic training, which has taken her around the world, followed her degree in art, which she earned from Queens College in North Carolina. Originally from Greenville, North Carolina, Jean Evans now lives and works in Cambridge, Massachusetts.

Gail M. Everett studied graphic design and calligraphy in Brighton, England. She has worked in an advertising agency and is currently Assistant Art Director of Penthouse Publications. Her work has been exhibited in Japan, Israel, and the United States. Gail Everett was born in Taunton and now lives in Devon, England.

Hal Fiedler is a freelance calligrapher, alphabet designer, and lettering artist from New York City.

Jenny Rose Folsom has been a professional calligrapher since 1974. She is the editor of *Scripsit* magazine, a publication of the Washington Calligraphers Guild, and was a contributor to *Calligraphy Today*, by Heather Child. Born in Madison, Wisconsin, she now lives in Washington, D.C.

Paul Freeman was a painter, sculptor, and calligrapher. Founder of the Society of Scribes in New York, he gave demonstrations and lectured throughout the United States. He was born in New York City where he lived at the time of his death in 1980.

Henri Friedlaender is a lettering and typographic artist. He was born in Lyon, France, and now lives in Motza Illit near Jerusalem, Israel.

Toshio Fukuyama, originally from Fukuoka, Japan, and now living in Muko-

City, is a graphic designer and calligrapher who hopes "to add a modern feeling to traditional Japanese calligraphy."

Jim Gemmill, from Salt Lake City, Utah, earned his Bachelor of Fine Arts Degree from the University of Utah, where he majored in painting/drawing and minored in art history. He is currently studying toward a Master of Fine Arts degree at Boston University, again specializing in painting/drawing. Jim Gemmill has studied calligraphy at seminars in the United States and England and has taught drawing, painting, calligraphy, and sumi-e in Boston, Massachusetts, and Salt Lake City. His work has appeared in one-person and group shows throughout the United States.

Barbara Getty, from Portland, Oregon, is co-author (with Inga Dubay) of the *Italic Handwriting Series,* eight manuals (including an instructional guide) for students in kindergarten through sixth grade. This series is being used in public and private schools in California, Idaho, Oregon, and Washington. She has led adult workshops in italic handwriting, calligraphy, and bookbinding. Barbara Getty earned her Bachelor of Arts and Master of Arts in Teaching degrees from Lewis and Clark College in Portland.

Tim Girvin, from Seattle, Washington, is the owner of a Seattle-based design office currently working on projects throughout the United States, Canada, and Great Britain.

Philip Grushkin, one of the jurors for the ITC exhibition "International Calligraphy Today," is a freelance book designer, book production consultant, and calligrapher. A graduate of Cooper Union, he was a former Vice-President and Art Director at Harry N. Abrams, Inc., Publishers. He has lectured widely; taught calligraphy, lettering, and graphic design at Cooper Union for more than twenty years; directed the Book Design Workshop of the Radcliffe Publishing Procedures course at Harvard University; and taught book design at New York University. Born in New York City, Phil Grushkin now lives in Englewood, New Jersey, where most of his home is now a well-equipped, Rube Goldbergesque studio containing a photography lab and a two-letterpress print shop.

Kazuo Hashimoto was born in Osaka, Japan. He now lives in Tokyo where he is a typeface designer.

Karlgeorg Hoefer is a calligrapher, type designer, graphic designer, and teacher from Offenbach, West Germany. Well known for his skilled brush-work, he has designed typefaces for the Klinspor, D. Stempel AG, and Ludwig & Meyer foundries. He is developing a new handwriting system to be taught in elementary schools in Germany. He studied calligraphy, typography, and book design at the School of Arts and Crafts and taught calligraphy at the Hochschule für Gestaltung.

Lothar Hoffmann is a graphic designer with Skidmore-Sahratian Inc. in Troy, Michigan. He is an Associate Professor at the Center for Creative Studies in Detroit, Michigan, where he teaches advanced design, environmental graphics, calligraphy, and typography. Lothar Hoffmann was born in Penzig, Germany, and now lives in Harper Woods, Michigan.

Victoria Hoke, originally from Cleveland, Ohio, now lives in Oakland, California, where she owns a calligraphy studio, Calligraphos, and teaches lettering and design.

Kris Holmes is a typeface designer with the Cambridge, Massachusetts, design studio Bigelow & Holmes. She studied calligraphy with Robert Palladino and Lloyd Reynolds at Reed College in Portland, Oregon. Kris Holmes was born in California.

Lorenzo Homar was a jewelry designer at Cartier, New York for ten years. Since then he has worked as a book designer, poster painter, easel painter, calligrapher, and lettering artist. As a printmaker, he has worked in intaglio, woodcut/wood engraving, and silk screen. Lorenzo Homar was born in Puerta de Tierra (San Juan) and now lives in Rio Piedras, Puerto Rico.

Otto Hurm is the head of the Institut für ornamentale Schrift und Heraldik (Institute for Decorative Type and Heraldic Art) at the Akademie der Bildenden Kunste in Vienna, Austria. He holds a Doctorate in engineering. His design work includes diplomas, inscriptions, book jackets, handwritten and illustrated books, ex libris, and stained glass. Otto Hurm is from Vienna, Austria.

Thomas Ingmire earned a Bachelor of Arts degree from Ohio State University and a Master of Arts degree from the University of California at Berkeley—both in landscape architecture. Born in Fort Wayne, Indiana, he now lives in San Francisco, California, where he teaches calligraphy and works as a noncommercial calligrapher.

Donald Jackson, a graduate of Bolton College of Art, started lecturing at the age of twenty at Camberwell College. He began teaching calligraphy courses and workshops in the United States in 1969. Since 1964 he has been Scribe to Her Majesty's Crown Office at the House of Lords. Born in Lancashire, England, Donald Jackson now resides in London where he enjoys "the forming of words with my own hands and tools—as an end in itself."

R. K. Joshi completed research on calligraphic analysis of the Devanagari Manuscript at the Royal Asiatic Society Bombay. Born in Sangli, in western India, R. K. Joshi now lives in Bombay where he teaches Indian calligraphy and is working on multilingual computer graphics.

Teri Kahan owns a commercial calligraphy studio, Graphique, in Newport Beach, California. In college she majored in art, but she is basically a self-taught calligrapher, taking workshops offered by the Society for Calligraphy and advanced courses with Los Angeles area professional calligraphers. She is currently the coordinator of the Orange County Society for Calligraphy. She teaches calligraphy at area colleges as well as from her studio. Teri Kahan is originally from Seattle, Washington.

Osamu Kataoka is a graphic designer from Tokyo, Japan.

Jerry Kelly is a typographer for A. Colish, Inc., Mount Vernon, New York, and previously worked as a calligrapher for Malcolm & Hayes, New York City. A partner of Kelly/Winterton Press in Queens, New York, he has studied calligraphy with Denis Lund, Don Kunz, and Hermann Zapf and taught at the Queens College Student Union and at the South Street Seaport Museum. Jerry Kelly lives in New York City.

Hermann Kilian was born in Weisbaden, West Germany. He now lives in Frankfurt where he works in the calligraphic and typographic fields.

Stanley R. Knight lives in Solihull, United Kingdom, where he teaches graphics and freelances in calligraphy, lettering, and typography. He is currently chairman of the Society of Scribes and Illuminators in London. His work has been published in *Modern Scribes and Lettering Artists* and appeared in the "Art of the Scribe" exhibition held in London, Birmingham, and Doncaster in 1981. Stanley Knight is originally from Birkenhead, United Kingdom.

Karen Kocon-Gowan teaches jewelry design, ceramics, crafts, and calligraphy at Andover High School in Andover, Massachusetts. She also teaches calligraphy in the evening program at the Massachusetts College of Art. She earned a Bachelor of

Arts degree from Purdue University and a Master of Science degree at the Illinois Institute of Technology.

Rachid M. Koraichi was born in Aïn-Beida, Algeria. The designer now lives in La Marsa, Tunisia.

Wieslaw Kosinski is a graphic designer specializing in books, posters, and illustration. He has worked in Warsaw, Poland; Leipzig, German Democratic Republic; and Los Angeles, California. Wieslaw Kosinski was born in Lodz, Poland, and now lives in Warsaw.

Lubomir Kratky is from Bratislava, Czechoslovakia, where he works in graphic design and book typography.

Eva Ursula Lange, from Niederkaina/Bautzen, German Democratic Republic, has worked in the book arts, interior decoration, ceramics, and calligraphy. She is currently chairwoman of the Sorbish Artists Circle in the Association of Formative Artists (German Democratic Republic).

Gun Larson specializes in designing book jackets, wine labels, and catalog covers, the last of which she has done for the past eleven years for BOR 201 and Pantheon Books. Born in Västerås, Sweden, she now lives in Klagstorp and spends part of each year working in New York City.

Olivia L. Lin is a designer and photographer from Taiwan, Taipei, Republic of China.

Alfred Linz is professor of graphic design at the Fachhochschule Nürnberg and the Academy of Arts Nürnberg. A graphic designer, he does lettering, calligraphy, posters, logos, and book jacket design in addition to teaching. Alfred Linz was born in Nürnberg, West Germany.

Herb Lubalin served on the jury for the ITC exhibition "International Calligraphy Today." He graduated from Cooper Union, New York City, where he later taught graphic design and typography. In 1965 he received its prestigious Augustus St. Gaudens medal for professional achievement in the field of art and in 1980 was given their Alumnus of the Year award. During his career as a graphic designer he received more than 500 awards of excellence from design organizations around the world. In 1977 he was elected to the Art Directors Club Hall of Fame and in 1980 was awarded the American Institute of Graphic Arts (AIGA) Medal. He was president of his own design firm, Herb Lubalin Associates, Inc., and Executive Vice President of Lubalin, Burns & Co., Inc. and International Typeface Corporation. He was also the Editor and Design Director of *U&lc: The International Journal of Typographics.* Herb Lubalin was born in New York City, where he lived at the time of his death in May 1981.

Denis Paul Lund was born in Plentywood, Montana, and now lives in New York City where he is an Adjunct Lecturer at the City University of New York at Queens College and City College campuses. He also teaches at the New School for Social Research.

Karina Meister worked for several years as a book designer. She now teaches and is a freelance calligrapher and book designer. Born in Salzburg, Austria, she lives in Amsterdam, the Netherlands.

Lawrence V. Mikol is a graphic designer and freelance calligrapher. Born in Chicago, he now lives in Lisle, Illinois.

Ahmed Moustafa was born in Alexandria, Egypt. He has done special advanced studies in printmaking using Arabic script as an expressive medium and conducted Ph.D. research on "The Scientific Foundation of Arabic Letterforms." Ahmed Moustafa currently resides in London, England.

Maury Nemoy is a calligrapher, graphic designer, and art director from North Hollywood, California. Currently freelance, he formerly worked for Capitol and Warner Brothers Records and Columbia Pictures where he created main title sequences for motion pictures and television. He taught calligraphy, lettering, and typography at UCLA (University of California at Los Angeles) for twenty-three years. Maury Nemoy was born in Chicago, Illinois.

Friedrich Neugebauer has been teaching type, graphic, and book design at the Kunstschule Linz since 1951. His own education included studying type and book design and serving an apprenticeship in lithography. In 1963 he founded the Neugebauer Press. Born in Kojetin, Mähren, Czechoslovakia, Friedrich Neugebauer resides in Bad Goisern, Austria.

Motoaki Okuizumi, from Tokyo, Japan, is art director and president of Studio G-2. He has received awards of excellence from the Type Directors Club, the Warszawa Poster Biennale, and the Asian Graphic Design Biennale.

Fred Pauker has worked as a freelance graphic designer in London, England; Bombay, India; and Jerusalem, Israel. He is currently working on calligraphy for a new Midrash (Commentary) on Jerusalem. He was born in Vienna, Austria, and now resides in Jerusalem.

David Peace, an architect by training, has been a glass engraver for the last forty-seven years, specializing in lettering and heraldry. His work is included in public collections including the Victoria and Albert Museum in England and the Corning Museum of Glass in the United States. He is a former member of the Art Workers Guild and president of the Guild of Glass Engravers. Peace was born in Sheffield, England, and currently resides in Hemingford Abbots.

Fredrich Peter is a freelance designer working in graphics and three-dimensional work, illustration, postage stamps, and coins. He was born in Dresden, Germany, and now lives in North Vancouver, British Columbia, Canada.

Michael Podesta studied at the San Francisco Institute of Art. He was born in San Francisco, California, and now lives in Carrollton, Virginia, where he is a freelance artist.

Friedrich Poppl is Professor of Graphic Design at the Fachhochschule Wiesbaden. He is a freelance type designer for H. Berthold AG and has had forty-three of his designs released. Friedrich Poppl was born in Soborten/Teplitz-Schönau, Czechoslovakia, and now lives in Wiesbaden, West Germany.

Gottfied Pott is an art director in a graphic design studio in Wiesbaden, West Germany. He was born in Lahnstein.

Leonid Pronenko was born in the Krasnodar district of the U.S.S.R. and has been working in the field of calligraphy for the past five years.

Heinz Renz is a book designer and typographic designer from Stuttgart, West Germany. His type design "Extra Condensed Grotesk" was released by H. Berthold AG. He was born in Bielefeld, West Germany.

Marcy Robinson is a self-employed graphic artist. She teaches in New York and New Jersey. Born in Passaic, she now lives in Nutley, New Jersey.

Guillermo Rodriguez-Benitez has practiced calligraphy as a hobby for more than twenty-five years while pursuing a business career. Born in Vieques, Puerto Rico, he now lives in Guaynabo.

Erkki Ruuhinen is an art director in an advertising agency in Helsinki, Finland, where he pursues calligraphy as a hobby. He has been the recipient of numerous graphic design awards around the world and has taught courses in lettering, typography, and advertising planning. Erkki Ruuhinen was born in Toivakka, Finland.

Herbert Sahliger was born in Karwin, Sudetenland, Czechoslovakia, and now lives in Munich, West Germany. He studied at the Academy of Arts in Vienna, Austria, and has been teaching writing and lettering at the German Masterschool of Fashion in Munich since 1960.

Ina Saltz is a computer video graphics designer at Time, Inc.'s Video Group (teletext) and was previously an art director for several magazines in New York. A past president and former member of the board of governors of the Society of Scribes, she teaches calligraphy at the New School and Cooper Union. Ina Saltz was born in Denver, Colorado, and now lives in New York City.

Robert Saunders is a freelance designer. He has taught calligraphy and typography at the School of the Museum of Fine Arts in Boston. Originally from Chicago, Illinois, he now lives in Squantum, Massachusetts, where he is the proprietor of The Alphabet Bookshop.

Werner Schneider is a Professor of Typographic Arts at the Fachhochschule Wiesbaden. As a graphic designer, he specializes in book design and calligraphy. His work has been on exhibit in New York City, as well as throughout Europe. Born in Marburg/Lahn, West Germany, he now lives in Wiesbaden.

Heinz Schumann is a type and graphic designer. He studied at the Hochschule für Grafik und Buchkunst Leipzig under Professor Dr. Albert Kapr. Schumann is from Karl Marx Stadt (Chemnitz), German Democratic Republic.

Yoko Shindoh, from Tokyo, Japan, was represented in the Second NAAC Exhibition and the Hong Kong Japan Design Exhibition.

Eita Shinohara, from Tokyo, Japan, is a lecturer at the University of Arts and graphic designer specializing in television title design.

Steven Skaggs has worked as a corporate designer in New York City and Atlanta, Georgia. He is currently Assistant Professor of design at the University of Kansas. Born in Louisville, Kentucky, he now lives in Lawrence, Kansas, where he is the proprietor of the Blackthorne Scriptorium.

Kennedy Smith, a craft member of the Society of Scribes and Illuminators, was born in Cardiff, South Wales, United Kingdom, and now lives in Netherhampton, Wiltshire, England.

Paul Standard, a self-taught calligrapher, used the texts of Alfred Fairbank, Edward Johnston, Rudolf Koch, Jan von Krimpen, and Stanley Morrison and an-

cient manuscripts and inscriptions as his teachers. He earned Bachelor of Science and Master of Arts degrees from Columbia University and later taught at Cooper Union for eighteen years and also at the Workshop School, Parsons School of Design, and the evening session at New York University. He has written numerous articles for the *Penrose Annual, Graphis,* and American, Canadian, Dutch, and Swedish periodicals. Paul Standard was born in Greenfield, New York, and now lives in New York City.

Mona Strassmann studied graphic design at Cooper Union and earned a Bachelor of Science degree in education from Boston University. A self-taught calligrapher, she used paleographic texts, museum pieces, and old teaching manuals as learning aids and later studied with Jeanyee Wong and Hermann Zapf. Mona Strassmann grew up in New York City and now lives in New Canaan, Connecticut.

Jacqueline Svaren is a professor at Portland Community College where she has been teaching drawing, basic design, and lettering for eighteen years. She earned a Master of Fine Arts degree in education from the University of Oregon. Born in Bend, Oregon, she now lives in Portland.

Ikko Tanaka established the Tanaka Design Atelier in Tokyo, Japan, in 1963. In 1980, he received the "Recommended Artist's Award" from the Ministry of Education, Japan. He is a member of the Tokyo Art Directors Club, the Japan Graphic Designers Association, and Tokyo Designers Space. Ikko Tanaka was born in Nara, Japan, and now lives in Tokyo.

Bill Taylor studied at Texas Tech and now lives in Dallas, Texas, where he is a designer and writer.

Villu Toots, from Tallinn, Estonia, U.S.S.R., specializes in writing manuscripts, diplomas, book jackets, and book plates.

Alvin Y. Tsao has done Chinese seal carving and Chinese water and ink painting. Born in Taipei, Taiwan, Republic of China, he now lives in Springfield, Virginia.

Julio Vega received a Bachelor of Fine Arts degree from Cooper Union where he studied calligraphy with Don Kunz, graphic design with Herb Lubalin, and typography with Bill Sekuler. He lives in New York City where he pursues calligraphy as a pleasurable pastime while employed as an art associate for a New York-based magazine.

Jovica Veljović, a calligrapher and type

designer from Suvi Do, Yugoslavia, graduated from the Academy of Applied Arts in Belgrade where he developed his own major in lettering and calligraphy. His work has been exhibited in Belgrade, London, and New York City.

Julian Waters is a graphic designer, lettering artist, book designer, and calligrapher who does much of his work for museums and art associations. He has taught workshops in lettering throughout the United States. Born in Hampshire, England, Julian Waters lives in Gaithersburg, Maryland, and is associated with Bookmark Studio in Washington, D.C.

Sheila Waters was born in Gravesend, Kent, England, and earned a degree in art from the Royal College of Art. She did freelance work for the map department of Penguin Books for twenty years and founded the calligraphy program at the Smithsonian Institution in Washington, D.C. Sheila Waters teaches calligraphy courses and workshops at her home in Gaithersburg, Maryland, and throughout the United States.

George Watson was born in Yorkshire, England, and now lives in Leicester where he is Studio Director at Frank Gayton Advertising.

John Weber has been a graphic designer with Goldsholl Associates in Northfield, Illinois, for thirty years. He has done the calligraphy for MacDonald's and Flair Pen television commercials. He teaches calligraphy and is a member of the Chicago Calligraphy Collective and the Society of Typographic Arts. John Weber was born in Chicago, Illinois.

Patricia Weisberg, from New York City, is a calligrapher for Steuben Glass. She also does freelance calligraphy, as well as calligraphic work for exhibit.

Martin Wilke, from Berlin, West Germany, is a calligrapher, graphic designer, type designer, and typographer. He studied with O.H.W. Hadank and D.W. Deffler. He designed the typefaces Ariston, Caprice, Diskus, Palette for H. Berthold AG and Photo-Lettering, Inc.

Jeanyee Wong, one of the jurors for the ITC exhibition "International Calligraphy Today," is a graduate of Cooper Union where she studied painting, sculpture, lettering, and design. She served an apprenticeship to Fritz Kredel, from whom she learned woodcutting and other illustration techniques. A freelance calligrapher, designer, and illustrator, she is best known for the more than thirty books she designed, illustrated, or decorated, some of which are entirely handwritten. She teaches calligraphy at the New School and

at the Pratt-Phoenix School of Design. Jeanyee Wong was born in San Francisco, California, and now lives in New York City.

John Woodcock has worked in graphic design, typography, engraving, and letter-cutting. Born in Yorkshire, England, he now lives in Surrey.

Margaret E. Young is a designer and calligrapher specializing in heraldic art. She was born in London and now lives in Wembley, Middlesex, England.

Morris Zaslavsky is a graphic designer and lettering artist. He is Professor of Art at California State University at Northridge. He graduated from Parsons School of Design, New York University, and the University of California at Los Angeles (where he received a Master of Fine Arts degree). Morris Zaslavsky was born in New York City and now lives in Los Angeles, California.

Gudrun Zapf von Hesse is a book binder and type designer. She designed Diotima, Smaragd, and Ariadne swash initials for D. Stempel AG and Shakespeare for Hallmark Cards. Born in Schwerin, she now lives in Darmstadt, West Germany.

Hermann Zapf, chairman of the ITC exhibition "International Calligraphy Today," is internationally known as a type designer. He is also a graphic designer and teacher. Among his more well-known typefaces are Melior, Optima, Palatino, ITC Zapf Book, ITC Zapf Chancery, and ITC Zapf International. He was the type director for D. Stempel AG, Frankfurt, West Germany (1947–1956); a design consultant to the Mergenthaler Linotype Company, New York and Frankfurt (1957–1974); and a consultant to Hallmark International, Kansas City, Missouri (1966–1973). He has lectured throughout the world and taught lettering at the Werkkunstschule, Offenbach, West Germany; graphic design at the Carnegie Institute of Technology, Pittsburgh, Pennsylvania; typography at the Technische Hochschule, Darmstadt, West Germany; and calligraphy and typographic computer programs at the Rochester Institute of Technology, Rochester, New York. His work has been exhibited throughout the world, and he has been the recipient of numerous typographic awards, the most notable of which is the Johannes Gutenberg prize, awarded in 1974. He is the author of *Pen and Graver, Manuale Typographicum, About Alphabets, Typographic Variations*, and *Orbis Typographicus*. Born in Nuremberg, Professor Zapf now lives in Darmstadt, West Germany.

Edit Zigány is a book and type designer. She is the designer of the typeface Pannon Antiqua, issued by the Hungarian Type Foundry. Edit Zigány is from Budapest, Hungary.

INDEX OF CALLIGRAPHERS